OUR WORLD
Our Music
Third Edition

one-time
online
access
code
included

Robert L. Elliott

Kendall Hunt
publishing company

Kendall Hunt
publishing company

www.kendallhunt.com
Send all inquiries to:
4050 Westmark Drive
Dubuque, IA 52004-1840

ISBN 978-1-5249-0505-7

Printed in the United States of America

In memory of Clark "Pinky" Curry and Trenton Cooper,
two dear friends and excellent jazz musicians
from whom I learned much.

Brief Contents

Contents

Preface

The presentation of *Our World, Our Music* is based upon a few key concepts:

- Music is a human activity that is practiced throughout our world and has been a part of the human experience since long before we had the ability to write about it.
- Music reflects the culture and society in which it exists. When a type of music ceases to resonate within a culture or society, something else takes its place.
- When different societies and cultures come into contact with one another, both are changed by the interaction and their music reflects these changes.

Content Organization: The eight chapters of *Our World, Our Music* are organized with the middle six chapters presenting a chronological approach to the development of the music that we hear today. These six chapters are bookended by a first chapter that presents musical terms, concepts, and performance media and a last chapter that examines the rise of pop culture and the development of modern pop music.

Pedagogy: A key pedagogical approach of *Our World, Our Music* is in relating historical and discipline-specific concepts to knowledge that students may already have as a result of cultural participation. Concepts and components in art music are often compared with similar ideas found in modern popular music. Historical styles are related to their supporting societies and compared with modern styles and their roles within modern society.

Recorded Music: *Our World, Our Music* includes a four-month subscription to its companion website, www.OurWorldOurMusic.com. The music accessed from the book's website provides both auditory and visual components to better serve students with a variety of learning styles. The modern database from which these recordings are drawn is so extensive that there is literally more music available than may be listened to in a single lifetime.

Listening: There are over a hundred Guided Listening boxes contained in *Our World, Our Music* that provide an even greater number of prescribed listening experiences to assist students in following and understanding musical examples as they view and listen. Access playlists at www.OurWorldOurMusic.com.

Worksheets: To facilitate student learning through strategies beyond reading and listening to lectures, *Our World, Our Music* contains student worksheets at the end of each chapter. All pages of *Our World, Our Music* are perforated to make it easy to tear out worksheets for submission to the instructor. Students may complete these exercises for grades or simply for individual study.

Concert Attendance: At most colleges and universities, the music appreciation or survey of music course includes a concert attendance component. To facilitate the reporting of this experience, seven concert attendance forms are provided at the end of the book. These may be completed, torn out, and submitted to the instructor.

Online Materials: The supporting website, www.OurWorldOurMusic.com provides access to student resources, including practice quizzes, learning games, listening drills, the Pronunciation Assistant, and other activities. Instructor resources may also be accessed through this website.

Index/Lists of Terms: Noticeably and intentionally missing from this text are both an Index and Lists of Terms for each chapter. Since defining terms is an activity that is included in each chapter's worksheets, it would be self-defeating to also provide that information. Each student, through his or her learning reinforcement activities, creates a list of terms and definitions for each chapter.

Acknowledgments

Reaching the milestone of *Our World, Our Music's* third edition is both exciting and humbling. A task as large as the creation and revision of a textbook is far too great for one person; it requires a team. Many influenced and had input into the creation of this book: my previous students, who helped me shape the presentation of this material into a meaningful, more accessible format; contributors who added directly to the book's presentation, including James Howard, Thomas Davis, Charles Cook, Karen Elliott, Brook Sutton, Renecia Walker, Cristian Codreanu, Pamela McCoy, Kyle Burnham, Kevin Durham, Maureen McCaffrey, Tony Artimisi, Leonard Morton, Mark Collino, and Cortessa Jenkins; colleagues who contributed ideas, including Ljerka Rasmussen, Patricia Reeves, Mark Crawford, and John Chiego; the schools, colleges, and universities, along with their faculties and students, who made suggestions for textbook and website improvements and then test-drove those attempts to fulfill their requests; the Kendall Hunt team, who find ways to make things work; and my family, friends, and colleagues who tolerated my monomaniacal periods of seclusion and binge writing in the midst of trying to also live a life. Any errors in the book are mine and should not reflect upon any of these supporters or the *Our World, Our Music* team.

Robert L. Elliott
Nashville, Tennessee
July, 2016

OUR WORLD, OUR MUSIC

Our world is one made up of many different yet similar parts. Its people practice different customs, cultures, societal structures, and languages. We all have basic human interests that are driven by our need for shelter, food, and security. We all place a high premium on the concept of family. We all want to provide for and to keep safe those whom we love. We all are very much the same, yet we celebrate these common components in different ways, though we use many common concepts in our approaches to marking important events in our lives. Music is a key element in ceremonies, celebrations, and cultural activities and in our world, the phrase "Music is the universal language" is repeated often. While that phrase may or may not be true, it is true that throughout our world, one human undertaking that seems to be universal is the making of music.

Figure 1.01

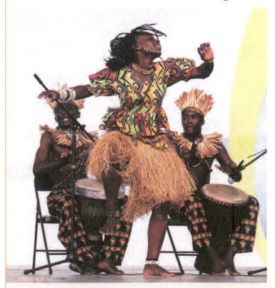

Buddhist monks in Mongolia play music on traditional dung-chen, long trumpet-like instruments that produce low notes and may be fifteen feet or more in length.

Figure 1.02

Artists from Angola in Southern Africa perform traditional music with dancing.

MUSIC IN LIFE

The arts in general and music in particular are uniquely human activities. No other animal on our planet builds a nest for shelter and then decorates it for no other reason than to bring pleasure in looking at it. Similarly, while many animals create sounds to mark territory, attract mates, or communicate danger, only humans create and organize sounds for no other reason than to bring pleasure in listening to and in creating it. While different groups of people may create and organize their music in different ways that reflect the diversity of cultures in our world, research indicates that the same parts of the human brain respond to these different types of music. Making and enjoying music is a human activity and experience that is enjoyed by people throughout our world, as indicated in Figures 1.01-1.06. No other living things share our perception of music.

As Mark Twain, the American author, once said, "Never try to teach a pig to sing. It wastes time and annoys the pig."

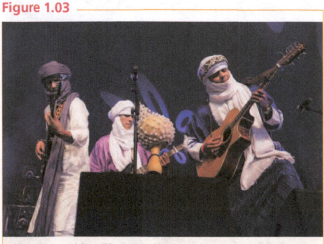

Figure 1.03

Moroccan musicians (Northwest Africa) combine their traditional music and culture with western instruments and influences.

Music in Our World

Music reflects the society in which it exists. This is true on many levels. The role of music in a society is reflected in many characteristics of its music. If the music supports text or words, it usually uses limited pitch ranges that mimic the distance between the highest and the lowest notes of a typical human voice. If instruments are also used in that society, they are often stringed instruments (Figure 1.03) capable of producing an almost infinite variety of pitches, much as the human voice can move and slide between pitches that are extremely close together. If the music serves outdoor, celebratory purposes, it often makes extensive use of various percussive-type instruments (Figure 1.04). Societies usually use the natural resources available to them in creating their instruments (Figure 1.05). For example, societies and cultures on islands and near beaches often make their instruments from shells and other bounty of the sea, while societies based around rivers and streams often create their traditional instruments from the reeds that grow along the banks.

Figure 1.05

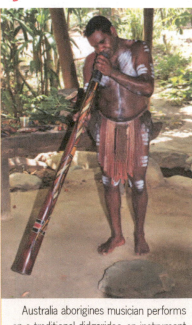

Australia aborigines musician performs on a traditional didgeridoo, an instrument made from locally available resources.

Figure 1.04

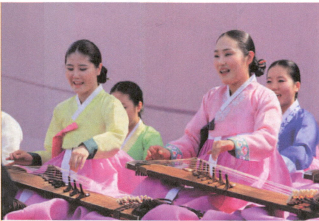

A Julsori Chorus performs Korean classical music on the gayageum, a traditional stringed instrument of that region.

Western Music

Although our world has many types of music, a large portion of this music is based upon a similar organizational foundation. This is the type of music with which you are probably most familiar; it is known as *Western music* (not Country Western, which is one small genre within Western music). Simply stated, *Western music*, *Western civilization*, and *Western culture* are terms that relate to those societies that were part of the ancient Roman Empire or were later influenced by a society that was part of the Roman Empire. The trade and cultural interaction among parts of the empire, coupled with the length of the empire's duration, resulted in many shared ideas and approaches that became part of these societies' cultural identities. American culture contains many of these common Western concepts, including the use of Roman numerals as a numbering system (I, II, III, etc.), logic applied to problem solving (borrowed from the Greeks by the Romans), houses and towns laid out in rectangles and squares (a concept promoted by the Romans), a Western alphabet (also derived from the Greeks), and a simple system from Arabia of counting and writing numbers based upon the ten fingers of the human hands (1, 2, 3, etc.). Europe, western Asia, the Middle East, and northern Africa were parts of the Roman Empire, while the Americas, Australia, New Zealand, and many Pacific Islands were settled, influenced, or both by European cultures that were once part of the Roman Empire. The music of these Western cultures shares many characteristics because it reflects many commonalities of these societies.

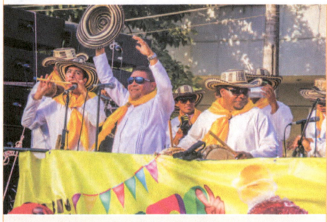

Figure 1.06

Musicians in Carribean coastal Colombia (Northeast South America) make instruments from corn stalks and other available resources to use in creating traditional music (note the *flauta de millo* player on far left).

Since non-Western societies do not share the unifying characteristic of a single empire's reign, they tend to be culturally independent in their approaches to music. Pitch systems are often unique to a culture, and instruments, if used, also tend to be distinctive for the culture. Organization and structure within non-Western music varies. Each type of music in our world has its own sound, is based upon a structure, and has a specific performance practice.

The pitches used in Western music can be traced back to the work of a Greek mathematician named Pythagoras, the same man whom you may have encountered in a math or geometry class while studying triangles and learning the Pythagorean theorem ($a^2 + b^2 = c^2$). Physics and mathematical relationships between musical pitches govern this aspect of our music. When some of these pitches are sounded simultaneously, the result is a unique type of sonority that makes up one of the foundations of Western music.

Music serves many purposes in Western society, and because Western society is an amalgamation of ideas and traditions from many sources, applications, instrumental types, and approaches vary. As Western society evolved, many traditional lines became blurred. An example is the stylistic difference between sacred (worship) music and secular (nonreligiously oriented) music. Beginning about four hundred years ago, music for church and music for the stage or everyday use began to grow so similar that often only the text or words would indicate the difference. In today's world, we find that this growing together of styles is still common as evidenced in the similarities between popular music for dance and styles of worship music, such as gospel.

FORM AND STRUCTURE IN MUSIC

Humans are beings that crave structure. We understand our world a little better if we can perceive an order to it. We are also better able to build our "nests" and other creations if we can think in terms of some underlying or organizational form and structure. Our music, regardless of its supporting society, tends to function in this way, too. Most music is not something that just starts, rambles along, and finally runs out of steam and ends. Organization and structure help us to follow our music. Sections, or "chunks," within the musical structure help to maintain interest, create a unity of form, and move the music forward. Using both repetition and contrast, these sections make up musical form. Often one section, an A section, is very different from the B and C sections that follow, creating contrast. (Interestingly, most music uses no more than three different sections; something in the human psyche tends to gravitate toward things organized in threes.) Sometimes sections are brought back through repetition to present the listener with familiar material. Sometimes both repetition and contrast are used simultaneously when musical ideas are repeated but the words are changed, as in the common practice of changing text for different verses of a song. This organization of sections, or "chunks," in music creates *form*. The following are examples of different musical forms.

GUIDED LISTENING 1.01

Finding Form in Music

Form in music is created by combining "chunks" or sections in a variety of different orders. Usually no more than three different sections are used in creating a piece of music's form. Listen to these musical examples to find their forms.

Music listening may be accessed from www.ourworldourmusic.com

While the preceding music pieces are all a bit different from one another, as are their forms, they also have many similarities. It is important to note that music, like much of what we know and do in a society, is constantly evolving and changing. Modern musical forms find their roots in music of the past. To truly understand our modern music, we must gain some understanding of the music of the past that shaped it.

ORGANIZING SOUNDS TO MAKE MUSIC

To aid us in our discussion of how sounds combine to make up music, we need some common terminology, or language, that describes some concepts and components of music.

High, Low, and When

Music may be described as sound that is organized in time. Sound has several components, and one of them is pitch. *Pitch* is the relative highness or lowness of a sound. In more specific physical terms, pitch is determined by the speed at which an object vibrates. It is important to understand that all sound begins, is transmitted, and is perceived as vibration. A physicist would say that sound is periodic motion, or that the vibrations are regular, recurring events. When something vibrates, whether it is a string, a piece of metal, or the window of your room when a car with a loud sound system goes past, sound is created. The vibrating object exhibits periodic motion. If a medium such as a gas (air) or a liquid surrounds the vibrating

object, the vibrations are transmitted through that medium. Sound travels at different speeds and with different characteristics through different mediums and different temperatures. Sound always travels dramatically slower than light; that is why from a seat in center field you see the ball leave the bat and the runner begin running before you hear the crack of the bat coming into contact with the baseball. It is also why you see lightning before you hear thunder. The longer the interval between seeing the event and hearing it, the further away you are from the event. The vibrations travel through the medium and reach our ears, setting several interior parts into motion and resulting in the vibrations being converted to chemical-electrical energy and sent to our brains for processing as the sense of hearing.

Pitch

Musical pitches follow the same rules of physics as other sounds and are processed by our brains in the same manner. Perceived highness and lowness of sounds is a result of the speed at which the sound-producing object is vibrating. Faster vibrations result in higher sounds, while slower vibrations are perceived as lower-pitched sounds. Humans have a specific range of hearing. The lowest sounds that we hear vibrate about twenty times per second (times per second is labeled *hertz* and notated Hz), and this sound would be represented as 20 Hz. The highest sound we hear vibrates at 20,000 Hz, or twenty kilohertz (*kilo* means "thousand") and is represented as 20 KHz. Knowing that the range of human hearing is 20 Hz to 20 KHz can help us when we purchase sound and stereo equipment, because we can look at the specifications for a set of headphones, stereo or surround speakers, or a microphone and determine whether the piece of equipment is truly capable of full-spectrum audio. It is surprising how often this is not the case. Some animals have hearing that exceeds the range of human hearing; that is why dogs will respond to very-high-frequency dog whistles that humans cannot hear.

Musical pitches occur at specific frequencies within the range of human hearing. In Western music, the mathematical relationship worked out by Pythagoras is the basis upon which we determine the frequencies at which musical pitches vibrate. In music of non-Western cultures, various formulas for pitch determination are used. Western music formulates these pitches into groups, wherein one pitch vibrates twice as fast as the other, and then divides these groups into twelve relatively equal parts to make up the twelve pitches that we see represented by the white and black keys on a keyboard instrument. Most Western music uses only eight of the twelve pitches at any given time, so we speak of the distance between the two outermost pitches in a grouping as an octave (from the Latin *octus*, meaning "eight"), since the eight pitches in common use are contained within an octave group. These eight pitches, visible as the white keys on a keyboard instrument, are given the letter names A, B, C, D, E, F, and G. The eighth letter would be the repetition of the letter A, and the sequence would begin again. Every note in Western music can have a note an octave above or below it, and every note can be the starting point for the eight-note grouping commonly used in making Western music. These eight-note groupings are called *scales*.

In Western music, we notate modern music on a series of five horizontal lines called a *staff*. (Most non-Western music does not have a notation system.) We use the lines and the spaces between in notating music, and we add a symbol called a *clef sign* at the beginning of the lines to indicate whether we are notating high pitches or low pitches, as indicated in Figure 1.06. Letter names assigned to each line and space correspond to the pitch letter names discussed earlier. Notes written higher on the staff sound higher in pitch than those

Figure 1.07

The five lines make up a staff, and the symbol at the beginning, a treble clef, indicates that high notes will be placed on this staff.

The bass clef indicates that low notes will be placed on this staff.

Staves with treble and bass clef signs.

placed lower on the staff. Room for even higher or lower pitches can be made through the addition of *ledger lines,* short lines added above or below the staff when additional pitch range is required. Note the assignment of pitch letter names to lines and spaces on the staff in Figure 1.07. Also note the use of ledger lines to extend the range of the staff.

Figure 1.08

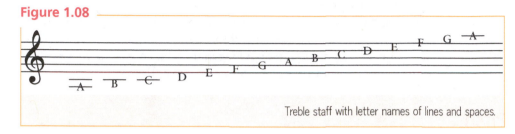

Treble staff with letter names of lines and spaces.

Figure 1.09

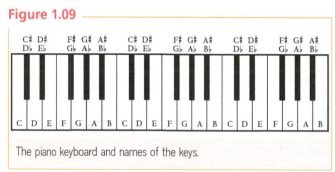

The piano keyboard and names of the keys.

An effective tool for visualizing musical notes is the musical keyboard. The keyboard is made up of two rows of keys that are arranged one above the other. Often, the top row is colored black and the lower row is white. Keys on the bottom row are arranged in a solid line, one key against the next, while those on the top row have frequent gaps between keys. Closer examination reveals that these gaps fall at regular intervals, resulting in alternating groups of two and three keys. If we consider the groups of two as "twins" and the groups of three as "triplets," we find that the white note between every set of twins is the note D. Moving to the right on the white keys of the keyboard corresponds with moving up through the musical alphabet, while moving to the left finds us moving backward through the alphabet.

Raising a note slightly, to the next higher adjacent note (on the right), is to make it *sharp,* and the symbol used is "#." When the note D is raised to the next adjacent note, a black one, it becomes D#, as indicated in the keyboard in Figure 1.08. A raised F becomes F#. Lowering a note slightly, to the next lower adjacent note (on the left), is to make it *flat,* and the symbol used is "♭." When the note B is lowered to the next adjacent note, a black one, it becomes B♭, as indicated in the keyboard in Figure 1.08. A lowered E becomes E♭. Notice that the same black key is used for both D# and E♭. When two notes share a common keyboard key but are called by different names, these notes are said to be *enharmonic.* Thus, D# and E♭ are enharmonic notes.

Rhythm

Pitch, the relative highness and lowness, is only one component of sound and music; another is rhythm, the "when" in music. *Rhythm* allows us to organize sound in time—the basic definition of music. Many things in our lives occur in rhythm: the sun rises and sets to a rhythm, we sleep and wake to a rhythm, objects in our night sky move in rhythms, waves move toward and away from the beach in a rhythm, and even life itself follows a rhythm of birth, to youth, to young adulthood, to middle age, to old age, and eventually, to death. What happens during that rhythm is part of what makes life interesting, and what happens during musical rhythm is part of what makes music interesting.

Just as things sometimes move faster in life and sometimes move slower, music, as a reflection of the human experience, sometimes moves faster and sometimes moves slower. The very concepts of *faster* and *slower* are relative expressions that relate one speed to another. Rhythm is also expressed in relative terms with an accompanying system for writing how sounds are organized in time. If we use one sound's duration as our reference standard, we could say that another sound that moves twice as fast has a duration that is half as long as our reference. If the reference duration or length of a sound (a note) is consider to be a "whole" note or period, then a sound that lasts half as long could be called a "half" note or period. It would take two half notes, played back to back or one after another, to equal the duration of sound contained in our reference whole note. Notation symbols exist for these note or duration values. The symbol ○ represents a whole note. It is written as a circle that has not been filled in. The symbol 𝅗𝅥 repre-

Figure 1.10

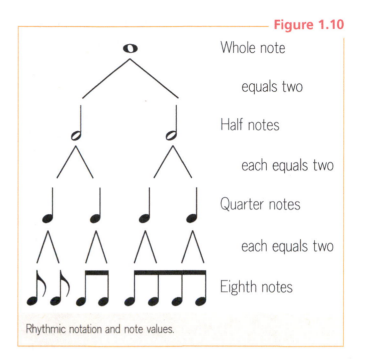

Rhythmic notation and note values.

sents a half note, or a note that has a duration half as long as the whole note. Notice that the half note symbol looks like a whole note with a stick, or *stem*, attached. This stem can be written so that it points either up, as in Figure 1.09, or down, depending upon which direction has more space available. The symbol 𝅘𝅥 represents a quarter note, or a note that has a duration half as long as a half note. (Half of a half is a quarter, or expressed another way, there are two halves in a whole and four quarters in a whole.) A quarter note looks like a half note in which the circle, or *note head*, has been filled in. Most often in modern music, we would tap our foot for each quarter note. Two taps would equal a half note, and four taps would equal a whole note. The symbol 𝅘𝅥𝅮 represents an eighth note, or a note that has a duration half as long as a quarter note. In our foot tapping example, we would count both the down and the up motions and an eighth note would occur on both the down and the up. An eighth note has a *flag* attached to the stem. If the eighth note occurs by itself, the flag will hang, or wave to the right. If eighth notes occur in groups, the flags will usually be stretched between the notes and the flag will be called a *beam*. The relationship among the various types of notes may be a bit more evident in Figure 1.09.

Sometimes in organizing sound in time we want to contrast the sound with silence. In music, we call these silences *rests*. Rests share the same relationships as notes; a half rest lasts half as long as a whole rest, a quarter rest lasts half as long as a half rest, and an eighth rest lasts half as long as a quarter rest, as indicated in

Figure 1.11

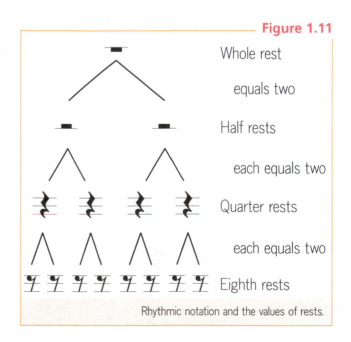

Rhythmic notation and the values of rests.

Figure 1.10. It is quite common to place notes of different duration next to one another, as well as to mix notes and rests in musical passages.

Notation

The system used to notate, or write, music is really quite simple. It is made up primarily of two parts: rhythm and pitch. To indicate how long a sound is to last, a duration or rhythm symbol is selected. This rhythm symbol is then placed on the staff of five lines and four spaces that was shown in Figure 1.06. The placement of the note head of the rhythm symbol indicates the pitch of the sound, depending upon the line or space selected. This then tells the performer what note to play and for how long. Upon completing that note, the performer then looks at the next note's rhythm value and pitch. This simple process of counting and performing pitches as indicated is the foundation of reading musical notation and is used throughout Western music.

Melody

When notes and rhythms are put together in a sequential manner in which one note or sound follows another, the result is *melody*. Perhaps the simplest way to describe melody is to say that it is the part of the song that we tend to sing, whistle, or hum when we participate with a song that we hear or when we bring up a song from our memory. Some melodies move up or down from one note to the next in a steplike manner.

Figure 1.12

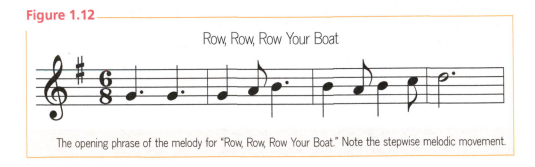

The opening phrase of the melody for "Row, Row, Row Your Boat." Note the stepwise melodic movement.

Some melodies skip around among notes.

Figure 1.13

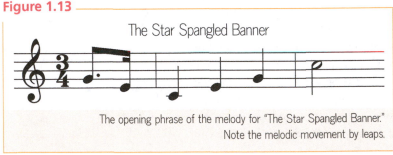

The opening phrase of the melody for "The Star Spangled Banner." Note the melodic movement by leaps.

Some melodies combine these two approaches.

Figure 1.14

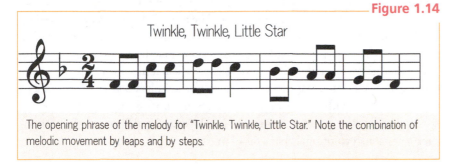

Twinkle, Twinkle, Little Star

The opening phrase of the melody for "Twinkle, Twinkle, Little Star." Note the combination of melodic movement by leaps and by steps.

A final word about music notation: it is primarily a Western approach. Most non-Western music relies upon handing down music from one performer to the next; no system exists for notating music in most non-Western cultures. Unfortunately, without the reference resource of a well-established and documented original form of a piece of music or a song, pieces of non-Western music often undergo changes from one performer to the next, much as a story can change, grow, evolve, or become distorted as it is retold from one person to the next. The written notation system in Western music allows us to look at original versions of musical works and to speak with authority about early Western music, as well as to trace its evolution and development over time.

Adding Emotion

If music were nothing more than "make a sound or don't" and "make this noise and then that one," it would be mechanical and would not reflect the humanity and emotion that is present in artistic activities. Music is one of the temporal arts; it is an art form that exists for a moment in time, like dance, rather than an art form that is more static and fixed in time, like a painting or statue. As an art that exists in the moment, it has the ability to express an emotion that is present in the moment. It can reach past the layers of processing that are present in decoding written or spoken word, or in deciphering meaning in visual presentations. Music can directly strike our psyche and influence emotions. It can evoke happiness, sadness, agitation, peacefulness, and many other emotional states. It does this by adding additional components to the simple "make this sound now" basics of musical notation.

Tempo and Meter

One of the tools that we can use to help enhance emotional impact in music is the speed with which events follow one another. Speed in music is called *tempo*. Very fast music can express lively, happy emotions. Music with a very slow tempo can express sad emotions, and music at other speeds can express other emotions. To be clear, rhythm is the relative duration and speed of musical notes in comparison with one another; tempo is the overall speed of the music. Tempo can be expressed as how fast you tap your foot while listening to music. Since modern music began about four hundred years ago in Italy, a concept explored in depth in later chapters, Italian terms are used to express tempo in music (even the word *tempo* is Italian).

Figure 1.15

Common terms for tempo (speed)

very, very fast	*prestissimo*
very fast	*presto*
lively	*vivace*
fast	*allegro*
a little fast	*allegretto*
moderately	*moderato*
a little slow, walking speed	*andante*
slow	*adagio*
very slow and solemn	*grave*
extremely slow and broad	*largo*

The Italian terms commonly used to indicate tempo, preceded by English translations.

About two hundred years later, about the time that the mechanical clock was invented, a man named Johann Nepenuk Maelzel invented a variation on the clock for use in music. His machine had a swinging pendulum with a weight that could be moved along its length, speeding up or slowing down how fast the pendulum moved. By matching pendulum speed with a tempo, his invention, the *metronome*, allowed musicians to more exactly express musical tempo as the number of beats per minute rather than in the relative Italian terms previously employed.

The gathering of beats or foot taps into regular groups establishes *meter*. Most modern Western music uses a meter with groups of four beats. Sometimes groups of three or two are used, and occasionally even other groupings are employed. Meter is one of the components that helps to establish emotional character in music.

Figure 1.16

Common terms for dynamics (loudness)*

very, very loud	***fff***	*fortississimo*
very loud	***ff***	*fortissimo*
loud	***f***	*forte*
medium loud	***mf***	*mezzo forte*
medium soft	***mp***	*mezzo piano*
soft	***p***	*piano*
very soft	***pp***	*pianissimo*
very, very soft	***ppp***	*pianississimo*

*Based upon four Italian terms:
 forte, meaning "loud"
 piano, meaning "soft"
 mezzo, a modifier meaning "medium" or "moderately"
 -issimo, a suffix modifier meaning "very"
 To add an additional "very," add another *-issi-.*

The Italian terms for dynamics, preceded by English translations and common abbreviations.

Dynamics

Loudness, or volume, in music is referred to as *dynamics.* The overall loudness of a piece of music, or the volume of specific parts within a piece of music, can contribute to the emotional content of the music. Just as different volume levels are marked on your music player and these levels have names (e.g., 1-10), different dynamic levels exist in music and these levels have names. Again, Italian terms are commonly used to express this concept.

Articulation

Making a sound, making it loud or not, doing it fast or slow—these are fundamentals of making music. Nuances change these fundamentals into art, allowing the emotional connection among performers and between the performer and the listener. One of these nuances in music is how the sound is played or sung; this is called *articulation.* Beginning a sound softly and gently adds intimacy; starting a sound sharply and strongly adds boldness and aggression. Smoothly connecting notes helps to imply one emotion, while performing each note in a detached, isolated manner implies another. Some common articulations terms and practices are

- *Legato* (translated as "catlike"), meaning to smoothly connect one note to the next
- *Staccato,* meaning to play each note in a short, clipped manner
- *Accent* (indicated by the ">" symbol), meaning to place emphasis upon a single note
- *Fermata* (indicated by the "⌢" symbol), meaning to hold a single note longer than usual.

Timbre

The color or tonal quality of a sound is called *timbre* (pronounced "tám-ber"). To listen to and distinguish among sounds around us, we recognize familiar timbres. Timbre is the characteristic that allows us to answer a telephone call and immediately recognize a friend's

voice from only hearing "Hello." Timbre is the quality that allows us to recognize the difference between a siren, a dog barking, a guitar playing, and a person humming. Musicians use timbre to add emotional content to music. Can you imagine a beautiful, intimate, romantic love song in a movie being accompanied by music on a tuba? Or can you picture an action film's chase scene with music played on a harp? Choices of instruments or types of voices figure prominently into the music composers have written for about the last 250 years.

Complexity

While much of early written Western music was made up of only a single melody, as it evolved, music became more complex. One of the early added complexities was the sounding of static or unchanging notes in a repeated, dronelike manner, not significantly different from the sound of a Scottish bagpipe.

Harmony

Many of our world's types of music use sounds occurring simultaneously with the melody. In every case, the type of music has structures and guidelines for creating these *harmony* notes. In Western music, most harmony is based upon a tertian concept, or notes a third apart. If you consider placing "1" on a line of the staff and then continuing to number the spaces and lines in an ascending order, the next higher line on the staff would be "3," making it a third above the previous line. The next higher line would be "5." If we were to place a "1" on a space in the staff, the next higher space would be "3" and the one above that would be "5." Western tertian harmonies, built of thirds, can be written on a staff as line–line–line or space–space–space. Harmonies of this type create *chords*. The simplest of all chords is the *triad*, made up of three notes that are each a third apart. As additional thirds are added, harmonies become more complex. It should be noted, however, that structured harmonies are foreign to some types of non-Western music. In traditional Thai music, for example, the focus is upon the linear shape of the musical line and the harmonies that occur can be accidental and fleeting.

Texture

If music were a milkshake, *texture* would be a term used to describe its thickness. Some milkshakes are quite thick and cannot pass through a straw; others are more "milk" than "shake." Milkshakes can take on various textures between these two extremes. Music, too, can be expressed in different textures.

Monophonic—The simplest, thinnest texture in music is *monophonic*, meaning literally "one sound." In monophonic texture, every voice or instrument does exactly the same thing at the same time. Only one sound is present. An example would be the customary singing while candles are blown out at a birthday party—everyone sings the same notes and words at the same time. Power occurs in monophonic texture, because everyone is doing the same thing. The texture is thin, however, because nothing enhances it, fills in the spaces, or acts against the melody.

Heterophonic—*Heterophonic* texture uses multiple versions of a single melody, all occurring simultaneously. The versions may be played or sung starting on different pitches or at different times, or they may proceed at a faster or slower tempo than the original melody. This texture is more common in non-Western music, such as gagaku music of Japan, gamelan music of Indonesia, and some types of vocal music from Africa.

Homophonic—When only one melody occurs and it is supported by simple accompaniment or harmony, the result is *homophonic* music. In this type of music, the melody is usually the only moving line. Accompaniment is often sustained, repeated, or alternated notes derived from the harmony.

Polyphonic—Almost no non-Western music developed *polyphonic* texture. Modern Western music, in contrast, extensively uses this texture, often almost to the exclusion of the other textures. In polyphonic music, multiple independent but related melodies occur simultaneously. An example would be a popular song in which the singer carries the main melody while the bass player contributes another melody, the guitar and keyboard players play their own separate melodies, and stringed, brass, or other instruments play additional melodies. The result is a dense texture of multiple layers. Just as the milkshake mentioned earlier can be so thick that it becomes difficult to drink, music can have such a busy, thick texture that it becomes difficult to hear individual melodies. Moderation, in the texture of both milkshakes and music, is often the key.

GUIDED LISTENING 1.02

Texture in Music

Texture in music refers to the number of melodies that are present. Most music may be defined as being monophonic, heterophonic, homophonic, or polyphonic. Only one texture may be used at a time in a piece of music, though it is not unusual to change from one texture to another during a piece. Listen to the musical examples to recognize the textures that are present.

Music listening may be accessed from www.ourworldourmusic.com

PERFORMING MUSIC

The performance of music can include voices, instruments, or combinations of both. The use of different types of voices and instruments lends variety of timbre to music. When different timbres are applied to different melodies in a polyphonic setting, the result can be individual melodies that not only blend into a musical whole but can also be heard and discerned individually, even while joined into the mix of sound. Humans use two primary means to perform music: voices and instruments.

Voices in Music

Three primary types of voices are used in making music: men's voices, women's voices, and children's voices. The obvious determining factor in the first two types of voices is the sex of the singer. Prepubescent children, lacking the hormones that will later transform many

parts of their bodies, have voices that are almost indistinguishable by sex. Differentiating among types of men's and women's voices is done by measuring the singer's range. *Range* is the distance between the highest and the lowest pitches that can be produced. Men's voices may be divided into two main types: high men's voices are called *tenor*, and low men's voices are called *bass*. A secondary division yields a middle range of voice called *baritone*. Women's voices are also usually divided into two main types: high women's voices are called *soprano*, and low women's voices are called *alto*. A secondary division yields a middle range of voice called *mezzo-soprano*.

The voice is an incredibly versatile means of performing music. Besides the obvious ability to produce words with pitch, an ability shared by an extremely few instruments, most of those electronic, the voice can produce various effects and sounds. Shouts, squeals, whoops, screams, clicks, and pops are only a few of the unusual singing sounds available to the voice. In the music of some cultures, nasal singing, throat singing, and other vocal effects are considered common practice.

GUIDED LISTENING 1.03

Recognizing Types of Voices in Music

Types of voices can usually be identified as those of men, women, and children. Sometimes only one type is used in a piece of music. Sometimes multiple types sing together. Sometimes types of music alternate and sometimes more than one of these approaches are present in a single piece. Listen to learn to recognize different types, regardless of whether or not you can understand the words.

Music listening may be accessed from www.ourworldourmusic.com

Instruments in Music

If a sound is under human control but is not created with the human voice, it is considered to be an instrumental sound. Instruments can produce sound in many ways, but the initial determination is whether the sound is acoustic (natural) or uses electricity. The harnessing of electricity has only been a part of everyday life for a little over a hundred years. Humans have been making music and using instruments for much longer, probably all the way back to caveman beating on a log. Early evidence of instruments in performance may be found in the decoration on ancient pottery, ancient tile work, carvings in temples, hieroglyphs in Egyptian architecture, and ancient writings. In Genesis 4, an early mention of an instrument is found; Jubal, grandson of Adam, is described as the father of those who sing or play the lyre (an ancient harplike stringed instrument).

World Music Instruments

In music throughout our world, acoustic instruments can be separated into four general categories, based upon their method of sound production: idiophones, membranophones, aerophones, and chordophones.

Figure 1.17

Ancient Greek jar with a picture of Apollo playing a lyre, 500–580 b.c.

Idiophones—Perhaps the oldest of all instruments, *idiophones* create sound through the vibration of the instrument itself, as opposed to other types of instruments that use vibrating strings or membranes. The log that caveman used would be an idiophone. Most percussion instruments in use throughout the world, except for those that we would call drums, are idiophones.

Figure 1.18

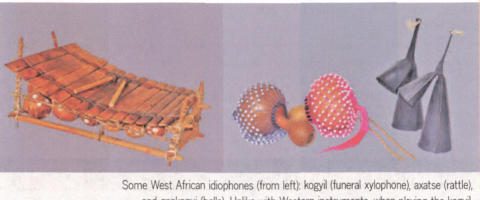

Some West African idiophones (from left): kogyil (funeral xylophone), axatse (rattle), and gankogui (bells). Unlike with Western instruments, when playing the kogyil, the high notes are on the player's left and the low are on the right.

Membranophones—Usually types of percussion instruments, *membranophones* are instruments with a stretched membrane that vibrates. The most common type, by far, consists of drums. Striking this membrane, sometimes called a *drumhead*, causes it to vibrate and thus produces sound. Membranes may be made of many substances, the two most common being skin (leather) and, in the last 75 years, plastic. The shape and makeup of the body over which the membrane is stretched affect the timbre of the instrument.

Figure 1.19

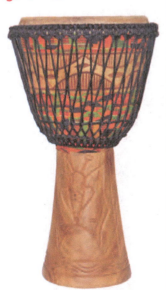

The djembe from West Africa is a membranophone instrument, a group known in Western society as drums.

Aerophones—Instruments that cause the air to vibrate directly, without the use of membranes and without the body of the instrument significantly impacting the loudness of the sound, are called *aerophones*. These instruments most often re-

Figure 1.20

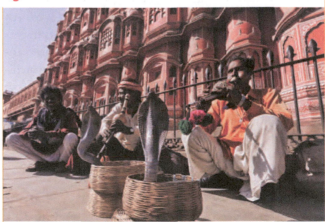

Aerophones, instruments that produce sound from the player's breath, are common in many cultures and may serve various purposes.

quire the player to blow into the instrument. The moving air of the performer's breath is affected by the instrument, producing sound.

Chordophones—Instruments that use a stretched, vibrating string to produce sound are classified as *chordophones.* The body of these instruments is usually a stable base upon which the tension of the strings may be maintained. Often, the body also has an empty chamber to resonate and amplify the sound. Strings may be made from various sources. Traditionally, dried animal intestine, or gut, was common. Modern strings are often made of plastic or metal.

Western Musical Instruments

While the four-part classification system noted earlier can be applied to instruments used in Western music, traditionally a slightly different division is most often used. The first division in Western musical instrument types is to separate those that produce sound acoustically from those that use electricity. Acoustic instruments fall into five categories: percussion, keyboard, woodwind, brass, and stringed.

Figure 1.21

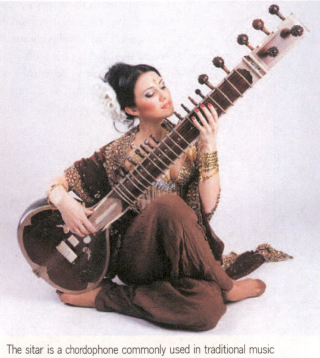

The sitar is a chordophone commonly used in traditional music from India.

Percussion Instruments—The basic guideline about percussion instruments is that if you hit it, shake it, or in general abuse it in some way, you are playing a percussion instrument. These instruments can be divided into two types: those that make a definite pitch and those that do not. Percussion instruments of definite pitch are capable of playing melodies. This type includes

- Xylophone, an instrument with different sizes of wooden bars that makes a brittle, cutting type of sound
- Marimba, an instrument also with different sizes of wooden bars but with resonator tubes suspended below the tubes to create a more mellow sound
- Glockenspiel, an instrument with small metal bars that makes a sharp sound
- Vibraphone, an instrument with larger metal bars, resonator tubes, a pedal to dampen ringing notes, and a mechanism for varying the application of resonance
- Chimes, a collection of tubes of varying length that makes a bell-like sound
- Steel drums, made by cutting metal oil-barrel drums in half and hammering out the bottom to create places of different thicknesses that produce different pitches
- Timpani, a type of drum with a pedal mechanism that allows the performer to quickly change between pitches

Many percussion instruments are of indefinite pitch. These instruments make up the largest group of percussion instruments. Many are drums of one type or another, all based upon a stretched membrane or drumhead that is struck with sticks, mallets, or hands. Other instruments in this group include

- Cymbals, disks of metal (usually brass) struck with a stick, mallet, or each other
- Gongs, larger and heavier brass disks struck with a mallet

- Wood blocks, struck with a stick
- Cowbells, with the clapper removed, struck with a stick
- Temple blocks, a set of tuned, hollow, wooden blocks
- Triangles, bent metal rods struck with another rod
- Maracas, dried gourds with seeds or other objects that rattle inside
- Guiro, a hollow wooden tube with outside ridges, scraped with a wooden stick
- Unusual items such as automobile brake drums, typewriters, and just about anything that someone can think of to use as an instrument

Figure 1.22

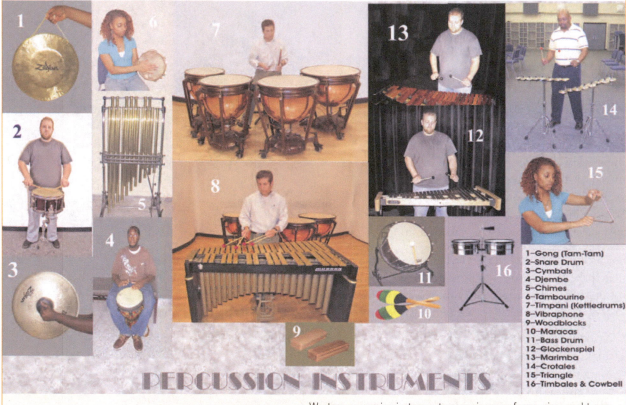

1–Gong (Tam-Tam)
2–Snare Drum
3–Cymbals
4–Djembe
5–Chimes
6–Tambourine
7–Timpani (Kettledrums)
8–Vibraphone
9–Woodblocks
10–Maracas
11–Bass Drum
12–Glockenspiel
13–Marimba
14–Crotales
15–Triangle
16–Timbales & Cowbell

PERCUSSION INSTRUMENTS

Western percussion instruments come in many forms, sizes, and types.

Keyboard Instruments—Just as the percussion instruments group is defined by the way that the instruments are played, the keyboard instruments group is identified by the way that the performer approaches, or interfaces with, the instrument. If the performer uses a keyboard-type controller to address the instrument, regardless of the acoustic method used to create the sound, we call this a keyboard instrument. Some keyboard instruments have a mechanism that causes strings to vibrate, others cause air to flow through whistlelike devices or over reeds that vibrate, and some keyboard instruments have other ways of creating sound. What these instruments share is the method of controlling which pitch is played, when, and for how long.

The harpsichord, clavichord, and virginal are all old keyboard instruments that create sound by causing strings to vibrate. They use slightly different methods of setting the strings in motion but share a common limitation in their inability to express a range of dynamics. In the early eighteenth century, these instruments began to be replaced by a new

Figure 1.23

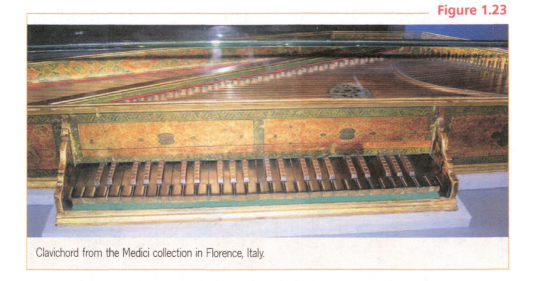

Clavichord from the Medici collection in Florence, Italy.

keyboard instrument with the ability to play soft *(piano)*, loud *(forte)*, and many levels between and beyond. This new instrument was called the *pianoforte*, or the "soft–loud." (The name was later shortened to simply the *piano.*) The piano mechanism causes one or more strings to vibrate with varying degrees of energy (loudness) based upon how much energy is used to depress a key. Continuing to hold the key in the depressed position causes the pitch to continue to sound; releasing the key ends the sound. Foot pedals allow the performer to alter characteristics such as how long a note sounds after being released or to extend the degree of soft dynamics. Sometimes the strings inside the piano are stretched horizontally, as with the grand piano, to expose the maximum amount of the string to vibrate the air around it. Grand pianos have lids that can be propped open to aid in projecting the sound. Sometimes strings are stretched vertically, as with the upright piano, to conserve on the space required for the instrument. Initially, pianos had fewer keys than those of today. In the nineteenth century, the instrument was standardized to today's eighty-eight keys.

Figure 1.24

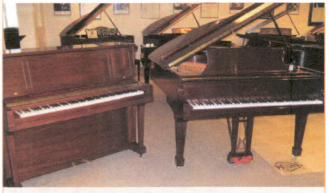

The upright piano (left) is a space-saving sibling of the grand piano. The grand piano (right), with its top that opens, is louder and better suited for filling large spaces with sound.

This image was provided by Brandon Herrenbruck of Steinway Piano Gallery of Nashville.

The organ, an old keyboard instrument, has a history stretching back hundreds of years. Because of its power and ability to change timbre, it was once known at the king of instruments. Organs can be found with widely varying mechanical complexity; however, the fundamental process of sound production and control is the same: Depressing a key directs air through a tube, or pipe. Once inside the pipe, the moving air creates sound by passing over a thin reed, causing it to vibrate, or by escaping through a whistlelike opening. Timbre and pitch result from the physical makeup of the pipe, being influenced by factors including whether the pipes are metal or wooden, the thickness of the pipes' walls, the length and diameter of the pipes, and the sound production by reeds or whistles. Originally, great organs

in cathedrals required groups of boys who took turns pumping a bellows to keep air moving through the instrument. It is now far more common to find an electric motor powering a fan or pump that supplies the air. Although electricity is used, the acoustic method of sound production is unchanged, maintaining the acoustic classification of the organ.

A rule of thumb that governs most instruments is the larger the vibrating surface, the lower the pitch. With pianos, longer strings result in lower pitches. Longer organ pipes produce lower pitches.

Figure 1.25

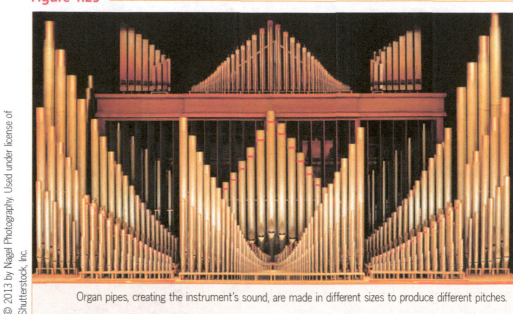

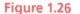
© 2013 by Nagel Photography. Used under license of Shutterstock, Inc.

Organ pipes, creating the instrument's sound, are made in different sizes to produce different pitches.

Figure 1.26

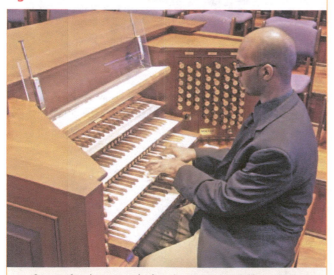

Organs often have many keyboards, or manuals. Pulling out stops assigns timbres to each of the manuals.

Organs with multiple sets, or *banks*, of pipes can produce a wider variety of timbres. Often organs have multiple, stacked keyboards that can be assigned to different pipe banks, allowing the performer's two hands to each play with a different timbre. A larger set of foot pedals, arranged in keyboard fashion, allows the performer to play not only with the hands but also with the feet, something that requires great coordination and skill. Performers control the selection of pipe banks by pulling a control on the organ, called a *stop*, that directs air to a specific bank. When more pipes are engaged, louder dynamics result. The common phrase "pulling out all the stops" is used in the English language to mean applying all resources or efforts to an activity. This phrase comes from the practice of playing the organ.

Woodwind Instruments—In Western music, aerophones are divided into two distinct classifications: woodwind instruments and brass instruments. The labels are traditional: woodwind instruments do not have to be made of wood, and brass instruments do not have to be made of brass. Woodwind instruments rely upon the player's breath (moving air) to create sound. The two types of woodwind instruments are open ended and closed ended. The distinction is made by whether the player closes off one end of the instrument by taking it into his or her mouth and directing all breath into the instrument or the player leaves the instrument outside of the mouth and directs the breath in such a way that part goes into the open-ended instrument and part escapes over or around it. All woodwind instruments work on the same basic principle: the longer the tube, the lower pitched the sound. An early instrument, the Pan flute that is associated with the demigod Pan and is depicted in some ancient Greek artwork, used several short tubes arranged side by side so that they could be blown and shifted by the performer to change pitches. Advancement in woodwind instruments resulted in a shift to a single tube with holes drilled along its length. When blown, air travels through the instrument to the first available hole and then escapes. When a hole is covered up and blocked, the air must travel further to escape. This, in effect, lengthens the tube. The more holes that are covered, the further the air must travel and the lower the resulting pitch that sounds.

Open-ended woodwind instruments include the flute, piccolo, fife, and recorder. The fife is an old type of instrument that is simply a wooden tube

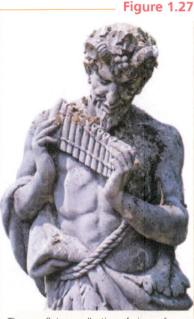

Figure 1.27

The pan flute, a collection of pipes of different lengths, is often associated with Pan, the Greek demigod who was half man and half goat.

© 2013 by mubus7. Used under license of Shutterstock,Inc.

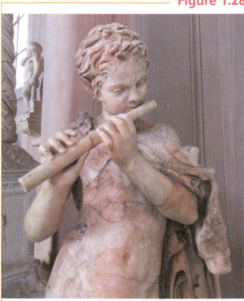

Figure 1.28

Old Roman art statue of a flute player, from the Vatican Museum.

Photo courtesy of Cristian Codreanu.

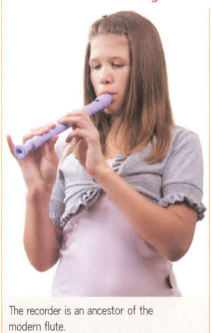

Figure 1.29

The recorder is an ancestor of the modern flute.

© 2013 by prudkov. Used under license of Shutterstock, Inc.

with holes along its length. The player covers the holes with his or her fingers. The instrument is held with one end near the mouth and the other pointing to the player's right. Sound is produced by blowing across a *tone hole*, in much the same manner that you may have blown across a drink bottle to create a sound. The recorder is somewhat like a fife but has a mouthpiece built into it that assures instant success in creating a sound. A part of the instrument is placed into the mouth; however, that portion of the tube only directs the air to an open whistle assembly that automatically splits the airstream so that some goes through the instrument while the rest escapes. Holes along the length of the instrument are covered with the player's fingers. The instrument is held with one end in the mouth and the other pointing out and down, directly away from the performer. While better recorders are made of wood, most manufactured today are made of plastic.

 The flute is a long metal tube that represents an advancement in woodwind instrument design, one that began in the early eighteenth century. Since the reach of the fingers on the human hand is limited, placement of the holes on the instrument often resulted in one or more notes being out of tune because the air did not travel far enough before escaping the instrument. To solve this problem, instrument makers began to put *keys* on instruments. Keys are mechanisms that allow the player to push on a lever and cause a hole to be covered

Figure 1.30

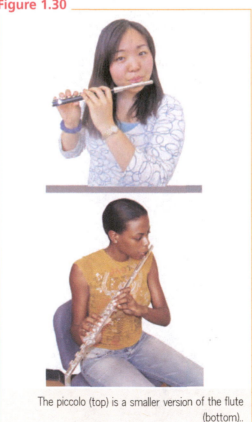

The piccolo (top) is a smaller version of the flute (bottom)..

that would normally be outside of the player's reach or that would be too large for the finger to completely cover. Initially, only one key was added to the flute. This grew to two, then three, and then more. The modern flute has a key for every hole. The instrument is played in a transverse position, much the same as a fife. A piccolo is a miniature flute that may be made of metal, wood, or plastic. Since the piccolo is smaller, having a shorter tube in which the air travels, the resulting sound is higher pitched.

The second group of woodwind instruments consists of those that are closed ended. When played, one end of the instrument is placed inside the player's mouth. Closed-ended instruments come in two types: single reed and double reed. Both use a reed (similar to

Figure 1.31

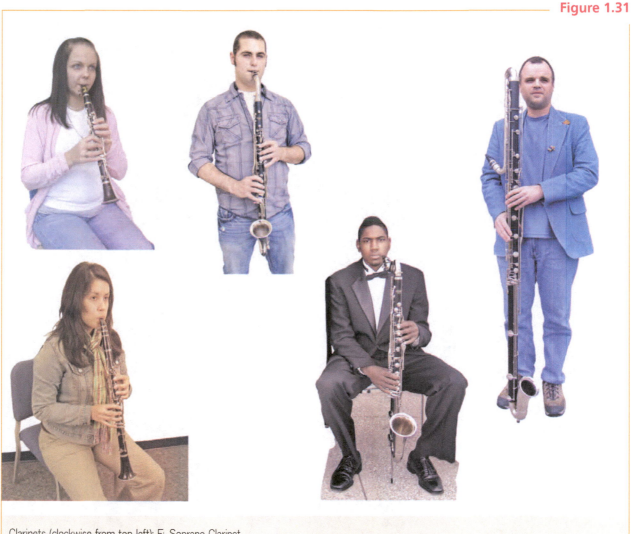

Clarinets (clockwise from top left): E♭ Soprano Clarinet,
E♭ Alto Clarinet, B♭ Contra-Bass Clarinet,
B♭ Bass Clarinet, and B♭ Soprano Clarinet.

bamboo) that is sharpened on one end. Air passing over the edge of the reed causes the reed to vibrate, creating a sound, in much the same way that air blown over the side edge of a blade of grass can create a sound. Single-reed instruments have one reed connected to a hollow mouthpiece for placement into the player's mouth. The most common single-reed instruments in Western music are the clarinet and the saxophone. Clarinets are made of wood or plastic. Saxophones are made of a brass alloy. Both of these instruments come in different sizes with different pitch ranges and use keys for reaching the holes to be covered.

Figure 1.32

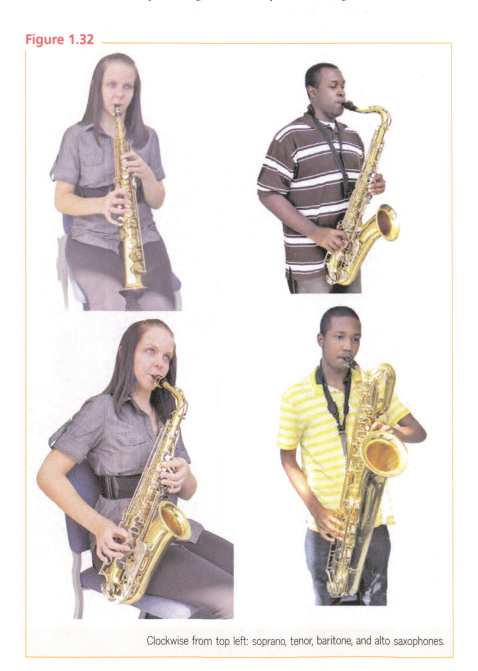

Clockwise from top left: soprano, tenor, baritone, and alto saxophones.

An interesting variant in approach to single-reed instrument design is the bagpipe, commonly associated with Scotland but historically found in many parts of the world, including Africa and the Middle East. This instrument uses multiple tubes of different length, each containing a single reed. One of the tubes, or pipes, is called a *chanter* and has holes along its length, allowing the player to change the pitch that is produced and thus to play melodies. Some versions of the bagpipe use two chanters. The remaining pipe or pipes have a fixed length and produce a single note each. All pipes have one end attached to a bag, originally the bladder of a goat or other animal. Another tube, called a *blowpipe*, containing no reed, is attached to the bag and is blown through at irregular intervals by the performer to keep the bag inflated. The inflated bag provides a constant supply of moving air to the pipes and results in sustained, *drone*, pitches from some pipes while the melody is played on the chanter or chanters.

Figure 1.33

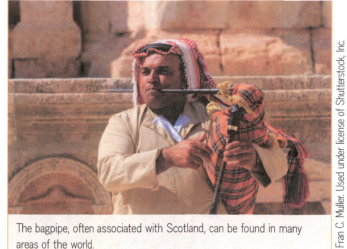

The bagpipe, often associated with Scotland, can be found in many areas of the world.

GUIDED LISTENING 1.04

Recognizing Types of Instruments in Music

Many different types of instruments are used to make music in our world. One reason for so many different instruments is that they sound different from one another. Bagpipes can be found in many places, though they are often identified with Scotland. Listen for the drone sounds that continue unchanged underneath the melody.

Music listening may be accessed from www.ourworldourmusic.com

Double-reed instruments also use keys to reach holes beyond the reach or size that the player can cover with his or her fingers. A double-reed instrument has no mouthpiece since the reed itself is the mouthpiece. To create a double reed to be used on an instrument, a reed with a diameter a little smaller than that of a pencil is cut into a 2- to 3-inch length. It is then split lengthwise. Both halves are sharpened to a flat, thin edge and then placed back together and wrapped with thread or string. The player inserts the double reed into the instrument, puts the reed into his or her mouth, and blows through the reed. Since the reed has two vibrating surfaces, the resulting sound is different from that of a single reed. The smallest of the Western double-reed instruments is the oboe, followed in order of size by the English horn, bassoon, and contrabassoon.

Figure 1.34

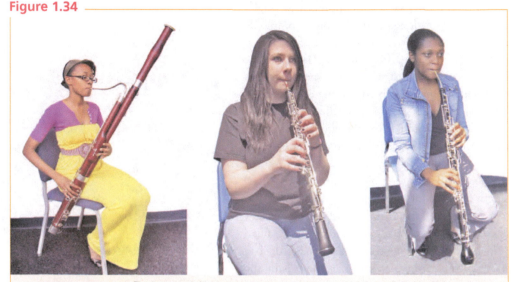

The bassoon (left), oboe (middle), and English horn (right) are all double-reed instruments.

Brass Instruments—The other classification of aerophone instruments in Western music is that of brass instruments. While modern brass instruments are indeed made of brass, many earlier members of this instrument family were made of other materials. An ancient brass instrument is the shofar noted in the Torah, Bible, and Quran. This instrument was made from a ram's horn. The determining characteristic for identifying brass instruments is not the composition of the instrument but the method of producing sound. Rather than simple blowing, as done on a woodwind instrument, brass instruments require the player to vibrate the lips to create a sound. The player places part of his or her lips inside a bowl-, cup-, or funnel-shaped mouthpiece, presses the lips together, and blows air through the lips, causing the lips and air to vibrate. The vibrating air passes through the instrument and exits as a sound. The length of the tube on brass instruments determines the pitch of the sound: longer tubes result in lower pitches, and shorter tubes result in higher pitches.

Originally, the length of the instrument was fixed and the number of pitches available to the player was limited. The bugle is a fixed-length modern brass instrument. The addition of mechanisms removed the available-pitch limitation. An early mechanism that allowed brass instruments to play all possible notes used two tubes, one slightly larger in diameter than the other, that fit one inside the other. The player could change pitches by sliding the outer tube over the stationary inner tube so that the overall tube length could be made longer and shorter quickly enough to change pitches during a piece of music. Today's modern trombone uses this device. In the early nineteenth century, *valves* were added to brass instruments. By depressing the valve, the player could direct the airstream into a detour through additional tubing and lengthening the overall tube through which the air travels. This is the mechanism used by every other modern brass instrument. The sizes of brass instruments determine the ranges of pitches available. In increasing size, the most common Western brass instruments are the trumpet, French horn, trombone, euphonium, and tuba. For marching band use, the tuba's plumbing is rearranged to make it easier to carry and to better

project the sound forward; besides the shape, the tuba and the sousaphone are basically the same instrument.

Figure 1.35

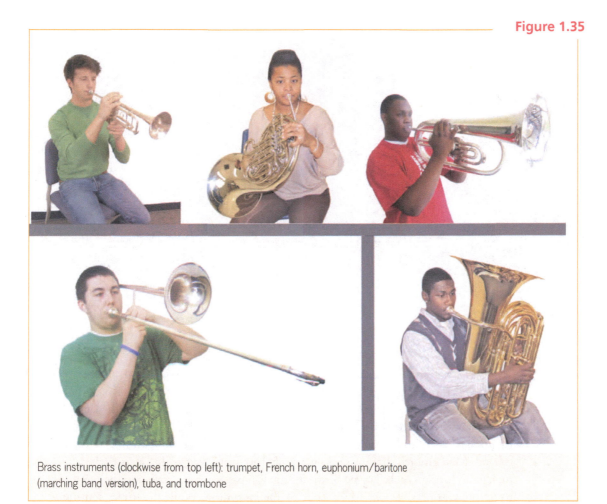

Brass instruments (clockwise from top left): trumpet, French horn, euphonium/baritone (marching band version), tuba, and trombone

Stringed Instruments—In Western music, chordophones are labeled as stringed instruments. The defining characteristic is the same: sound is produced by causing a tight cable to vibrate. The many ways of setting the cable, or string, into motion include plucking, striking, and rubbing. Features common to almost all stringed instruments include a somewhat solid framework over which the string is stretched, a means for adjusting the tension of the string, and an empty chamber to resonate and acoustically amplify the sound. Two general rules govern stringed instruments: (1) The longer the string, the lower the pitch, whereas the shorter the string, the higher the pitch, and (2) the tighter the string, the higher the pitch. Tighter strings tend to result in louder sounds. While it is possible to produce low pitches with short, loose strings, the resulting sound lacks power. Most often, when low pitches are desired, instruments will be made in larger sizes so that string tension and loudness may be maintained. Strings were originally made from dried animal intestines and were called "gut" strings. Modern strings are made of plastic, metal, metal-wrapped plastic, or plastic-coated metal.

Figure 1.36

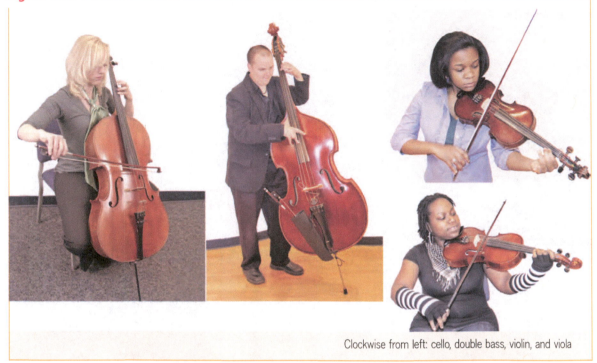

Clockwise from left: cello, double bass, violin, and viola

Orchestral stringed instruments are based upon a single design concept that is then enlarged and modified in creating each of the four common instruments. In this design, an hourglass-shaped hollow body is the resonating chamber; holes shaped somewhat like the letter *f*, called *f-holes*, allow sound to escape the vibrating body; an attached stick called the *neck* allows the string length to be extended; and tuning mechanisms at the end of the neck provide for adjusting string tension. Modern orchestral instruments usually have metal strings that are stretched from the tuning mechanisms to the far end of the instrument, passing over a *bridge* near the end that helps to transmit string vibrations to the body of the instrument. While the strings sometimes are plucked, called *pizzicato*, more often they are set into motion by rubbing the string with a *bow* in a manner called *arco*. The bow is based upon the principle of a hunter's bow, having a stick that, when bent, tries to spring back, creating a stretching force. Instead of a bowstring, horsehair from the long tail of a horse is stretched between the two ends of the bow stick. Tension from the stick stretches the hair tightly. The hair is rough, and when rubbed against a string, it skips along the string and sets it into motion. To enhance the roughness of the hair, a boiled-down tree sap called *rosin* is usually rubbed on the hair before playing. The four commonly used orchestral stringed instruments, in order of increasing size and decreasing pitch, are the violin, viola, cello, and double bass. The same double bass instrument, when used in a jazz music setting and played mostly in a pizzicato manner, is then called a string bass.

Most stringed instruments use only four to six strings but allow the player to shorten the length of the vibrating string on demand, resulting in a range of available pitches. To change pitch, the player places his or her fingers directly on the strings and presses them down against the neck. The result is that part of the string is stopped from vibrating. The remaining, shorter portion of the string then vibrates at a higher pitch. Quickly depressing the string at a position on the neck, causing the string to vibrate, and then depressing the string at a different position allows the player to change pitches and play melodies.

Another stringed instrument that is often used in orchestral settings is the harp. The harp has an open design that does not allow the player to press down fingers and change string lengths. Instead, the harp uses many strings of different lengths, usually around 32 strings, and color-codes the strings so that the player can quickly identify one pitch's string from the next. The harp is played by plucking the strings with both hands. Pedals on some harps allow the player to quickly make slight changes to the tuning of groups of strings. The strings are stretched over a solid framework with tuning mechanisms at one end and a hollow resonating chamber at the other.

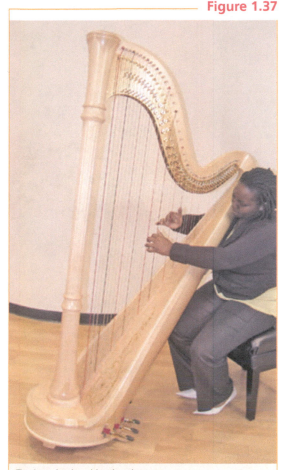

Figure 1.37

The harp is played by the player reaching around both sides to pluck strings with each hand.

GUIDED LISTENING 1.05

Recognizing Types of Instruments in Music

In Western music, the primary acoustical instruments that are most often used in mixed- or like-instrument groups are those of the Woodwind, Brass, String, and Percussion families. Sometimes instruments from a single family are used and sometimes those of multiple families are combined. Switching between types of instruments helps to create contrast and variety while returning to a previously used type helps to create repetition.

Music listening may be accessed from www.ourworldourmusic.com

Other common modern acoustic stringed instruments include the guitar, mandolin, banjo, dulcimer, and guitarron. These instruments usually find uses far outside an orchestral setting. Except for the guitarron, they also share a common characteristic: they are *fretted* instruments. Frets are bands of metal placed across the neck of an instrument. When the player depresses a string against the neck, it becomes bridged over the band of metal, regardless of

Figure 1.38

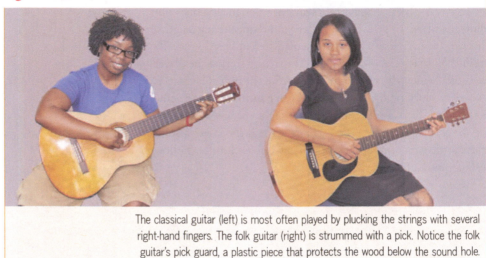

The classical guitar (left) is most often played by plucking the strings with several right-hand fingers. The folk guitar (right) is strummed with a pick. Notice the folk guitar's pick guard, a plastic piece that protects the wood below the sound hole.

slight variations in finger placement. Strategic placement of these frets allows the instrument to always be played in tune, regardless of exact finger position. Fretted instruments are easy to recognize, since they will appear to have lines drawn across the neck at regular intervals and often have a series of dots or other markings placed between some frets.

The guitar and mandolin share a basic body design, one that is not significantly different from that of the violin: a hollow body that is a resonating chamber, a heavy stick with frets pointing out of one end of the body, tuning mechanisms on the end of the stick, a place on the opposite end of the body to anchor the other end of the strings, and a bridge near that attachment to be a means for transferring string vibrations to the body of the instrument. The guitar and mandolin also share a common playing position that is not used with orchestral stringed instruments: diagonal placement across the performer's body, with the lower instrument body on the player's right and the neck reaching toward and beyond the left shoulder. The guitar has a large, round *sound hole* placed near the middle of the body, directly under the strings. This hole allows sound to exit the instrument, enhancing the vibration of the strings as it passes and feeding more sound and vibration back into the instrument in a resonating, amplifying loop. Guitars can use plastic strings or metal strings.

The choice of strings is usually based upon the type of music to be played. Metal strings are more brilliant in sound and are louder. They are usually coupled with guitars that have larger bodies and are generically called *folk guitars*. The strings on folk guitars may be plucked with the fingers, but more often a plastic *plectrum,* or *guitar pick,* is used to strum the strings. Because of this, folk guitars usually have a flat plastic *pick guard* attached just below the sound hole that helps to protect the wooden body from the plastic pick. Plastic strings have a softer, warmer tone. They are most often coupled with smaller-bodied guitars generically called *classical guitars.* These instruments, intended to be played by plucking with the fingers, do not have pick guards. They also do not have dots or other markings between their frets. The mandolin is between a violin and a guitar in size, taking on characteristics of both.

Mandolins, due to their size, are rather high-pitched instruments, having frets like a guitar but allowing sound to escape through f-holes like a violin. Players usually use a plec-

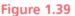
Figure 1.39

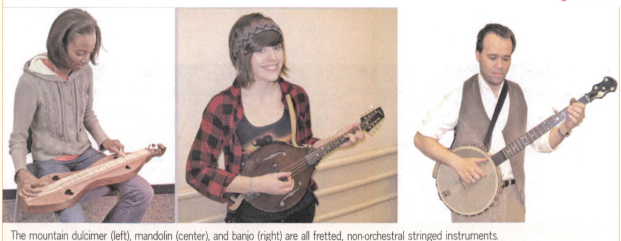

The mountain dulcimer (left), mandolin (center), and banjo (right) are all fretted, non-orchestral stringed instruments.

trum to strum the strings, and the strings are made of metal. One distinguishing feature is that mandolins use four pairs of strings that are tuned an octave apart; another is that the lower part of the body is significantly larger than the upper part, resulting in an almost teardrop-shaped instrument.

The banjo looks almost like a hybrid between a drum and a guitar. The circular body looks like a drum with a drumhead stretched over it. Attached to this body is a neck with frets along it and tuning mechanisms at the end. Four, five, or six strings are stretched from the end of the neck to the opposite side of the body. These strings pass over a bridge that sits directly on the drumhead part of the instrument. The strings are plucked with the fingers and cause the drumhead to vibrate. Sometimes, to increase the loudness of the instrument, the fingers of the right hand are fitted with individual thimblelike picks. The banjo was created in the United States by African slaves and was based upon similar instruments from their homeland.

The mountain dulcimer, also called the Appalachian dulcimer, is another hourglass-shaped instrument; however, the fretted neck sits directly upon the elongated instrument body as an attached *fretboard* rather than extending out from the body. For many years, the mountain dulcimer was perceived as an instrument for women, since it is often played by laying it across the lap while sitting down. One hand uses a plectrum to strum the three or four strings while they are depressed against the fretboard with the other. Most often, only the one or two highest-pitched strings are depressed while the remaining two continue to vibrate for their full length. The result is a single melody that sounds with two drone pitches in much the same manner as a bagpipe.

Significantly different from the mountain dulcimer is the hammered dulcimer that finds its roots thousands of years ago in Persia (modern Iran) and in other places throughout the world. This instrument is somewhat like a harp laid on its side or a piano's string assembly without the keyboard or key mechanism. Strings are struck with small handheld mallets or hammers. Due to

Figure 1.40

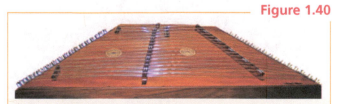

The hammered dulcimer uses many strings tuned to different notes, like the harp and piano..

the increased number of strings, hammered dulcimers have greater melodic and harmonic possibilities than mountain dulcimers and are used in some types of American folk music, as well as in traditional gypsy music of Romania and other Eastern European countries.

GUIDED LISTENING 1.06

Recognizing Types of Instruments in Music

Bluegrass music combines voice, fiddle (violin), mandolin, guitar, banjo, and other stringed instruments. Interestingly, authentic Bluegrass music does not use drums. Listen as different instruments take turns being the main melody and then retreat into the background as other instruments take over the lead. The instruments then retreat when the voice takes the lead. See if you can identify the different instruments and also the form of the song.

Music listening may be accessed from www.ourworldourmusic.com

Figure 1.41

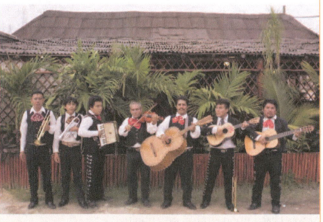

Mexican mariachi band. Left to right: trumpets, accordian, violin, guitarron, and two different sized guitars.

© 2013 by Blend Images. Used under license of Shutterstock, Inc.

The guitarron is an interesting blend of stringed instrument types. The body looks much like a bloated, oversized guitar. The neck is extremely short for the instrument. Like the violin, it has no frets. Plastic strings are set unusually high above the fingerboard, allowing the player to violently pluck the strings to produce louder sounds. The guitarron is the bass voice in traditional mariachi music from Mexico. Because of its shape, it can easily be carried and played at the same time, providing a portable bass voice for strolling bands.

GUIDED LISTENING 1.07

Recognizing Types of Instruments in Music

Mariachi music combines voice, violin, mandolin, trumpet, guitar, guitarron, and sometimes accordian. It is intended to be a moveable or "portable" type of music; all of the instruments used may be played while walking. Listen as different instruments take turns being the main melody. One common characteristic of Marichi music is that the violins and trumpets often take turns playing the same melody back and forth.

Music listening may be accessed from www.ourworldourmusic.com

Electricity and Musical Instruments—The widespread electrification of our world in the early twentieth century resulted in the incorporation of electricity into musical instrument design. Initially, this electrification of musical instruments was as simple as using a microphone to convert sound into electricity, amplify or increase strength of the electrical signal,

and convert it back into louder sound. Soon, musicians and instrument makers learned that placement and design of the microphone affected the electrical signal that resulted from capturing the sound. They also learned that the use of different electrical components, such as different electronic vacuum tubes, capacitors, and resistors, affected the electrical signal as it was amplified and that different types and sizes of loudspeakers could alter the result of the conversion from electricity back into sound. As understanding of electricity advanced, so did its incorporation into musical instrument design. Before long, these instruments became divided into two types: electrical instruments and electronic instruments.

Electrical instruments begin with an existing acoustic musical sound, capture it, and then modify it in some manner. Electrical instruments can be unplugged and still produce enough sound for individual practice purposes, if desired. Most electrical instruments are adaptations of existing acoustic instruments. The electric guitar has the neck, frets, tuning mechanism, and six metal strings found on the folk guitar; however, instead of a hollow resonating chamber for a body, most electric guitars have thin, solid pieces of shaped wood for bodies. Most electric guitars use magnetic induction coils, often called *pickups*, to convert sound into electricity. To be more accurate, the magnetic coil senses changes and disturbances in the surrounding magnetic field and generates an electrical signal. These changes result from metal strings interacting with the field. Plastic strings will not work with electric guitars that use magnetic induction coils. Hollow-bodied electric guitars use the

Figure 1.42

The electric guitar (left) and electric bass guitar (right), versions of traditional instruments, are adapted for electrical amplification.

acoustic principles of resonance to help amplify and shape the sound. Unfortunately, when the sound is electrically amplified, it is too easy for the amplified sound to cause the string and resonating chamber to vibrate. These vibrations acoustically amplify the sound, causing the electrical amplification to increase, again vibrating the string and resonating chamber, and setting up a cycle, or *feedback loop*, that can quickly turn into a squealing and howling that can be unmusical. The use of a solid body on the instrument dramatically reduces feedback from resonance.

The electric bass guitar is somewhat of a hybrid or blend of the orchestral double bass, the guitarron, and the electric guitar. Like the double bass, the basic electric bass guitar has four strings. These strings are tuned to the same pitches on both instruments. Like the guitarron, the instrument is strapped across the body and is easily carried. Like the electric guitar, the electric bass guitar has a fretted neck (see Figure 1.41), a solid body, uses only metal strings, and most often uses magnetic induction coil technology in converting the vibrations of the string into electrical signals that are then amplified and converted back into sound. The string length on electric bass guitars is a bit longer than that of the electric guitar but somewhat shorter than that of the double bass.

Many other electrical instruments follow the same approach of adapting an existing acoustic musical instrument and installing a pickup. Some pickup designs sense disturbances in a magnetic field by a metal string, some sense and respond to vibrations in the body of the instrument, and some are simply microphones that are optimized in size, shape, and frequency response for specific instrument types and ranges. The electric violin, for example, can be simply an acoustic violin with an attached microphone or vibration sensor,

or it can be a redesigned version of the instrument with a solid body and magnetic coil pickup. The electric piano can use various vibrating elements, including sticks, metal bars, and strings. The vibrations produced are converted into electrical signals and then amplified and manipulated electrically before being converted back into sound. Electrifying an instrument, even with nothing more than a microphone, changes the instrument's characteristic sound and opens the door to other possible timbres and playing styles.

GUIDED LISTENING 1.08

Recognizing Types of Instruments in Music

Note the use of electric instruments (electric guitar, electric bass guitar, and electric piano) and acoustic instruments (woodwinds and brasses). Drums (amplified with microphones and altered somewhat electronically) and voices complete the ensemble. Also take note of the interplay and trading of lead roles between instruments and voices. It is always good practice to listen to identify the form of a piece of music.

Music listening may be accessed from www.ourworldourmusic.com

Figure 1.43

Woman playing a theremin. Moving her hands in relation to the upright and looped antennas affects the sound.

Electronic instruments create sounds from scratch within the instrument by creating and shaping electrical signals. Instruments that create these acoustic, or synthetic, sounds are often called *synthesizers*. Synthesizers use various approaches to create and alter sounds, including applications of both analog and digital technologies. Synthesizers often use a piano-type keyboard to control and allow musical performance of these sounds. Other devices, or *controllers*, include guitar-type devices, woodwind- and brass-type performance controllers, and other more exotic creations. One of the earliest synthesizers was the theremin. This device altered components of sound, including pitch, dynamic, initial attack or start of the sound, and sliding between notes or *portamento*. The theremin used a unique controller that sensed the movement of the player's hands within an area. A performance often looked much like the player was conducting or molding the sound with his or her hands. The theremin found substantial use in making sound effects in science fiction movies during the 1950s, as well as in some musical applications.

GUIDED LISTENING 1.09

Recognizing Types of Instruments in Music

This listening example also uses electric instruments (electric guitar, electric bass guitar, and electric piano/organ) and acoustic instruments (drums amplified with microphones and altered somewhat electronically). The voices have a far-away sound caused by an electronic effect called reverb. Also in this song is an early electronic instrument called a theremin. Take note of the trading of lead roles as the song moves from section to section in the form.

Music listening may be accessed from www.ourworldourmusic.com

Analog synthesizers alter the shape of an electronic signal by altering components such as voltage. These early synthesizers were once so large that they would take up an entire room. The advent of transistor circuits greatly reduced the size of electronic devices, and synthesizers became small enough to be carried from place to place by musical performers. These portable synthesizers had numerous knobs, dials, and switches that each controlled a parameter of sound and acted in conjunction with one another in creating new sounds. Never before had so many new sounds become available at one time for use in making music. One of the strengths of these instruments, the ability to constantly create never-before-heard sounds, was also a weakness, as it was extremely difficult to recreate a sound. Many new, unique sounds found their way to the palette that musicians drew upon in creating music, and many older pieces of music took on new life when played using these new sounds.

Figure 1.44

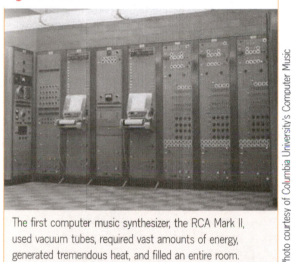

The first computer music synthesizer, the RCA Mark II, used vacuum tubes, required vast amounts of energy, generated tremendous heat, and filled an entire room.

Photo courtesy of Columbia University's Computer Music Center

Figure 1.45

Early portable synthesizers allowed new sounds to travel to audiences.

© 2013 by Peter Albrektsen. Used under license of Shutterstock, Inc.

GUIDED LISTENING 1.10

Recognizing Types of Instruments in Music

Electronic instruments, those that create sounds from nothing more than math and electricity, offer an endless variety of possible sounds and a limitless pallet of sounds from which an artist may draw. Combining these new sounds with music from earlier time periods allows for the old to become new again. Notice how this familiar piano piece has been set with multiple timbres of synthesizer sounds.

Music listening may be accessed from www.ourworldourmusic.com

Until the late 1970s and early 1980s, analog technology was at the forefront of electronic applications. Analog approaches usually use a single variable, often the amount of voltage present, and an infinite variety of values. Men traveled to the moon using analog technology. The integrated circuit became the computer chip, and a revolution took place as digital technology quickly began to replace analog. Digital approaches have multiple variables, but each has only two possible values: one or zero. Since these values can easily be inserted into mathematical calculations, or algorithms, and the results of these calculations can be stored and retrieved, synthesizer makers quickly realized that instruments based upon this technology could instantly

Figure 1.46

Connecting musical instruments to computers allows composers to create music in new ways.

retrieve a stored algorithm for a specific sound and have the instrument sound the same each time a timbre is accessed. As computers shrank in size due to advances in electronic technology, the word processor replaced the typewriter for creating documents. In 1983, musical instrument manufacturers released a common language and approach, called musical instrument digital interface (MIDI), that expressed musical performance as numbers. The numbers could be sent to a computer, and the computer would store the information in the order, or sequence, in which it occurred, much as a word processor stores keystrokes in the sequence in which they were typed. These musical computer programs, called *sequencers*, went beyond the word processor approach of remembering the order in which things occurred by also storing timing information about when something happened. Digital synthesizers, MIDI language, and computer-based sequencers combined to provide musicians with tools that created powerful recording studio capabilities in their living rooms and opened the possibilities for creative activities to many more people than before. The music that followed reflected this new technology's influence and the society in which it existed.

As technology advanced, more tools became available to musicians, including the ability to record an acoustic sound, manipulate it, and then perform it with an electronic controller. Capturing sounds in this manner is known as *sampling*, and devices that make capturing, manipulating, and performing of sounds possible are called *samplers*. Sampled sounds can begin as acoustic instrument or voice sounds, any sound in our world around us, or even snippets from existing songs. Indeed, much of today's Hip-hop music relies upon the use of sampled portions of earlier music.

GUIDED LISTENING 1.11

Recognizing Types of Instruments in Music

The foundation of this song is a part of a song from a 1960s television show. Speech and sounds from the show are also used. These sound samples are then manipulated with computer devices and these devices become instruments themselves. When additional music is created and added, the result is a new piece of music that has a tie to a previous piece, raising questions about what is originality and creativity.

Music listening may be accessed from www.ourworldourmusic.com

The line between what is and what is not a musical instrument becomes more blurred with each advance in technology. Recording studios that once cost millions of dollars and were simply used to capture existing sounds have been reduced to the size and cost of a laptop or tablet computer, and the technology present in these small devices allows so much manipulation of the sound that the recording and editing process often becomes part of the musical creative process.

Figure 1.47

Computers, ever smaller and more powerful, continue to offer musicians new, more cost effective ways of doing creative things.

Figure 1.48

Even simply playing back recordings of music can take on creative approaches as new technologies are applied.

© 2013 by Corepics VOF. Used under license of Shutterstock, Inc.

Music in our world continues to evolve and change, but this is not a new phenomenon; music in our world has always evolved and changed. To understand our new music of today, we must gain a better understanding of the music from which it evolved. We also must remember that all music was once new and fresh and that it reflected the society in which it was created and where it flourished. In the remaining chapters of this book, we examine earlier music and its links to the new music of today. We explore unique characteristics of traditional music of many cultures and its influences upon and from music of other cultures. We attempt to gain better insight into the cultures and societies in which these types of music exist or existed. Mostly, we explore, examine, experience, and try to better understand our world and our music.

For learning activities, practice quizzes, and other materials,
visit: www.ourworldourmusic.com

1.1 Worksheet

Name: _____

1. Why is making and enjoying music considered to be a human activity?

2. Does music reflect a society? Explain your answer.

3. What do the terms *Western culture, Western music,* and *Western civilization* relate to?

4. What is the difference between sacred and secular music?

5. The organization of "chunks" in music creates _____ .

6. Pitch is the highness or lowness of music. What is an octave?

7. Define these terms:

staff _____

clef sign _____

ledger lines _____

8. Explain how a sharp or flat note is created.

9. What is rhythm, and how does it relate to music, as well as life?

1.2 Worksheet

Name: _____

List the duration names of notes and rests, and draw their symbols.

Notes	Rests
1. _____	1. _____
2. _____	2. _____
3. _____	3. _____
4. _____	4. _____

Match the musical term and the definition.

_____ 1. notation A. An Italian word that means "speed" in music

_____ 2. dynamics B. When notes and rhythms are put together in a sequential manner

_____ 3. timbre C. A system used to write music

_____ 4. harmony D. How a sound is played or sung

_____ 5. melody E. The gathering of beats into regular groups

_____ 6. tempo F. The tonal quality of sound

_____ 7. articulation G. Sounds occurring simultaneously with the melody

_____ 8. meter H. Volume

Dynamics (loudness) is often notated using Italian terms. Match these terms:

1. fortississimo _____ very, very soft

2. pianississimo _____ very loud

3. forte _____ medium soft

4. piano _____ medium loud

5. fortissimo _____ loud

6. pianissimo _____ soft

7. mezzo forte _____ very soft

8. mezzo piano _____ very, very loud

The "thickness" of music is called texture. List the four textures of music and explain each.

1. _____

2. _____

3. _____

4. _____

1.3 Worksheet

Name: _____

1. Of these three textures of music, which is the most complex? (circle one)

 Monophonic Homophonic Polyphonic

2. The performance of music can include voices, instruments, or combinations of both. List the three ranges of male and female voices.

Male Voices	Female Voices
Highest _____	Highest _____
Middle _____	Middle _____
Lowest _____	Lowest _____

3. If a sound is under human control but is not created with the human voice, it is considered to be an instrumental sound. Describe these types of instruments:

 idiophones _____

 membranophones _____

 aerophones _____

 chordophones _____

4. Name the five categories of Western acoustic instruments.

5. There are two types of percussion instruments. Give examples of each.

definite pitch _____

indefinite pitch _____

6. Some of the first keyboard instruments were the _____ , the _____ ,

and the _____ .

7. In the early eighteenth century, they were replaced by the _____ , or the _____ ,

as we call it today.

8. What are the differences between a piano and an organ? _____

1.4 Worksheet

Name: _____

1. The two classifications of aerophones are _____ and
 _____ .

2. What is the difference between a closed-ended and an open-ended woodwind instrument? Give examples of each.

3. What are the two types of closed-ended instruments?

4. How does a reed instrument produce sound?

5. When were valves added to brass instruments? _____

6. How is the playing of a brass instrument different from the playing of a woodwind instrument?

7. Name the five most common Western brass instruments.

8. In Western music, chordophones are called stringed instruments. How do these instruments produce sound?

9. What are f-holes?

10. What determines the pitch of a modern stringed instrument?

11. Name five common modern acoustic stringed instruments.

12. How does a guitarron differ from a guitar or a dulcimer?

1.5 Worksheet

Name: _____

1. In the early twentieth century, electricity became part of our world. As it advanced, so did musical instrument design. What are the two types of instruments using electricity?

2. What is a pickup, and how does it work?

3. Which features are shared with an electric bass, a double bass, a guitarron, and an electric guitar?

4. Explain how a synthesizer works.

5. What is the difference between analog and digital?

6. What does the acronym MIDI represent and how was it used in making music ?

7. What is sampling?

8. Do you think that music in our world will continue to change? Why or why not?

1.6 Worksheet

Name: _____

Listen to a piece of music (any piece of your choice, from the textbook or not) and complete the following.

1. Name of the piece of music: _____

2. Name of the composer: _____

3. List of instruments used: _____

4. What is the musical texture of this work?

5. Discuss the dynamics.

6. Discuss the tempo.

7. Describe your mood or moods while listening to this piece of music.

1.7 Worksheet

Name: _____

Define the following terms:

1. Western music _____

2. Pythagoras _____

3. form _____

4. pitch _____

5. hertz _____

6. octave _____

7. scales _____

8. staff _____

9. clef sign _____

10. ledger lines _____

11. sharp _____

12. flat _____

13. rhythm _____

14. notation _____

15. melody _____

16. meter _____

17. dynamics _____

18. articulation _____

19. whole note _____

20. half note _____

21. quarter note _____

22. eighth note _____

23. whole rest _____

24. half rest _____

25. quarter rest _____

26. eighth rest _____

27. *legato* _____

28. *staccato* _____

29. accent _____

30. fermata _____

31. timbre _____

32. tempo _____

1.8 Worksheet

Name: _____

Define the following terms:

1. complexity _____

2. texture _____

3. monophonic _____

4. heterophonic _____

5. homophonic _____

6. polyphonic _____

7. range _____

8. tenor _____

9. bass _____

10. baritone _____

11. soprano _____

12. alto _____

13. mezzo-soprano _____

14. acoustic _____

15. idiophones _____

16. membranophones _____

17. aerophones _____

18. chordophones _____

19. percussion instruments _____

20. keyboard instruments _____

21. woodwind instruments _____

22. brass instruments _____

23. stringed instruments _____

24. electrical instruments _____

25. electronic instruments _____

26. synthesizer _____

27. theremin _____

28. MIDI _____

29. sequencers _____

30. sampling _____

1.9 Worksheet

Name: _____

Locate the following musical elements and place the corresponding number in the space provided.

1. Whole rest
2. Half rest
3. Quarter rest
4. Eighth rest
5. Instrument names
6. Dynamic indication
7. Tempo indication
8. Sharp
9. Half note
10. Quarter note
11. Whole note
12. Eighth notes
13. Bass clef
14. Treble clef
15. Flat

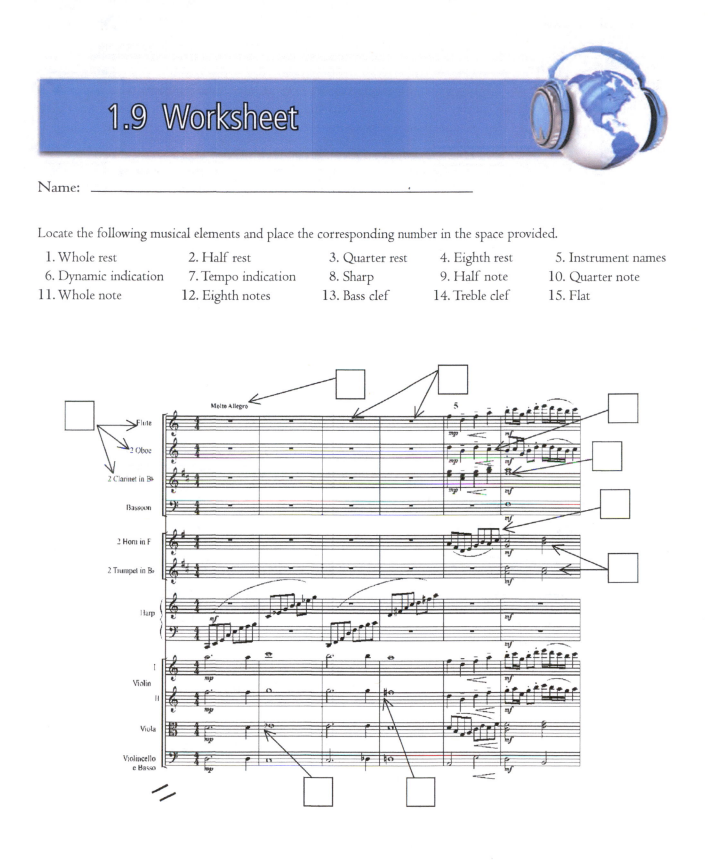

Locate the following musical elements and place the corresponding number in the space provided.

1. Whole rest 2. Half rest 3. Quarter rest 4. Eighth rest 5. Instrument names
6. Dynamic indication 7. Tempo indication 8. Sharp 9. Half note 10. Quarter note
11. Whole note 12. Eighth notes 13. Bass clef 14. Treble clef 15. Flat

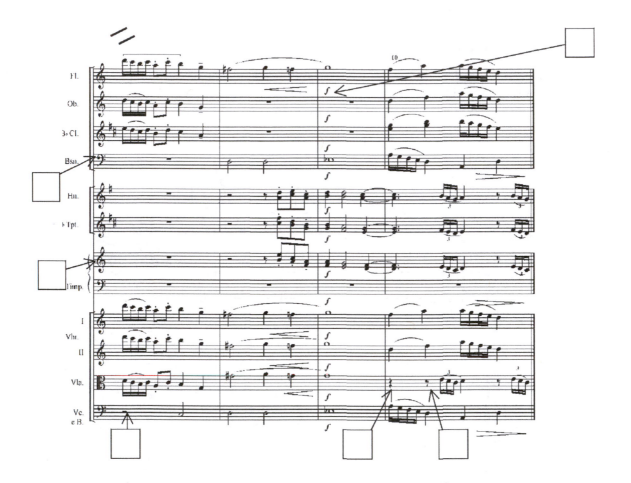

MUSIC IN A SOCIETY

Music reflects the society in which it exists. Societies and cultures reflect their differences in the music that they create and to which they respond. When a type or style of music no longer resonates within a society, another type of music replaces it. This pattern has occurred throughout human history, and evidence indicates that it was the pattern before history was written and recorded. The dynamic of music reflecting a society continues today and can be seen in the changing of music as our society changes and evolves. The culture of the early twenty-first century is somewhat different from that of fifty or a hundred years ago, and the music of today is not the same as that of a century or half-century ago. To understand the music of today, we must know about the roots from which it evolved. To better understand an earlier type of music, we must know something about the society that supported it.

Figure 2.01

Music that is popular and reflects one culture or society may not resonate with the next society when times change.

© Shutterstock, Inc.

MUSIC IN ANCIENT SOCIETY

Many surviving writings from the ancient world make mention of music, but few provide extensive details. For most writers, music was simply a part of life. They did not write about the cups from which they drank or the beds upon which they slept as these, too, were simply a part of life. We know that music making took place in prehistoric times. One piece of evidence is an early flute, made from a bear bone and discovered in the mid-1990s. This instrument dates to 41,000 B.C. and was used by Neanderthal man to make music. The earliest known record of music and musical instruments is a broken clay tablet from the twenty-sixth century B.C., pictured in Figure 2.01. This Sumerian tablet's inscription lists several types of

Figure 2.02

MS 2340 Lexical list of harp strings, 23 types of musical instruments. Sumer, 26th c. BC.
The earliest record of music and instruments in history

Lexical list of harp strings and twenty-three types of musical instruments. Sumer, twenty-sixth century B.C. The earliest record of music and instruments in history.

Image courtesy of The Schøyen Collection, Oslo and London. Used by permission of Martin Schøyen, The Schøyen Collection.

55

Figure 2.03

MS 5105
Old Babylonian cuneiform musical notation. Babylonia, 2000-1700 BC

And in modern transcription

Cuneiform musical notation, Babylonia, 2000–1700 B.C., and modern transcription.

instruments that were in use at the time and lists nine strings, or possibly notes, on these instruments. A type of tuning system is referenced, but the information is incomplete.

We do not know what music of ancient times sounded like; no machines existed for recording music until late in the 1800s. While a few cultures created methods or systems of notating or writing music, two major issues affect our ability to perform and hear this ancient music: (1) often, we cannot fully interpret what was written, either through our incomplete understanding of the language or as a result of incomplete surviving remnants of what was written, and (2) we do not fully understand the tuning or pitch systems used, so we do not know what notes are being referenced in the writing. Although attempts at translating the music into modern musical notation have been made, as indicated in Figure 2.02, these attempts are at best only educated guesses. It would be a bit like figuring out a written language, for instance, ancient Egyptian, but being unable to pronounce the words because no one knows how they are meant to sound. Understanding a written musical language and not being able to translate it into sound is indeed an incomplete understanding.

Many ancient societies and cultures refer to music. Figures 2.01 and 2.02 are evidence of Sumerian writings about music and Babylonian musical notation, respectively. Biblical references include Jubal, mentioned in Chapter 1 of this text; music's role in the Battle of Jericho; King David playing a lyre (a type of harp); and Paul's reference to empty speech resembling a sounding cymbal or gong. Many ancient societies from throughout the world have left evidence of music's role in their cultures through pictures in their artwork and on pottery. Some, including the ancient Sumerians and ancient Greeks, left writings about their music and the emotions that it invoked, reminding us that music has been a part of our world for thousands of years.

DEVELOPMENT OF WESTERN SOCIETY

About 500 B.C., the Roman Republic came into existence. As with many societies, it had several social classes. Nobles, or patricians, made up the aristocracy. Common people fell into the class of plebeians. As the Republic evolved, an interesting dynamic developed in which representational democracy came to include not only members of the patrician class but also plebeian representatives. Two other social classes, noncitizens and slaves, did not participate in this representative government.

One of the activities at which Rome excelled was organization. The Roman army was evidence of this organization. One person was put in charge of ten others. That person, along with nine others of the same rank, was supervised by one person. By organizing with a

pyramid-like structure, each elevation in rank maintained the principle of simple supervision of ten people. Messages and orders could quickly be passed along this chain of command. Another organizational principle practiced by Rome was to equip each of its soldiers with the same weapons and armor. Shields were rectangular but shaped and sized in such a way that they could be strapped onto the back and the soldier could walk without it hitting the backs of the knees. This allowed an army to travel quickly, when necessary. The shields could be held in such a way that soldiers standing beside each other created a wall of protection in front of their formation. Soldiers in the next lines could hold their shields next to one another overhead, protecting the group from arrows. The whole formation, called a "turtle" by the Romans, could then walk right into the midst of an enemy army, break apart, and begin fighting. At that time, another piece of Roman army equipment would come into play: the short sword. At about two feet long, this was a much shorter weapon than was used by most other combatants. Long swords keep soldiers at a safer distance from enemies, but the length requires plenty of room to effectively swing the sword. By walking the "turtle" up into the middle of the enemy lines, the Romans turned the long sword into a disadvantage and the short sword into extreme advantage.

The result of this superior army was growth of the Republic, expansion that secured borders and increased revenue through the taxing of trade. Retiring soldiers were given land in newly conquered regions, and their settlement in these areas helped to spread Roman culture. Increased wealth through expanded trade allowed for an even larger army that was used to push back borders and continue to expand the republic's influence. During the first century B.C., Rome's domain became so large that a more centralized government was adopted. It was during this time that the Roman Republic became the Roman Empire and that Julius Caesar was elected emperor for life by the Roman Senate.

The Roman Empire came to include most of Europe, including England, France, Germany, and Spain, along with northern Africa, the Middle East, and eastern Europe, including Greece. Spreading out from Italy, Rome came to rule everything that bordered the Mediterranean Sea, as shown in Figure 2.05. The Roman Empire then continued to spread until it ran into natural barriers such as deserts, mountains, or oceans.

Besides organization, almost every other idea and concept in Roman culture was initially adopted from conquered territories. From the Greeks, Rome learned mathematics, philosophy, and logic and accepted most of its early gods. From Egypt came medicine and engineering. Valuing of an educated population came from Israel, as did Rome's eventual shift from polytheism to monotheism.

Figure 2.04

Rome's soldiers were issued identical equipment, enabling Rome's armies to develop battle tactics that were far more advanced than its adversaries.

© 2013 by meunierd. Used under license of Shutterstock, Inc.

Figure 2.05

Rome's soldiers practiced and drilled in preparation for battle, applying teamwork against enemies who were accustomed to battles based upon simultaneous one-to-one fighting.

© 2013 by Regien Paassen. Used under license of Shutterstock, Inc.

Figure 2.06

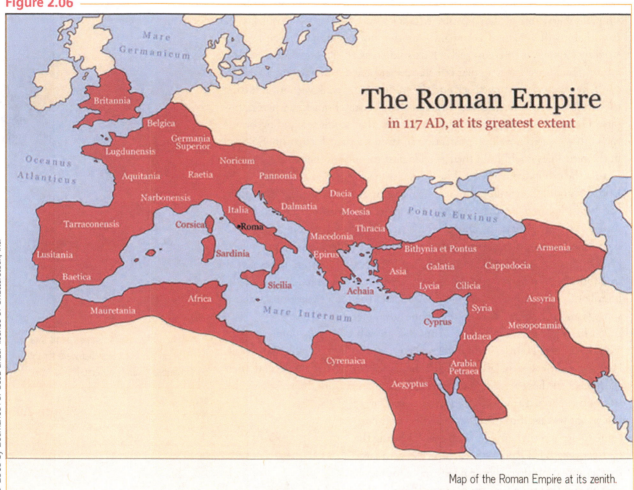

Map of the Roman Empire at its zenith.

The shift to monotheism did not happen quickly. Many followers of the new religion, Christianity, were killed as a result of being seen as a threat to the Empire. Despite persecutions, the new religion continued to spread, and in A.D. 380 Emperor Theodosius proclaimed Christianity as the official religion of the Empire. Rome soon organized it in a manner similar to its army's organization. In its hierarchal structure, one pope led a group of cardinals. Cardinals led archbishops, who led bishops, who led priests. Nuns and monks lived full-time religious lives in cloisters, convents, or monasteries. Priests led local congregations of laypeople, who made up the bulk of the church's membership. Catholic Christianity was declared the official imperial religion. The word *catholic* simply means "universal." This universal church used only one language, Latin, the language of the Roman Empire. (The Roman Catholic Church continued to conduct all of its worship services in Latin until 1963.) It also used a single order of worship. Every local congregation was perceived as a branch office of the Roman Catholic Church.

Near the end of the Roman Empire, Boethius wrote *De institutione musica* (The Fundamentals of Music) which brought Pythagoras's ideas about music to the Roman

world. His translation used the terms *perfect* and *imperfect* to describe intervals, or relationships, between notes and influenced how music was written for worship for hundreds of years. In the strict, symbol-laden society that would follow, no music containing anything "imperfect" could be offered as being worthy of worshiping God. Many combinations of notes were avoided by composers. One combination, made up of two notes six half-steps apart, even came to be called *Il Diablo*, or "The Devil," and was avoided at all costs.

Eventually, after about a thousand years, Roman rule ended with the collapse and fall of the Roman Empire. Rome was not conquered. No greater power took it over. Roman society and the Roman Empire fell apart for many reasons. One factor was the decline of the mental capacity of the ruling class. Two things brought this about: (1) intermarriage within a small group of aristocracy led to reinforcement of negative genetic traits, including mental instability, and (2) cooking and eating utensils made from an easily worked metal, lead, contributed to arrested development of mental capacities in the aristocracy. Several of Rome's emperors dis-

© 2013 by Apriiphoto. Used under license of Shutterstock, Inc.

Figure 2.07

Ancient metal tableware

played these traits, including Caligula and Nero. In A.D. 455, a group of invaders entered the gates of Rome and sacked it, looting it of treasure and destroying many things that could not be carried away. They were a tribe called the Vandals, and a word entered our vocabulary as a result of this event: when something is intentionally destroyed or defaced for no reason, we say that it has been *vandalized* and we call the people who did it *vandals*. Since the Roman Empire fell apart piece by piece over hundreds of years, it is difficult to determine an exact ending date. The sacking by the Vandals provides an event upon which to focus. To simplify dates, it is common to speak of the end of the Roman Empire and the beginning of the Middle Ages as happening around A.D. 450. While we cannot speak with authority about music from ancient times, we do know how music of the Middle Ages sounded.

MUSIC IN THE MIDDLE AGES

The Middle Ages began around A.D. 450 and lasted until A.D. 1450, spanning a thousand years. In the early years of the Middle Ages, the last remnants of the Roman Empire continued to break apart and wars of conquest and looting became almost continuous. Without Rome's power and ability to enforce peace within its realm, petty

Figure 2.08

Celsus Library in Ephesus, Turkey—built in 117 A.D., the third greatest library of the ancient world.

© 2013 by Dimos. Used under license of Shutterstock, Inc.

warlords and would-be kings fought with one another and in the process destroyed much of what had previously been built. Much of human knowledge, gained, guarded, and cataloged over thousands of years, was burned and destroyed during this period. The Middle Ages are sometimes referred to as the *Dark Ages*. During this time, most people in Western civilization were illiterate, including much of the ruling class. Only one organized part of the Roman Empire survived: the Roman Catholic Church. As the unifying structure of the Western world, the Church wielded great power.

Middle Ages Society

A system of thought, called *determinism*, was promoted by the church and became the dominant philosophy of the Middle Ages. Deterministic approaches suggested that, since God was all-powerful and all-knowing, He already knew what a person would do in advance; a person's life was predetermined, and free will was almost nonexistent. The Church taught that life on Earth was a short and terrible trial, during which a person earned a place in heaven through a virtuous life. Satan was constantly present to tempt the virtuous into sin, and if something was enjoyable, sin was most likely somewhere in it. While members of the congregation were encouraged to be fruitful and multiply, they were also cautioned not to enjoy it so that they would avoid sin.

Class structure in the Middle Ages was made up of three groups: *nobles* who lived in castles, feasted, and ruled those who lived nearby; *clergy*, often drawn from second and third noninheriting sons of nobles, who were the society's literate religious members and lived in monasteries and convents; and peasants, or *serfs*, who worked the land. This third class was believed to belong to the ruling noble in much the same way that the land belonged to him. Movement between classes was not something that happened during the Middle Ages.

Despite the lost knowledge resulting from the wars, some technological advances occurred. One example is that late in the Middle Ages a new power source was developed, one that did not rely upon humans or animals and their muscles. A new machine, the waterwheel, harnessed the power of moving water to drive devices that could grind grain into flour. Another example of technological advancement can be found in shifting architectural styles.

Early in the Middle Ages, large construction projects such as castles and especially churches used *Romanesque* architectural style. Romanesque construction is extremely heavy, requiring massive supports. One hallmark of this style is the use of rounded archways. Rounded arches, because of the weight pressing down upon the center of the arch, require thick

Figure 2.09

Capturing the energy of moving water, waterwheels were an early power source in pre-electric/pre-steam engine society.

supports and pillars (Figure 2.09). In contrast, *Gothic* architectural style, from later in the Middle Ages, uses pointed arches. A pointed arch has no downward pressure, since any weight pressing down only drives the arch point tighter together and transfers the force to

the uprights. Gothic architecture allows for creation of large, open spaces. When churches are constructed in this style and the huge, pointed-arch windows are filled with stained or colored glass that is backlit by the sun, the result is an interior space that suggests an other-worldly character.

Figure 2.10

Begun in 1172, the bell tower for the cathedral in Pisa, Italy uses Romanesque architecture's heavy curved arches and required walls at its base that are over eight feet thick. This is like the construction used 1,000 years earlier for Celsus Library in Ephesus (see Figure 2.08).

© 2013 by Dmitriy Kurnyavko. Used under license of Shutterstock, Inc.

Figure 2.11

Interior of the cathedral in Amiens, France, begun 1220—Gothic architecture, brought back from the Middle East as a result of the Crusades, allowed for creation of large interior spaces and new types of buildings.

© 2013 by Pecold. Used under license of Shutterstock, Inc.

Visual art of the Middle Ages served a much different purpose than it does in our modern world. Since most people could not read, pictures were intended to carry messages rather than to accurately portray real-life images. When a picture stands for or represents something else, it is termed an *icon*. This is the same term and approach used on a computer screen when a small picture stands for something else, such as a software program or a folder containing information; we click on an icon to access these resources. People of the Middle Ages viewed icons to help them to understand concepts and ideas,

Figure 2.12

Middle Ages iconic painting of the Madonna and Child.

especially those associated with religion. In Figure 2.11, notice the hand pointing at the baby, indicating that he is the path to salvation. Also notice that the child's hand is poised to grant a blessing upon the viewer. Simplicity was important in this type of art, to not distract the viewer from the message. For this reason, visual art of the Middle Ages does not accurately depict images from the world around us, as is obvious in the baby not looking like a real baby and the mother's face and hands being somewhat stylized.

Middle Ages Sacred Music

The most powerful entity during the Middle Ages was the Roman Catholic Church. To be Christian was to be a member of this universal church. The Church endorsed the divine right of kings to rule and admonished subjects to follow their kings, since these leaders were anointed and appointed by God. Failure to do as the Church instructed could lead to the ultimate punishment: excommunication. To be excommunicated was to be cut off from the Church, from God, and from the possibility of heaven. Popes could even exercise this punishment upon kings. Those subjects who continued to follow an excommunicated king were viewed as following a man not endorsed by God and therefore in league with Satan. These subjects were also excommunicated and damned to burn in hell; their only hope was to rise up and slay the false king. For this reason, the Church had the ability to exercise a degree of control not only over a population but also over its rulers.

The Catholic worship service is called *Mass*. The Mass follows a standard order of worship. The service, on any given day, is the same throughout the world, emphasizing the concept of a single church with branch offices in local communities. This order of worship is virtually unchanged since the Middle Ages.

Figure 2.13

This 12th Century mosaic from the Church of Santa Maria dell' Ammiraglio in Palermo, Italy supports the concept that kings rule with divine blessing.

Figure 2.14

Krak des Chevaliers is a 12th Century Crusader fortress near Homs, Syria and is one of the most important preserved medieval castles in the world. It helped to guard the Christian Crusaders' path to their Kingdom of Jerusalem but was doomed to eventually fall after Saladin's Muslim armies subdued Homs and the remainder of Syria.

During the Middle Ages, another of the world's great religions arose: Islam began under the prophet Mohammed in A.D. 610. Its tenets are outlined in its holy book, the Quran. Islam, an Arab religion, spread rapidly throughout the Middle East and eventually extended along northern Africa, stretched across the Strait of Gibraltar, and overtook Spain. When followers of Islam moved into Jerusalem and the rest of the biblical Holy Land, the Roman Catholic Church promoted Crusades to fight off the Arab "invaders" and push them out. Crusades took place repeatedly over about two hundred years, accomplishing little more than consumption of resources on both sides. After the final crusade near the end of the thirteenth century, Islam came to rule the area until the midtwentieth century, when the modern nation of Israel was formed, based upon another, even older of the great religions: Judaism. All three of these religions, Judaism, Christianity, and Islam, hold Jerusalem and the surrounding area to be sacred, and this area of the world is still hotly contested.

At the same time that Mohammed was experiencing the revelations that became the foundations of Islam, a strong pope was exerting an influence upon the church, an influence that is still felt today. One of those influences led to the development of modern music notation. Pope Gregory I, who ascended to the head of the Church in A.D. 590, is often credited with singlehandedly developing this notation system. Paintings of him, created centuries later, often depict him with a dove on his shoulder, representing the Holy Spirit singing into his ear the true music of worship, while Gregory single-handedly creates music notation and writes down what he hears. While this is rather fanciful and was widely known, it is most likely incorrect. What is correct is that the music of the early– and mid–Middle Ages is still called *Gregorian chant*, sometimes shortened simply to chant, and that Gregory probably played some organizational or enabling role in the process.

Figure 2.15

Example of early music notation (with Latin text), from the Museum of the Basilica di Santa Croce in Florence, Italy.

Photo courtesy of Cristian Codreanu.

Gregory and others wanted to help assure that the Church remained catholic (universal) and did not begin to fragment and break apart like the Roman Empire. One way to do that was to better standardize the Mass. Several parts of it were sung to help the illiterate congregation to better remember the words that were said. It should be noted that from its earliest days the church, in an attempt to distance itself from pagan religions, avoided instruments, since many musical instruments were identified with specific gods. As the church's mass songs were handed down from one generation to the next and traveled from one area to another, they began to change, much as a story begins to change after being passed along through several people and generations. If the music could be written down, it would be easier for priests to remember and it would remain in its original, true form. The system that developed later evolved into modern music notation. In its early form, it used symbols called *neumes* to notate pitches, but the system lacked a rhythmic notation component. Pitches usually flow in chant without much regard for meter, tempo, or pitch duration.

Gregorian chant was a form of unaccompanied, monophonic, vocal music that was an integral part of the Mass. Chant text was always in Latin, and almost everything that could have been spoken by the priest was sung in chant style. *Vernacular* languages, those spoken by

a local population (in America, usually English), were not used until after the 1963 reforms to the Church. Initially, the *range* of a chant melody, the distance between the lowest and the highest pitches, was limited and the melodies moved in a *syllabic* manner, one pitch or note for each syllable of a word. These chants evolved into a *neumatic* style with specific two- or three-note figures assigned to some words and notated as rather stylized symbols. Eventually, more pitches came to be added to key, important words, emphasizing them through long, moving-note passages and creating *melismatic* chant. This style of chant can be so involved and ornamented with moving notes (*melismas*) that sometimes the text can become obscured. Solo, unaccompanied chant is still used in the Catholic Church, although the text is now in the vernacular of the congregation. Sometimes, stylistic devices are borrowed and combined with modern styles to create worship music that is old, new, and just as haunting in its sound.

GUIDED LISTENING 2.01

Gregorian Chant

In these musical examples, listen for: neumatic chant where most word syllables receive one note or only a few notes, melismatic chant where important syllables or words are emphasized through using many notes, and a mashup of old and new combining modern instruments and musical styles with fragments of Gregorian Chant that create something that is both old and new at the same time.

Music listening may be accessed from www.ourworldourmusic.com

Development of Polyphony

Most music in our world uses a single melody. Sometimes this melody is accompanied by a percussive or rhythmic underlayment. Sometimes it is supported by a single, droning pitch. Sometimes this single melody is performed simultaneously by multiple players or singers, each embellishing it in different ways or choosing to start the melody on a different pitch. Western music is almost unique among the world's musics because of its development of the use of polyphony. Modern Western music, regardless of genre, is predominately polyphonic in style.

Early Western music, such as Gregorian chant, was monophonic. The next step in our music's development was the addition of a second, simultaneous statement of the melody at a higher pitch level. This parallel voicing of a single melody was called *organum* and was developed in Paris. Leonin and Perotin, two early champions of organum, worked as musicians at Notre Dame Cathedral in Paris, and this method of writing music came to be called the Notre Dame school.

A parallel, second voice sung at a different pitch transformed monophonic chant into heterophonic early organum. Soon, the parallel upper voice became increasingly embellished until that

Figure 2.16

Notre-Dame de Paris Cathedral in Paris, France.

took on a life of its own, transforming into a third, distinct melody. This use of simultaneous, different melodies brought polyphony into Western music. It is interesting to note that although singers and listeners in the Middle Ages heard the faster-moving, more ornamented movement of the highest voice, they also universally recognized that the melody in this music was in the lowest voice. This is different from modern Western music, in which the melody is usually in the highest-sounding voice.

GUIDED LISTENING 2.02

Organum

This is an example of an early form of organum, the musical development that will become polyphonic Western music. Note that most of the time, the two voices move together in parallel on different pitches. When they move independently, the upper voice embellishes the traditional chant melody being sung in the lower voice.

Music listening may be accessed from www.ourworldourmusic.com

The order of service of the Catholic Mass included several parts that happened at every service. These parts are called the *ordinary* of the Mass. During the late Middle Ages, and still continuing today, it became common for a single composer to take the text, or words, of the ordinary and write music to fit. The music for each part of the ordinary is complete in itself, as are the individual songs on a modern album of music. The combined songs or parts then fit together to make up a greater whole, again like the songs that make up an album. When a composer writes music to fit the words for the ordinary parts of the Mass, the result is called a *mass setting*.

The first known mass setting by a single composer was by Guillaume de Machaut, a French composer and poet from the fourteenth century. Machaut (c. 1300–1377) was, and still is, the most famous composer of his time. He wrote both *sacred* and *secular* music (religious and nonreligious). During Machaut's time, music notation had evolved a system for notating not only pitch but also rhythm. This new advance allowed composers more freedom to treat individual musical lines differently. Although a traditional, familiar chant melody still formed the basis of most pieces, the two upper voices had more freedom and interacted with each other in ways that were previously not possible. This Middle Ages style was called *ars nova*, or new art. Today, independence and interaction of voice and instrument lines are hallmarks of modern Western music.

GUIDED LISTENING 2.03

Polyphony

During the Middle Ages, *ars nova* music notation developments enabled composers to write truly independent parts for different voices—the definition of polyphonic music. Three voices were the norm and the chant melody that everyone knew was in the lowest voice. The two upper voices were independent, faster moving embellishments.

Music listening may be accessed from www.ourworldourmusic.com

Middle Ages Secular Music

Machaut's secular music often centered upon topics of *courtly love*, a melancholy state in which singers love someone from afar who they believe to be above their station or out of their league. Machaut also often played almost mathematical games with the music he wrote. One example is *Ma Fin Est Mon Commencement*, a song for three voices. The top voice sings from beginning to the end. The second voice sings the same melody as the first voice but backward, from the end to the beginning. The third voice has fewer notes than the other two, so it starts at the beginning of its part and, when it runs out of notes long before the other two voices, the part is then is sung from its end to its beginning. Still not having

GUIDED LISTENING 2.04

Secular Music in the Middle Ages

Secular music in the Middle Ages was often written by the same educated priests who wrote the period's sacred music. The way voices combined was similar between both. The latitude one could take in the creation of secular music allowed for playing games and doing things that were not possible in the highly structured Church service.

Music listening may be accessed from www.ourworldourmusic.com

Figure 2.17

Wooden printing press, similar to Gutenberg's. Individual letters would be placed on a tray and swabbed with ink, a piece of paper would be place on them, and a hand-screw would be turned to press the paper against the inked letters. This manual process would be repeated for each page of a book.

enough notes, it again reverses, finally stopping when the other two voices finally run out of notes. The text for the song even speaks about the game that Machaut plays: not only making the notes for the three voices end together but also making the pitches that sound simultaneously at any given time sound good together.

MUSIC IN THE RENAISSANCE PERIOD

The Renaissance period in music spans 1450–1600. The events marking the end of the Middle Ages and the beginning of the Renaissance period are the invention of the mechanical printing press by Johannes Gutenberg and the release of the first printed edition of the Bible in 1454 or 1455. Again, to simplify dates, the commonly used date for the beginning of the Renaissance period is 1450. Before Gutenberg's mechanical printing press, every page of every book had to be copied by hand, a process that could take one copyist a year or more per book. Handwritten books were expensive, and few people owned or had access to them. No public libraries existed at this time. Gutenberg's mass production process took a fraction of the time previously required to copy a book. When books became more plentiful and affordable, people began to become interested in what might be contained between the covers. The French word *renaissance* translates as "rebirth," and this period of Western history is one of a rebirth of interest in learning, knowledge, and the world around us. In Western society, the Renaissance period marks the beginning of modern times and modern thought.

Renaissance Society

The dominant philosophy of the Renaissance period was *humanism*, which includes belief that an all-powerful and all-knowing God created humankind in his own image. This image could only be good, since God can only be good. The philosophy also included the belief that God provided people with the ability to make choices that determine their destiny. While Satan was still in this world tempting people to sin, the world was a good and beautiful place because God created it and people should learn more about this world. alue came to be placed upon education. Even today, a term applied to a well-educated person who knows something about many areas is *Renaissance man*. This valuing of a well-rounded education is why most colleges and universities today have a substantial block of general education course requirements that students must fulfill. It is quite possible that the reason that you are reading this textbook and participating in this class is because of the Renaissance concept of holding a complete education in high regard.

Renaissance visual art reflected this rebirth of interest in learning and in the world around us through its attempt to accurately depict what the artist saw. Realism in art was highly desired. Unrealistic, iconic art fell out of style. Visual art using perspective to emphasize relative distances came into style. Artists tried to make their artwork look real. (See Figures 2.12 and 2.18 to compare.) Many great artists came from the Renaissance period, including Michelangelo and Leonardo da Vinci.

Interest in the world around them led some people of the Renaissance to try to see what was over the next hill or around the next curve. The great explorers of the Renaissance included Christopher Columbus and Ferdinand Magellan. The Americas were discovered by Western society, and the first circumnavigation of our world took place during this time. Interest also extended to what was outside of our world. During the Renaissance period, Nicolaus Copernicus, as a result of his observations of the movements of the stars and planets, proposed that the Earth was not at the center of the universe but that the Earth revolved around the Sun. Because of this, he is now known as the Father of Modern Astronomy.

Gutenberg's printing press had an impact upon religion in Western society. One of the first books that Gutenberg sought to publish was the Bible. Previously, most people were illiterate. Even if they could afford a handwritten copy of the Bible, they probably would not be able to read it. Gutenberg's more affordable Bible, coupled with Renaissance society's valuing of literacy and education, resulted in people reading the Bible for themselves. In the Catholic Mass, the priest had read the Bible to the congregation, and it was sometimes difficult to determine when the reading ended and the sermonizing began. Some people began to raise questions about differences in what they read for themselves and what they had been taught. A Catholic priest in Germany became so concerned with these differences that he drew up a list and nailed it to the door of the church. This list came to be called the *95 theses*. The priest, Martin Luther, then renounced his Catholic vows and established a church in protest. People who joined this church were known as *protest-ants*, giving rise to the *Protestant Church*.

Figure 2.18

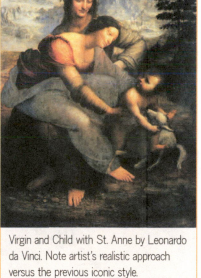

Virgin and Child with St. Anne by Leonardo da Vinci. Note artist's realistic approach versus the previous iconic style.

© The Gallery Collection/Corbis

Renaissance Sacred Music

During the Renaissance period, the Protestant Church was in its infancy. Most Christians were members of the Roman Catholic Church, and most music written for worship was for that church. Mass settings by a single composer became increasingly common. Unlike the music of the Middle Ages, when the names of composers were not usually recorded, Renaissance music often listed who wrote it. The two most common forms of sacred music during the Renaissance were settings of the mass and the *motet*, a song form developed in the Middle Ages and evolved in the Renaissance.

People have always wanted new music, just as we do today. The people of the Renaissance were no different. They wanted worship music that was fresh, and composers continued to set the parts of the mass to music but used the new musical styles of what these people considered to be modern times—what we now call the Renaissance period. (Do you wonder what name future generations will give to the "modern times" in which we now live?)

Evolution of Polyphony

The technique of polyphony that began in the Middle Ages evolved throughout the Renaissance period and several specific factors, or compositional devices, contribute to the identity of this music. One of the most obvious and widely used during this period was the technique of *imitation*, in which one voice part mimics what another voice part has just performed. The imitation can be direct, it can be set at a different pitch level, or it can be imitation only at the beginning of a line that then wanders into new musical territory. Imitation can help to create unity within a piece of music by tying parts together through repetition. This device is often used in modern music, especially when two singers echo or imitate each other's words during a song.

Voice pairing is another compositional device often heard in Renaissance music. Two voice parts join and sing together as a pair while the other voices wait their turns. This pair of voices is often answered by another pair singing in imitation. The change in texture from all voices singing to only a pair of voice parts created contrast in Renaissance music, especially when the pairs contrasted high voices against low voices.

Music of the Middle Ages extensively used Pythagoras's perfect intervals between musical notes. Composers of the Renaissance became bolder about using the imperfect intervals, and the result was the development of the three-note *chord*, a staple in Western music. A three-note chord, also called a *triad*, uses three pitches based upon every other letter of the repeating musical

Figure 2.19

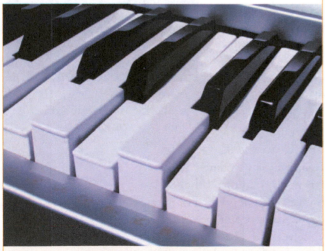

In this image, depressing the keys for the notes C, E, and G results in sounding a C major chord.

alphabet (A B C D E F G). Sounding the pitches A C E simultaneously produces a chord. Sounding C E G or F A C also produces chords. These chord sounds, new to the ears of Renaissance listeners, are foundational components of modern Western music. Today, we hear them in almost every piece of music.

Middle Ages music used three voice parts, with the melody in the lowest voice. Renaissance composers were beginning to think not only about the polyphonic melodies but about the chords that sounded when voices sang different pitches simultaneously. To enhance the sound of these chords, Renaissance composers added something that is still used today: a bass part sounding a pitch below the other three voices. This new fundamental voice strengthened the chord and added depth to the sound, but it also began to change their music. Previously, the lowest voice was easy to discern and the melody was obvious. The addition of the new bass part tended to obscure the melody in what was now the tenor voice. When composers began to write for larger groups of five, six, eight, ten, twelve, or even more parts, the listener tended to lose the tenor voice melody. It is during this time that the perception of melody in Western music began to shift from the tenor voice to the highest-sounding pitches. Today, the voice that sings the highest notes is usually perceived as singing the melody.

While we know of many Renaissance period composers, three tend to stand above the rest as both leaders and examples of musical practice during their times. Each of these composers influenced those who followed them. In chronological order, they are Guillaume Dufay (c. 1400–1474), Josquin des Prez (c. 1450–1521), and Giovanni Pierluigi da Palestrina (c. 1525–1594). Since Dufay and Palestrina represent the extreme ends of the Renaissance period, listening to differences between their music provides examples of musical development during the period.

GUIDED LISTENING 2.05

Polyphonic Music in the Renaissance

Composers in the Renaissance began to work with chords, so they added a bass part below the chant melody. This new lower part provided foundation for the harmony but obscured the now-tenor line chant melody. The perception of melodic line shifted to the top voice, much as we hear it today. Listen for smoother melodic lines and fuller sounding chords that make this music sound different than that of the Middle Ages.

Music listening may be accessed from www.ourworldourmusic.com

Renaissance Secular Music

Not all music in the Renaissance period was for use in worship; many forms of secular music were available. Sometimes the audience members sat and listened, sometimes they danced to the music, and sometimes they participated in making the music. Recorded music did not yet exist, so if music was to be heard, someone had to perform it live. For small dinner parties, it was not uncommon for the hosts and guests to perform music as part of

Figure 2.20

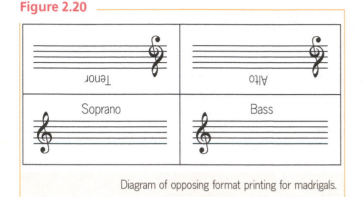

Diagram of opposing format printing for madrigals.

the evening's activities. *Madrigals*, musical pieces written for amateur musicians, were often used in these settings. Most often, these pieces were written in four parts, calling for two men and two women. Instruments only doubled or replaced voices. Separate instrumental parts were not written in Renaissance vocal music. Printed madrigal music was either distributed in separate part books or printed in opposing format. Music printed in opposing format would appear on a single sheet of paper that could be placed flat on a table, and the performers stood across the table from one another, read the music, sang the parts, and secretly flirted. Often the text of madrigals would lend itself to this secondary activity. *Text painting*, or fitting the words and music together so that one reflected the other, was a popular device employed in madrigals. Examples of text painting would be having pitches ascend if the text spoke of the sun rising, fast-moving pitches if the text was about running, or only two voice parts if the text mentioned two people being together—an excellent opportunity for flirting.

GUIDED LISTENING 2.06

Renaissance Madrigals

In the Renaissance Period, music was often made by the hosts and guests at dinner parties for their own and others' entertainment. Sung by four people, usually two men and two women, madrigals provided a diversion for couples and opportunity for sly flirting in a rather strict society. Text painting, easy to sing melodies, and non-sacred topics made these a favorite pastime.

Music listening may be accessed from www.ourworldourmusic.com

Unlike the dreamy, floating, almost meterless sound of Renaissance sacred music, dance music of the period had a regular beat. Dancing was choreographed with specific steps. It somewhat resembled modern line dancing in that all dancers knew the steps or they did not enter the dance floor. Specific types of dances were intended to be performed with specific types of music. Common forms of dances and dance music were the pavane, galliard, allemande, and courante. Dance music followed the tradition in Middle Ages and Renaissance music of not mixing voices and instruments.

GUIDED LISTENING 2.07

Renaissance Dance Music

Dance in the Renaissance Period was a rather sedate and highly structured court affair. Steps were specific and known to those who joined, similar to modern line dancing. Couples dancing was not the norm. Instead, participants engaged in slow moving but complex steps that often brought every male participant into contact with every female participant. Important to note as you listen—there is a regular pulse and meter not heard previously.

Music listening may be accessed from www.ourworldourmusic.com

Music was often performed in between acts of theater plays; often the text of the music would create a plot or mini-storyline. These musical interludes were called *intermedio*. If the main play was a drama, the intermedio would often be a comedy. These interludes allowed for changing of sets between acts in plays and were a bit of relief or diversion and often even commented upon the main play. The intermedio became important in the next stylistic period as they evolved into something new that altered music in ways still felt today.

For learning activities, practice quizzes, and other materials,
visit: www.ourworldourmusic.com

2.1 Worksheet

Name: _____

1. What evidence is found that music existed in prehistoric times and the ancient world?

2. Do we know what music in the ancient world sounded like? Why or why not?

3. The Romans excelled in organization. Give an example of this.

4. The Roman Empire came to include most of Europe and other areas, including _____ .

5. Roman culture adopted ideas from conquered territories. Discuss what these cultures added to Roman culture:

Greece _____

Egypt _____

Israel _____

6. Boethius wrote about Pythagoras's ideas about music. Name his writing and discuss.

7. What are two things that contributed to the decline of the mental capacity of the ruling classes of Rome?

8. Who were the Vandals? What does it mean to vandalize?

2.2 Worksheet

Name: _____

1. The period of the Middle Ages begins in _____ and ends in _____ . This period is also known as _____ .

2. The one organized part of the Roman Empire to survive was the _____ .

3. What is determinism?

4. Name and describe the three groups of class structure in the Middle Ages.

5. What new source of power was harnessed in the Middle Ages? How was it used?

6. Describe these two architectural styles from the Middle Ages:

 Romanesque

Gothic

7. What is an icon?

8. Explain the meanings of the iconic Madonna and Child image.

9. The most powerful entity during the Middle Ages was the _____ .

10. The order of the Catholic worship service is virtually unchanged since the Middle Ages. It is called the _____ .

11. During the Middle Ages, this religion arose, its tenets outlined in the holy book, the Quran. The religion is _____ .

12. What part did Pope Gregory I play in what we now know as Gregorian chant?

13. Describe the aspects of Gregorian chant.

2.3 Worksheet

Name: _____

1. The parallel voicing of a single melody is called _____ . It was developed in _____

2. Two musicians, _____ and _____ , used this method of writing music. It became known as the _____ .

3. The parts of the order of service of the Catholic Mass are called _____ .

4. Guillaume de Machaut was a French composer from the fourteenth century. He wrote both _____ and _____ music and is known for writing the first _____ .

5. Describe the "mathematical game" Machaut used in the writing of *Ma fin est mon commencement.*

6. This Middle Ages style was called _____ , or new art.

7. In Western society, the Renaissance period marked the beginning of modern times and modern thought. The French word *renaissance* translates as _____ .

8. The Renaissance period spans the years of _____ .

9. What was the dominant philosophy of the Renaissance period? Explain.

10. Discuss the contributions of the following men from the Renaissance period:

Michelangelo and Leonardo da Vinci _____

Christopher Columbus and Ferdinand Magellan _____

Nicolaus Copernicus _____

Johannes Gutenberg _____

Martin Luther _____

2.4 Worksheet

Name: _____

1. Discuss these two compositional devises used in the Renaissance period:

 imitation

 voice pairing

2. What is a triad? _____

3. Middle Ages music used three voice parts, with the melody in the lowest voice. Renaissance composers added a _____ part, sounding a pitch below the others. Today, the voice that sings the _____ part is usually perceived as singing the melody.

4. Name three notable Renaissance composers.

5. In the Renaissance period, there was also secular music. Name some ways in which the audience participated.

6. What are madrigals?

7. Name some common forms of dance and dance music used in the Renaissance period.

8. What was an *intermedio?*

2.5 Worksheet

Name: _____

Define the following terms:

1. lyre _____

2. polytheism _____

3. monotheism _____

4. catholic _____

5. Il Diablo _____

6. vandalize _____

7. Dark Ages _____

8. determinism _____

9. Romanesque _____

10. Gothic _____

11. icon _____

12. excommunication _____

13. Mass _____

14. Gregorian chant _____

15. vernacular _____

16. syllabic _____

17. neumatic _____

18. melismatic _____

19. Renaissance _____

20. humanism _____

21. motet _____

22. Ordinary of the Mass _____

23. madrigal _____

24. *intermedio* _____

25. voice pairing _____

26. imitation _____

27. triad _____

BAROQUE PERIOD

The period of musical development that followed the Renaissance was the Baroque period. It spans 1600–1750. Its beginning is marked by the first opera and its end by the death of one of its greatest composers, Johann Sebastian Bach. In modern usage, the term *baroque* has come to mean "elaborate," and this period of Western history was truly a time of elaborate extravagance and living large.

Significant Events

The Baroque period saw many scientific, humanistic, and societal events. In 1600, William Shakespeare, who straddled the Renaissance and Baroque periods, published *Hamlet*. In 1607, Jamestown, the first permanent colony in the New World, was founded. In 1610, Galileo Galilei claimed that the Earth revolves around the Sun. So powerful was the Catholic Church at this time that he was placed under house arrest for heresy, since his claim went against the church's teaching that humankind, and therefore the Earth, was at the center of God's universe. Galileo recanted but then on his deathbed reasserted his claim. In 1611, the King James Bible was published, strengthening the Protestant Church in England. In 1653, the Taj Mahal in India was completed. This magnificent structure, pictured in Figure 3.03, was built as a mausoleum to house the remains of the beloved wife of the country's ruler. In 1682, the infamous witchcraft trials in Salem, Massachusetts, took place. Women were tried and tested in absurd and extreme ways to determine whether they

© 2013 by Pack-Shot. Used under license of Shutterstock, Inc.

Figure 3.01

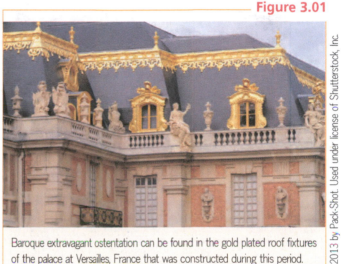

Baroque extravagant ostentation can be found in the gold plated roof fixtures of the palace at Versailles, France that was constructed during this period.

Figure 3.02

Galileo turned a telescope on the night sky, becoming the first person to see the lunar mountains, the shape of Mars, the phases of Venus, and Jupiter's four largest moons. Discovery of an object orbiting another object went against Church doctrine that the universe revolved around the Earth.

© 2013 by Elenarts. Used under license of Shutterstock, Inc.

Figure 3.03

The Taj Mahal in India

were witches. The trials and tests often ended in death; however, it was believed that if the person was a witch, then the world was rid of her and if she was not, she must have died in a state of grace and was therefore transported to heaven. In 1687, Sir Isaac Newton published *Principia Mathematica* that provided the world with the field of calculus and the laws of physics that govern motion, inertia, and gravity. In 1726, Jonathan Swift published *Gulliver's Travels*, a fantastical tale of travel and interaction with different peoples and cultures.

Baroque and the World

The Baroque period is a Western concept, and the societal attributes and generalizations of this period apply to Western society. This is the time period when many of the world's cultures began to be subsumed under a spreading, dominant, ruling European/Western culture. Exploration of the Renaissance period led to colonization during the Baroque period. As a result, European and Western concepts and culture dramatically affected many of the world's other cultures. In many instances, Western advanced technologies, especially those that supported making war, facilitated domination of indigenous cultures. European colonization and rule were chiefly aimed at shifting resources from other areas and societies to Europe, thus enriching Western society.

BAROQUE SOCIETY

The societal makeup of Western Baroque society closely resembled that of Western Renaissance society. It was ruled by an aristocratic class of nobility directly or indirectly affected by the influx of wealth from the New World and other places. This period of booming Western economy drove a culture that reveled in excess and ostentation. A merchant class arose and expanded as a result of the new trade opportunities, but this merchant class did not become a middle class. At this time, as in the Middle Ages and the Renaissance period, most Western people were serfs, bound to the land and to the aristocrats who owned the land.

BAROQUE ART

All forms of art in the Baroque period seemed to reflect this time of excess and ostentation. Every available space was filled, whether it was corners of a canvas; leftover areas within a block of stone; ceilings, corners, and spaces surrounding architectural works; or empty spaces between notes in works of music. Baroque art was active, busy, and filled the available space.

In comparing Michelangelo's sculpture *David* from the Renaissance period and Gian Lorenzo Bernini's *David* from the Baroque period, it is immediately evident that the calm, thoughtful, realistic approach of Renaissance art is transformed into active, in-motion Baroque art. Michelangelo portrayed David in the completive moment before he threw his rock at Goliath. Bernini depicted the moment of throwing the rock. The faces, muscle tension, and stance of these two statues demonstrate the difference in the art of the two periods.

Figure 3.04

David by Michelangelo.

Photo courtesy of Cristian Codreanu.

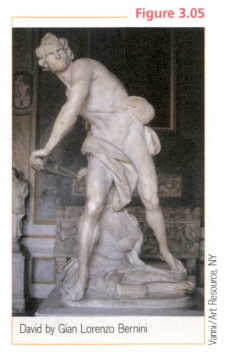

Figure 3.05

David by Gian Lorenzo Bernini

Vanni/Art Resource, NY

In painting, this same approach is evident. The art fills the available space with busy, active subjects. Nicholas Poussin chose as his subject the story of the ancient people of Israel turning to another god while Moses was up on the mountain receiving the Ten Commandments (Figure 3.06). The painting is titled the *Adoration of the Golden Calf*. Note how every part of the canvas is filled with action, as opposed to the calm and serenity of Leonardo da Vinci's painting in Figure 2.18.

Figure 3.06

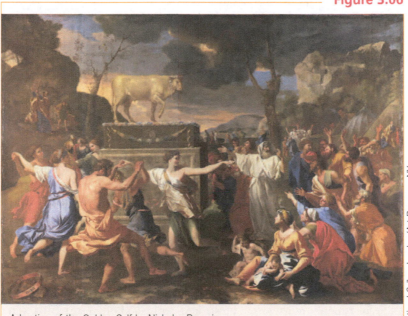

Adoration of the Golden Calf by Nicholas Poussin.

© National Gallery, London/Art Resrouce, NY

In architecture, this same busy, fill-the-space approach was also evident. Two palaces constructed during the Baroque period, Louis XIV's Palace at Versailles in France and Frederick the Great's somewhat smaller Sanssouci in what was then Prussia, demonstrate the opulent, extravagant approach to life that was practiced by Baroque aristocracy. Both use extensive grounds around the main building. Statuary, reflecting pools, and highly ornamented exteriors and interiors are all part of Baroque architecture.

Figure 3.07

The Palace at Versailles.

Figure 3.08

Sanssouci Palace.

MUSIC IN BAROQUE SOCIETY

Many changes in Western music occurred during the Baroque period; it was one of the most turbulent times in music in history. New approaches to performance, musical composition, and music's role within society occurred during this time. In addition, evolution in the construction of musical instruments, especially those of the violin family, resonated throughout the Baroque period and continue into today.

Changes over Time

Baroque music did not suddenly spring forth and supplant Renaissance music. The changes, as revolutionary as they were, developed over time. The first forty years of the Baroque period, 1600–1640, can be labeled as Early Baroque. This was the period of working out the new harmonic approach, beginning to use different types of musical scales, and presenting music in new ways. These changes developed primarily in Italy. The next forty years, 1640–1680, are known as Middle Baroque. During this time, the new ideas from Italy were refined and spread to the rest of the Western world. The remainder of the period, 1680–1750, is called Late Baroque or High Baroque. The new ideas were firmly in place by then, composers had worked out how to use the new techniques and tools, and audiences came to expect their new music to sound different from the music of a hundred years before.

Church to Court

Music of the Middle Ages and Renaissance periods had been primarily associated with the church. During the Baroque period, music began to shift from the church to the court. Secular music rivaled sacred music in quantity and often surpassed it in quality, since many of the best musicians and composers chose to work in the courts of the aristocracy where the pay was considerably better than in the churches. As Baroque music evolved, the difference

between sacred and secular music became almost unrecognizable. Many secular elements found their way into sacred music, and sacred elements were transferred to secular music. This blurring of lines of distinction that began in the Baroque period continues to today. Modern religious music often sounds much like modern secular music. In the early second half of the twentieth century, Ray Charles created controversy when he brought stylistic devices from gospel music to bear in his secular music.

GUIDED LISTENING 3.01

Baroque Sacred and Secular Music

The line between sacred and secular music began to break down during the Baroque Period, angering some traditionalists. The same thing happens in modern music when a performer uses popular music ideas in sacred music or vice versa. In this and many other ways, the Baroque Period became the beginning of modern music.

Music listening may be accessed from www.ourworldourmusic.com

Music's role at court was as daily dinner and recreational background music. During frequent parties and balls, it played the role of a type of status symbol. A large court orchestra implied success and power of the aristocrat, just as wheels on an automobile might imply success in today's world. To carry that analogy further, the larger the Baroque orchestra, the greater the status symbol, much as larger wheels may be interpreted today.

Also important as a status symbol was maintaining a court composer. Audiences craved new music, and no Baroque party or ball was a real success unless new music was included. Good new music brought even more status. For that reason, most music during the Baroque period was written on demand to fulfill specific needs. All Baroque music that we hear was once new and created excitement within the society that supported it.

STYLISTIC DEVICES

Music of the Baroque period sounds distinctively different from music of the Middle Ages and Renaissance period. Several stylistic devices contribute to this different sound. These stylistic devices profoundly changed music of the Baroque period, and they can be found in almost all modern Western music.

Solo Voice

Music of the Middle Ages and Renaissance used groups of voices or choirs. While Baroque composers continued to write for choirs and groups of voices, one of the major changes in music that occurred at this time was the use of the solo voice and the focus upon performances by individuals. This device is commonly used in modern music. Most performances and recordings of people singing today are of solo singers.

Voice with Instruments

In the Middle Ages, most music was for use in worship. Since many pagan gods were associated with specific musical instruments, and since the Church was striving to differentiate itself from the older religions, instruments were not

Figure 3.09

Solo singing is common in modern music; it is a product of the Baroque period and the changes it brought to making music.

Figure 3.10

The practice of mixing voices with independent instrumental parts, a mainstay of modern music, began in the Baroque period.

Figure 3.11

Instrumental music, music without singing, takes many forms in our modern world and is a product of the Baroque period.

used in worship. In the Renaissance period, this ban on instruments in worship was mostly upheld; however, it became common to use instruments with voices in music outside of the church. When instruments and voices were mixed, the instruments functioned only to replace missing singers or to strengthen a vocal part. The voices and instruments performed the exact same part. Under Baroque composers, voices and instruments developed independent parts. The voice continued as the dominant part; however, unique, separate, and individually interesting instrumental parts served as accompaniment to the voice or voices. Modern music often combines voices and independent instrumental accompaniment.

Instrumental Music

Music of the Middle Ages and Renaissance was overwhelmingly vocal; if instruments were used, they were only meant to strengthen or replace missing vocal lines. In the Baroque period, as instrumental accompaniment parts for vocal music became increasingly independent, composers began to write purely instrumental music. A new genre of music developed, one that used only instruments without voices. Modern music, too, is often composed for instruments without voices.

Clearly Identifiable Beat

During the Middle Ages and Renaissance period, music often lacked a clearly defined beat due to limitations of the notational system, or the beat was intentionally obscured by the composer in the quest for independence of melodic lines. One of the few exceptions to this approach was in music for dance, where definition of the beat was critical. In the Baroque period, a regular, almost clocklike beat became a standard part of almost all music, whether sacred or secular. One of the characteristics almost immediately noticeable when comparing earlier music with Baroque music is that it is easy to tap your foot when listening to Baroque music. This regularity of beat, and its extension of grouping beats into meter, continues throughout almost all modern music.

Major and Minor Keys

Music of the Middle Ages and the Renaissance was almost exclusively based upon scales known as *modes* or *church modes*. These scales arrange the white and black notes within each scale in slightly different ways. The result is music that sounds somewhat eerie or unfocused

to our modern ears. During the Baroque period, composers moved away from these modal scales and focused upon two types of scales: major and minor. The major scale sounds bright and happy, while the minor scale sounds rather dark and sad. In modern Western music, we find almost exclusive use of major and minor scales.

Basso Continuo

As Baroque music developed, a common instrumental core came to be used in most compositions. This fundamental core was made up of a chording instrument like a keyboard or lute, and a bass instrument like a cello or bassoon. This two-person chording/bass instrument group was called the *basso continuo*. Two players were required, yet they read the same music. Baroque music was built by adding instruments, voices, or both to this core. This approach to creating and performing music continues today in modern popular music that usually has a core of keyboard, guitar, bass, and drums collectively called the *rhythm section*.

Polyphony Dominates

Music of the Middle Ages began as monophonic and, through organum, evolved into polyphonic texture. During the Renaissance period, leaders of the church became concerned about using extensive polyphony and its ability to obscure the words and message of sacred music. A movement even occurred back toward the simpler texture. When the musical centers shifted from the church to the courts during the Baroque period, polyphony exploded and pushed the other textures from the forefront. Modern Western music is almost exclusively polyphonic, with each voice or instrument performing its own part and melody.

INSTRUMENTS

Some instruments available to Baroque period musicians were highly evolved; others were not. Evolved instruments included the organ and those in the violin family, like the one pictured in Figure 3.12. Evolving instruments included the woodwinds and keyboards. Brass instruments were still rather primitive, and percussion instruments, other than timpani drums, were rarely used.

Violin Family

Late in the seventeenth century, the art of violin making reached its peak in northern Italy, primarily in the towns of Brescia and Cremona. Three family names stand out among makers of excellent instruments: Guarneri, Amati, and Stradivari. Hundreds of years later, their instruments are still regarded as perhaps the best ever made. These highly developed instruments became the main melodic instruments of Baroque period music.

Antonio Vivaldi

One of the great composers of the Baroque period was Antonio Vivaldi (1678–1741), a violinist and the son of a violinist in Venice, Italy. A sickly child, his time was spent

Figure 3.12

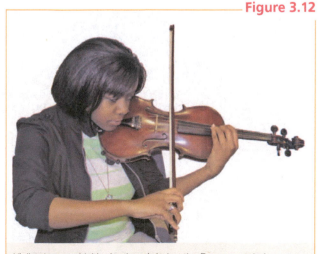

Violins became highly developed during the Baroque period.

learning to play violin and to compose music, rather than in running and playing sports. As a young man, he was ordained as a Catholic priest and given the nickname *il Prete Rosso* (the Red Priest) because of his red hair. Within a year, however, he was given a reprieve from his sacred duties because of his health. Although he officially remained a priest, from that time on he lived a secular life outside of the church. Supporting himself, he served as a music teacher in an orphanage for girls for thirty years while composing and publishing several hundred musical works of various types—about half of which featured the violin. His most famous composition, *The Four Seasons*, celebrates the annual progression of our world's seasons. Each group of pieces in this composition attempts to present one of the seasons.

GUIDED LISTENING 3.02

Antonio Vivaldi

Vivaldi is remembered for his large output of Baroque music for violin and orchestra. His music was regularly performed by the girls at the orphanage where he taught and by professional musicians fortunate enough to be familiar with his work. Listen for music that fits the idiomatic arrangement of notes on the violin and sounds more difficult than it really is. His students sounded great when they played his works.

Music listening may be accessed from www.ourworldourmusic.com

Basso Ostinato

As noted earlier, many elements of modern music can be found in music of the Baroque period. One Baroque approach to music was the use of *basso ostinato*, a repeating bass line. Since Baroque composers viewed the bass part as the foundation of a musical work's harmonic structure, they would often set up a cyclic repetition of harmonies through a repeated bass line. This repeating structure provided a stronger, almost hypnotic underlayment for melodic ideas that occurred above the bass line.

The approach of using a repeating bass line is common in modern popular music. Many genres use this device, some using it more strictly than others. The hypnotic effect is the same now as when it was first used in the Baroque period.

GUIDED LISTENING 3.03

Basso Ostinato

In Italian, *basso ostinato* literally means "stubborn bass." In practice, it means a bass line that repeats over and over--perhaps the term stubborn is correct. The idea of a repeating bass line, begun in the Baroque period, is a hallmark of several types of modern popular music. Listen for the repeating bass line in these musical examples.

Music listening may be accessed from www.ourworldourmusic.com

Organ

In terms of raw power and the ability to quickly change timbre by assigning a different tone quality to each of several stacked keyboards, the pipe organ was the king of the Baroque instruments. Its closest modern counterpart would be the electronic synthesizer, also having this capacity for power and rapid timbre change. Baroque organists would sit with each hand playing

a melody on a different level of the tiered keyboard while their feet played yet another melody on the oversized keyboard below the bench where they sat. Although there was no electricity to drive the air needed to produce sound through the pipes, organists could play for as long as the choirboys could continue to pump the huge mechanical bellows that supplied the necessary air pressure.

As new great churches were built, a product of the dramatic growth of Protestantism during this period, new, bigger, and more advanced pipe organs were built and installed in these facilities. Upon the grand opening and dedication of a church, it was common to bring in a highly renowned organist to perform and to demonstrate the capabilities of the new church's instrument. In Germany, one of the organists often called upon was Johann Sebastian Bach.

Figure 3.13

The Baroque "King of Instruments", the organ, required skill and coordination to play, especially when playing a Baroque fugue.

Johann Sebastian Bach

One of the two dominant composers of the Baroque period, Johann Sebastian Bach (1685–1750) was born into a family of musicians and his children continued in the family business of making music. The husband to two wives (serially, not simultaneously), he fathered 20 children, several who went on to become important composers and musicians. So significant is he to the identity of Baroque music that his death is the identifier commonly used to mark the end of the period.

Bach, a violinist and an organist, initially studied with his brother. His career included both church and court positions, and since most Baroque music was written on demand for a specific use or occasion, his musical output contains both sacred and secular works. He was a deeply religious man who often included a note at the bottom of his compositions that said "to God be the glory." The church in which he worked was the Lutheran Protestant Church. His sacred music was composed to fit this new worship service and was in the highly ornamented, elaborate style of the Late Baroque period.

During his lifetime, Bach was more highly regarded as an organist than as a composer. He was often called upon to travel to evaluate newly installed pipe organs and to then present concerts upon these new instruments. Bach was known as a master at improvising, the art of creating music on the spot, in the moment, as it is being played. Modern jazz musicians regularly do this, as do popular music performers when they play solos in the middle of a piece of music. Just as jazz musicians or popular music musicians work within the styles and devices of music most familiar to them, Bach did that with Baroque styles and devices.

Fugue

One of the major forms of music from the Baroque was the fugue. A fugue is a complex polyphonic combination of melodies that follows a specific formula. Initially, a single melody, called the theme, is played alone (monophonically). At the conclusion of the theme, it is then played at a higher or lower pitch level while another part performs an accompaniment to the theme. The fugue is an evolution of the imitation between voices that

was common in Renaissance music. Following the second presentation of the theme, a brief transitional section of music often comes before yet another voice or part begins the original theme while both of the other voices or parts provide accompaniment. Frequently, a fourth voice or even more continues the theme presentations while the other voices provide accompaniments. Development of the theme usually comes after the theme has been heard from each of the voices. The structure of a fugue is indeed complex and fugues can be difficult to create. That is one of the reasons that all college music majors study the music of Bach and learn to write music in the styles in which he wrote. While these college students often struggle to work out and write down these types of pieces, Bach was known to create fugues while just improvising. One of the truly impressive ways that a fugue can be performed is on a pipe organ by a single performer who plays all of the multiple melodies simultaneously using feet and hands.

GUIDED LISTENING 3.04

Fugue

Entering one at a time, creating a building tension, the reiterations of the fugue melody demonstrate a superior command of musical and compositional elements. Performing a fugue as a group, it is difficult to maintain synchronization. Performing a fugue alone, a musician demonstrates mastery of his or her musical skills.

Music listening may be accessed from www.ourworldourmusic.com

Harpsichord

The other commonly used keyboard instrument of the Baroque period was the harpsichord. When a performer pressed down on a key, the internal mechanism caused a tight string to be plucked. The instrument had several advantages over a pipe organ, including being simpler, less complicated, more affordable, and more portable. While organs were found in churches, harpsichords were found in the homes of the aristocracy. A disadvantage of the harpsichord was that its mechanism did not translate the force with which a key was depressed into differences in sound. The way that Baroque musicians created dynamic changes on a harpsichord was by playing more or fewer keys at once, resulting in more or fewer strings vibrating inside the instrument. Music for harpsichord often created interest through quickly moving notes, and harpsichords were often used not only as performance instruments but also as tools for teaching. Bach wrote a considerable quantity of music for harpsichord, pieces that not only stand alone as interesting musical works but were also intended for training young musicians.

GUIDED LISTENING 3.05

Inventions

A Baroque invention is a piece, usually for keyboard, that contains two melodies that create a polyphonic texture. Each hand has its own melody and neither is dominant. Inventions were often written as "textbooks" or teaching materials used in the instruction of young musicians.

Music listening may be accessed from www.ourworldourmusic.com

Woodwinds

While the violin family and the organ were highly developed instruments during the Baroque period, woodwind instruments were in a state of evolution. Most woodwinds were open-hole instruments. Transverse flutes (those played by holding them across the body, as in Figure 3.14) were emerging and gaining in popularity due to the greater control that this design offered to the performer. Firmly entrenched, however, was the Baroque recorder, an inline flute with a whistlelike mouthpiece, pictured in Figure 3.15. Both of these types of flutes used an open-hole design. In Prussia, Frederick the Great, an amateur flautist (flute player), had hired one of the foremost players and makers of the new transverse flute, Johann Quantz, to work in his court as his personal teacher. Part of Quantz's employment contract stipulated that he would be paid an additional sum for each flute that he built for Frederick. Quantz became one of the first instrument makers to experiment with the addition of keys to expand the reach of the player's fingers and allow for more and better in-tune notes to be played.

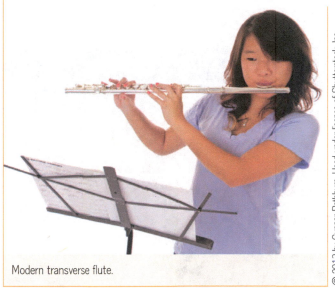

Figure 3.14

Modern transverse flute.

© 2013 by Gunnar Rathburn. Used under license of Shutterstock, Inc.

Other evolving woodwind instruments included the single and double reeds. These instruments, too, were undergoing changes in their design. The arrangement of holes, and sometimes keys, was almost unique to each instrument maker. While instrument makers were striving to improve their instruments' capabilities for playing in tune, a downside of this experimentation was that performers had to learn new systems of fingering every time they purchased a new instrument.

Brass Instruments

Perhaps the most primitive instruments in common use during the Baroque period were brass instruments. At this time, these instruments did not have the valves that we associate with modern instruments. Trumpets and horns were able to deliver power to enhance composers' music; however, they were limited in the number of notes that could be played. Few players could produce more than a handful of different notes, and these were spread over two or more octaves. Playing melodies on these instruments was impossible for most players. An early version of the trombone, capable of producing enough notes to play melodies, was sometimes used in churches. Interestingly, the trombone was viewed as an instrument for sacred music and did not find its way into secular music until late in the period that followed the Baroque period.

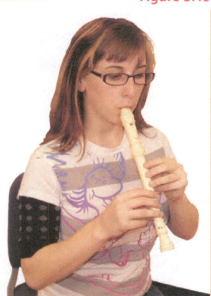

Figure 3.15

Baroque recorder.

Henry Purcell—Although he lived a brief life, Henry Purcell (1659–1695) is recognized as one of England's greatest musicians. He worked primarily in Westminster Abbey, the church where England's kings and queens are crowned and where many of these nobles are also buried. (Yes, it was common practice to bury them right there in the church, under the

floor.) Purcell wrote instrumental and vocal music for both sacred and secular uses. He was so highly regarded that he is buried beneath the organ at Westminster Abbey, an honor accorded to few outside of royalty.

GUIDED LISTENING 3.06

Henry Purcell

One of England's most celebrated musicians, during his lifetime and continuing to the present, Henry Purcell was the organist for kings and queens at Westminster Abbey. He helped to bring English music to a highly prominent place, resulting in several well-known musicians choosing to make their homes in London.

Music listening may be accessed from www.ourworldourmusic.com

Figure 3.16

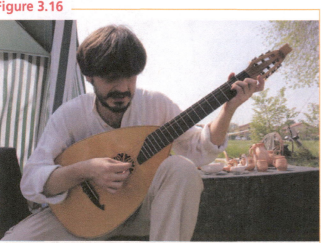

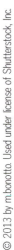

The lute, originally an Arabian instrument, followed the path of Muslim conquests and entered the Western world, where it eventually evolved into the modern guitar.

Figure 3.17

Opera is a play in which the dialog is sung rather than spoken. Music helps to strengthen the emotional content of the text.

Lutes

Guitarlike instruments, called *lutes*, were common during both the Renaissance and the Baroque periods. In the Baroque period, lutes usually functioned as a chording instrument in the basso continuo duo of a bass and a chording instrument. One advantage of the lute over other chording instruments was its easy portability. These instruments became somewhat more refined during the Baroque period.

VOCAL MUSIC

During the Baroque period, vocal music changed drastically. One change was a move from ensembles of voices to a solo voice. Another was the inclusion of instruments in an independent, accompanying manner.

Opera

As noted earlier in this chapter, the event that marked the beginning of the Baroque period around 1600 was the development of opera. Jacopo Peri, an Italian, is credited with creating the first opera, *Dafne*, in 1597. Unfortunately, that opera is lost; however, his 1600 opera, *Euridice*, still survives. It tells the Greek mythological story of Orpheus and Eurydice, a tale about two lovers who are parted by death and are given another chance.

Opera was the ultimate art form when first created and remained the ultimate art form until technological advances in the twentieth

century created a new art form: movies. *Opera*, in its simplest description, is a play in which the entire dialogue is sung rather than spoken. Singing the dialogue, along with the instrumental accompaniment, allows for increased emotional content. Opera combined all available art forms, including singing, dancing, acting, painting scenery, making costumes, and playing instruments. Special effects were as much a part of operas as they are a part of modern action movies. The combination of all of these art forms resulted in an evening of elaborate entertainment for nobles; unfortunately, opera was not available to most commoners. Several types of songs were developed to enhance the presentation of these stories through music.

Recitative

A type of extremely simple song, called *recitative*, helped to provide narration or expose plot to help move the storyline along. Recitative used melodies with limited pitch range and little ornamentation. Accompaniment was simple, often using only basso continuo.

Aria

Show-off pieces for singers were called *arias*. These types of songs conveyed emotion. It was quite common to find recitative–aria pairs of songs throughout operas. These pairs allowed characters to present a plot development and then sing about their feelings related to the new development. Arias usually used the full instrumental accompaniment resources that were available.

Vocal Ensembles

When a dialogue between two characters fit an opera's storyline, the two characters would usually appear on stage together and sing their lines to each other in a duet. Three characters in conversation make up a trio, and four are a quartet. More than three or four are simply termed an *ensemble*. Sometimes a *chorus*, or large group of singers, would be on stage together for a crowd scene.

Castrati

The pop stars of the Baroque period were the *castrati* singers. A *castrato* was a male singer who, as a boy, underwent a medical procedure to assure that his voice would not change. This procedure, castration, resulted in the boy continuing to grow without entering puberty. The result was a large man with enormous lung capacity and strength who had the high voice range of a woman. These singers were the most admired of all opera performers. Unfortunately, many Baroque operas cannot be performed in their original form due to the modern shortage of castrati singers.

Claudio Monteverdi

The first large-scale, or grand, opera was *Orfeo* by Claudio Monteverdi in 1607. Interestingly, its storyline is based upon the same Greek myth of Orpheus and Eurydice that Peri used in his *Euridice*. Monteverdi used the types of opera song styles discussed earlier.

Figure 3.18

Choral music continued during the Baroque period, in both Catholic and Protestant churches, though it began to include elements of opera such as soloists and small ensembles, along with instrumental accompaniment.

© 2013 by posztos. Used under license of Shutterstock, Inc

Cantata

The Protestant Church grew in strength during the Baroque period. This was especially true of the Lutheran Church in Germany. Just as music was an important part of the Catholic Mass, it also played a major role in the Lutheran worship service. One major change in music's role was the expectation of congregational singing during a Lutheran service. Another was its use in passing along biblical teachings in the vernacular (local language) rather than in Latin. The *cantata* form developed to address these and other needs. Cantatas were sacred works for solo, duet, trio, ensemble voices, choir, and congregation, performed without acting, scenery, or costumes. Cantatas used elaborate instrumental accompaniment and sounded much like secular musical forms of the period.

A cantata was a lot like a modern record album project. It was made up of several independent, contrasting songs that fit together into a whole. The text was drawn from scripture. Usually, a unifying melody and text could be heard in several of the songs, leading up to a song, called a *chorale*, that was sung by the entire congregation. A chorale is a simple piece of music, sometimes called a *hymn*, that has all voices and parts moving with similar rhythms. The earlier songs in a cantata would help to teach the new text and melody to the members of the congregation before they would join in during the chorale.

Oratorio

The middle ground between the sacred cantata and the secular opera was *oratorio.* Oratorio used a chorus and featured solos or small groups of voices. In that way, it was like both opera and cantata. While cantatas were each based upon a few verses of scripture, oratorio, like opera, told a story. Oratorio, like cantata, used no acting, costumes, or scenery. The text for oratorios could be drawn from scripture, like the cantata, or it could come from mythology, like many operas. It is important to note that although oratorios are now performed in both sacred and secular settings, they were perceived by Baroque audiences as secular events.

George Frederick Handel

The other giant of the Baroque period, George Frederick Handel, is an interesting study in similarities and differences when compared with Bach. Both Bach and Handel were born in 1685. Both were German. Both wrote highly evolved, complex music in the Late Baroque style. Bach was happy working as a *kapellmeister* (a chapel-master, or church music leader), but Handel was unhappy during the short time that he held a kapellmeister position. Bach did not write opera, while Handel flourished at it. Bach lived all of his life within 300 miles of where he was born; after graduating from university in Germany, Handel went to Italy to study music and then worked for almost his entire career in England. Bach was little known as a composer during his lifetime, being perceived as an organist. Handel was famous during his lifetime and even wrote music for the king of England. Bach wrote his music primarily in German, while Handel, after moving to England, wrote almost exclusively in English. Bach died in 1750. Handel died in 1759, spending his last several years blind.

One of Handel's most famous works is an oratorio titled *The Messiah*. Composed in 1741 during an extremely creative period of Handel's life in just 24 days, *The Messiah* is made up of several recitatives, arias, and choral pieces. Through excerpts of biblical scripture, it tells a story of the prophecies, birth, death, and resurrection of Jesus. Text painting is present throughout, and the work requires not only the soloists and choir but also an orchestra for accompaniment. Almost every Baroque compositional device is used. Perhaps the most famous individual song from *The Messiah* is a choral piece titled the *Hallelujah Chorus* that draws its text from the book of Revelation. One story told is that the king of England, when hearing this piece for the first time, became so enthralled that he rose to his feet. Protocol says that if royalty stands, everybody stands. To this day, one tradition associated with the *Hallelujah Chorus* is that the audience stands at a live performance of this part of *The Messiah*.

GUIDED LISTENING 3.08

George Frederick Handel and Oratorio

Oratorio, like opera, tells a story. Oratorio, however, uses only a choir, some soloists, and some instruments. There is no acting, contumes, stage movement, or other theatrical devices. George Frederick Handel is the composer of perhaps the best known oratorio ever. Listen for Baroque devices such as instrumental accompaniment, solo voices, and even fugue sections.

Music listening may be accessed from www.ourworldourmusic.com

OTHER INSTRUMENTAL TYPES

During the Baroque period, instrumental music took off and soared. Many types developed, including those noted previously in this chapter. In addition, a multimovement instrumental form called the Baroque *suite* evolved. Each movement was based upon a contrasting dance type. Movements were like songs on a CD—they contrasted yet complemented one another to help make up a greater whole.

Another Baroque instrumental form was the *concerto*. A Baroque concerto was an instrumental work that featured a group of instrumentalists accompanied by an orchestra. This form was the beginning of types of instrumental music that feature solo or groups of instrumentalists, such as modern instrumental jazz.

GUIDED LISTENING 3.09

Johann Sebastian Bach and Concerto

As noted previously, the Baroque Concerto was a work that featured a solo instrumentalist or group of soloists. This form of the newly-important instrumental music allowed for presentation of exceptional players, balancing them against the larger instrumental group. Listen for soloists alternating with the orchestra.

Music listening may be accessed from www.ourworldourmusic.com

Another instrumental form that grew during the Baroque period was the *toccata*. Typically associated with music for organ or sometimes a stringed instrument, this form was usually a show-off piece for a gifted performer. It was often used as an introduction to another piece of music, but it allowed the solo performer to play lots of fast-moving notes and create excitement.

GUIDED LISTENING 3.10

Johann Sebastian Bach and Toccata

A toccata was an instrumental piece for organ or sometimes a stringed instrument. It was usually a show-off piece for a gifted performer and was often used as an introduction to another piece of music. Listen for a solo performer and lots of fast-moving notes that create excitement.

Music listening may be accessed from www.ourworldourmusic.com

For learning activities, practice quizzes, and other materials,
visit: www.ourworldourmusic.com

Name: _____

1. The term *baroque* has come to mean _____ .

2. All forms of art in the Baroque period reflect a time of _____ and _____ .

3. What are the three phases of the Baroque period and their dates?

4. Name five significant scientific, humanistic, and societal events that took place during the Baroque period.

5. During the Baroque period, music began to shift from the church to the court. Discuss what changes happened with sacred and secular music.

6. Name and describe some stylistic devices used in the Baroque period that changed music and can be found in almost all modern Western music.

7. Scales in the Middle Ages and the Renaissance were called _____ .
During the Baroque period, composers moved away from these and focused on two types of scales, the
_____ and the _____ .

8. The dominant texture of music from the Baroque period was _____ .

9. Describe the Baroque instrumental core and how this approach has translated into modern popular music.

3.2 Worksheet

Name: _____

1. Name seven instruments used in the Baroque period. Give a brief description of each.

2. Who were the three outstanding makers of violins in the late seventeenth century?

3. What is a fugue?

4. Give five facts about Johann Sebastian Bach.

5. Antonio Vivaldi was also a great composer of the Baroque period. Why do we remember him?

6. What is opera?

7. What is the name of the first opera? Who wrote it, and when?

8. Who were the pop stars of the Baroque period? Why?

9. How does the development of opera relate to modern popular music?

10. What are the similarities and differences of a cantata, an opera, and an oratorio?

11. George Frederick Handel's most famous oratorio is titled _____ .

Name: _____

True or false?

_____ 1. As Baroque music evolved, the difference between sacred and secular became recognizable.

_____ 2. The Baroque period has three phases.

_____ 3. During the Late Baroque, many new ideas were refined.

_____ 4. Operas and oratorios are the same in every way.

_____ 5. The texture of Late Baroque music is chiefly homophonic.

_____ 6. Audiences in the Baroque period craved for the old music.

_____ 7. Most music of the Baroque period was based on church modes.

_____ 8. Many secular elements found their way into sacred music during the Baroque period.

_____ 9. In the Baroque period, a regular beat became a standard part of all music, whether sacred or secular.

_____ 10. A castrato was a female singer with a deep voice.

_____ 11. Antonio Vivaldi was an ordained Baptist minister.

_____ 12. Lutes are woodwind instruments.

_____ 13. Both Johann Sebastian Bach and George Frederick Handel were German kapellmeisters.

_____ 14. Claudio Monteverdi wrote the first opera in 1600.

_____ 15. The pipe organ was the king of Baroque instruments.

_____ 16. Johann Quantz was a violin maker for Frederick the Great.

_____ 17. Henry Purcell is buried beneath the organ in Westminster Abbey.

1. Discuss and compare the differences between the Middle Ages and Renaissance and the Baroque period.

2. Compare Michelangelo's sculpture _David_ from the Renaissance Period and the sculpture of _David_ by Gian Lorenzo Bernini. Tell how each represents its period.

3.4 Worksheet

Name: _____

Define the following terms:

1. Baroque _____

2. Early Baroque _____

3. Middle Baroque _____

4. Late Baroque _____

5. meter _____

6. modes _____

7. major scales _____

8. minor scales _____

9. basso continuo _____

10. basso ostinato _____

11. opera _____

12. recitative _____

13. aria _____

14. castrati _____

15. castrato _____

16. cantata _____

17. oratorio _____

18. concerto _____

19. toccata _____

20. movement _____

21. kapellmeister _____

22. chorale _____

23. theme _____

24. fugue _____

25. secular _____

3.5 Worksheet

Name: _____

Match the following terms with their definitions:

_____ 1. aria A. A common instrumental core used in most compositions

_____ 2. Baroque suite B. Middle ground between cantata and opera

_____ 3. basso continuo C. Melodies with limited pitch and range and little ornamentation

_____ 4. basso ostinato D. The stars of the Baroque period

_____ 5. cantata E. A male singer

_____ 6. castrati F. A multimovement form

_____ 7. castrato G. Baroque show off piece for solo performer

_____ 8. chorale H. A song sung by the entire congregation

_____ 9. concerto I. A Baroque composition featuring a group of instrumentalists

_____10. fugue J. A somewhat guitarlike instrument

_____11. kapellmeister K. One of the major forms of Baroque music

_____12. lute L. Sacred works for solo, duet, trio, choir, and congregation

_____13. opera M. A play in which the entire dialogue is sung rather than spoken

_____14. recitative N. Show-off pieces for singers

_____15. toccata O. A chapel-master or church music leader

_____16. Oratorio P. A repeating bass line

17. Who was Henry Purcell and where was he buried?

18. Who was Frederick the Great and what instrument did he play?

19. Who was Johann Quantz and what were some of his contributions to music?

20. What is music without singers called?

21. Galileo was the first person to see:

Music Takes Form

CLASSICAL PERIOD

The period in Western music that followed the Baroque was the Classical, 1750–1820. Although this was a brief period when compared with the 150 years of Baroque music, the 150 years of the Renaissance period, and the 1,000 years of the Middle Ages, it was society-changing. Since music reflects the society in which it exists, the music of the Classical period evolved to become rather different from that which came before.

Classical Society

Perhaps the major contributing factor to societal change during the Classical period was the decline of the fortunes and influence of the aristocracy. The influx of wealth from the New World had enabled Baroque period aristocrats to live elaborate, extravagant lifestyles. As they flaunted this wealth, they were increasingly viewed in a negative light. The decline of the strength and influence of the Catholic Church contributed to the decline of the strength and influence of the aristocracy, since rulers and ruling classes were sanctioned by the church. The Protestant Church was not as involved in the selection of worldly rulers, and Protestant followers were not obligated to church-anointed rulers in the same way as before. As people began to question their church leaders, they also began to question their worldly leaders.

This approach to life and society was a product of the Age of Enlightenment, a philosophical movement that reached its height in the second half of the eighteenth century—the same time that the Classical period was beginning. A Western movement, the Age of Enlightenment was a time of conflict among writers, rulers, and clerics. As the church attempted to continue traditions, followers of the new philosophy advocated examining everything and weighing it on its own merit. Belief in concepts such as natural law, the value of reason, freedom, and democracy are all hallmarks of the Age of Enlightenment. This philosophy, articulating the rights of man, set the stage for the movement that would follow closely upon its heels: abolitionism. Near the end of the Classical period, Abolitionists gained their first major victories, such as the 1807 ban

Figure 4.01

Freemasons promoted Age of Enlightenment concepts and were banned by the Catholic church. This mosaic is inlaid in the outside wall of their Grand Lodge in Boston, the birthplace of the American Revolution

on the importation of African slaves to the British West Indies and the 1808 ban upon importation to the new United States of America.

Significant Events

In Europe, the aristocracy's influence was in decline. As would be expected, aristocrats struggled against the change. Followers of the Age of Enlightenment saw Napoleon Bonaparte as the leader who could banish aristocratic rule and bring about a new societal order. Flocking to him, they fought against aristocratic rulers. These rulers had no recourse other

Figure 4.02

Courtesy of Library of Congress.

Broadsheet of the Declaration of Independence.

than to hire mercenary soldiers to fight for them. As a result, the Napoleonic Wars achieved their goal of breaking the power of traditional aristocratic rule; however, they did this by financially draining these rulers and thus draining their power. Unfortunately, Napoleon fell victim to the trappings of power, married a princess of the Habsburg aristocratic family, and began to live the entitled life of the people whom he fought against. He, too, was eventually deposed.

Another series of significant societal events occurred on the western side of the Atlantic Ocean when the British colonies in the New World banded together and, in a historic 1776 document titled the Declaration of Independence, broke away from England. When the king objected, the new nation, the United States of America, fought the American Revolutionary War to decide the issue. Although initially doomed to failure due to lack of resources, the United States was eventually successful thanks to the decision by France to enter the conflict on the side of the Americans. Following the war, the new nation set up a form of government based upon Age of Enlightenment ideals; primary among them were democracy and the freedoms outlined in the Bill of Rights.

Slightly more than a decade later, France found itself embroiled in its own revolution. In 1789, French citizens began the French Revolution, a violent and turbulent period in French history. The revolution eventually resulted in the overthrow of French aristocracy and the execution of King Louis XVI and his queen, Marie Antoinette. In earlier times, to kill a ruler anointed by the church was viewed as bringing with it damnation for eternity. In the Age of Enlightenment, all men, including kings, were believed to be equal, and in France this equality could often be found in the baskets at the bottom of a new invention: the guillotine. (Interestingly, the first version of this device was built by a harpsichord maker.)

Arts in Classical Society

As aristocratic elitism gave way to democracy and equality, patronage of the arts moved from the courts to the public arena. Elaborate, ostentatious displays of Baroque period artwork became more simplified and lighter as artists attempted to reflect and survive in the new societal order. Visual art in the Classical period became less busy than Baroque art, as demonstrated in Figure 4.03. Colors were often somewhat muted. Two of the main characteristics of all forms of art in this period were symmetry and balance.

Figure 4.03

Madame Recamier by Jaques-Louis David, 1800, displays simplicity and balance.

© Shutterstock, Inc.

Music in Classical Society

Reflecting the society in which it existed, musical activity during the Classical period began to shift away from the courts. This can be seen in the lives of the three leading composers of this period: Franz Josef Haydn, Wolfgang Amadeus Mozart, and Ludwig van Beethoven. Haydn, who came first chronologically, worked almost all of his life in the court of Prince Nicholas

Figure 4.04

The shift in arts funding from aristocrats to ticket-buying public led to building of larger concert halls and theaters, since performances needed to generate enough revenue to be self-supporting.

Esterhazy. Mozart, in the middle of the Classical period, began his career in the court of the archbishop of Salzburg before becoming a freelance musician; however, he continued to dabble with court work for the emperor of Austria. Beethoven, who lived at the end of the Classical period, tried a brief court appointment but quickly left to have a successful career as a freelance composer.

As the influence and fortunes of the aristocracy declined, so did their supremacy as patrons of the arts. Composers quickly realized that they must either find new audiences or find new careers. Musical events, previously limited to the aristocracy and the guests that they invited to their private performances, soon began to derive funding from another source: ticket sales. Near the end of the Classical period, as one group of patrons, the aristocracy, began to disappear, a new group, the ticket-buying public, began to become the patrons of the arts. To avoid becoming marginalized, composers began to adapt their work to address the tastes and educational levels of this new group. Successful composers wrote music that was popular enough to generate substantial ticket sales.

Often, composers would participate in the revenue of ticket sales through agreements that provided a percentage of the money that was generated. At other times, composers would write pieces of music for specific clients. This work-for-hire approach was different from the previous patronage approach because composers were paid for only a single commission and not provided with ongoing sustenance and livelihood. The work-for-hire approach was similar, however, to the Baroque period's written-on-demand system in which someone other than the composer determined the style, topic, and genre of the piece of music to be written. Another revenue stream that began to become available to Classical period composers was sale of music to publishers. Some composers sold their works outright, realizing a one-time income from the piece. Others were fortunate enough to demand a royalty or percentage of the proceeds from the sale of their music. One of the most famous published composers of the Classical period was Haydn.

CLASSICAL PERIOD MUSIC

As a result of the societal influences noted earlier, music of the Classical period sounded a bit different from music of previous societies and periods. Clear, simple melodies and forms are two components of Classical period music that can still be found in the music of today.

Classical Period Melodies

It is relatively easy to discern differences between Baroque and Classical melodies. If we think of a melodic phrase as being like a sentence in language, we often find a comma that separates the two parts—just like in this sentence. While melodies of both the Baroque and Classical periods tend to be written in a two-part manner that can be compared to subject–predicate sentence structure, significant differences occur. Baroque melodies tend to be unbalanced, with short first parts and much longer second parts; Classical period melodies tend to be balanced with relatively equal first and second parts. Baroque melodies can be rather complex, especially in the second part of the melodic phrase. Classical melodies are more folklike and tend to use simple rhythms and combinations of pitches. In short, Classical period melodies are often more singable than Baroque period melodies.

Opera

While opera continued and flourished during the Classical period, the topics for the storylines changed. Abandoning the mythological subjects of Baroque opera, composers in the Classical period preferred to address more current topics. Comic opera came into being, and both serious and comic opera examined topics from everyday life. Human topics of love, strong emotion, betrayal, and other types of relationships found their way into opera. When all things Turkish came into style in Vienna, Mozart capitalized upon this by setting one of his operas in a harem. The topic of gossip and sensationalism was as fascinating to Classical period opera audiences as it is to daytime television audiences in today's society. It seems that some parts of the human experience remain with us.

© 2013 by Apriphoto. Used under license of Shutterstock, Inc.

Figure 4.05

Opera storylines, characters, and settings in the Classical period attempted to better engage everyday people.

One of the main changes in opera of the Classical period was an adjustment of plot and melody to better engage opera's new audiences. Songs that could be remembered and sung as audiences departed were highly desired. Solo singers with instrumental accompaniment continued. Just as the boys choirs associated with the Catholic Church declined, so did the development of the castrato singer. Women took on ever-larger roles in performances, and audiences moved on to find new things to capture their attention.

An example of adapting opera to its new audiences can be found in Mozart's *Don Giovanni*. The story is based upon the legendary lover Don Juan. In this telling of the story, Don Giovanni (the Italianized version of the Spanish name Don Juan) is a promiscuous ladies man who also does not understand that "No" means "No." After forcing himself on a woman, he fights and kills her father. The father's ghost comes back to get Don Giovanni

to change his ways. Don Giovanni refuses, the two argue, culminating in Don Giovanni being carried off to hell. In an early comic scene, Don Giovanni, who has a servant as his sidekick, sees a woman and begins to flirt with her. Soon realizing that she is one of his recent conquests, he becomes bored, and leaves. His servant, Leporello, steps in to stop the distraught woman from following, and attempts to talk her out of her interest in Don Giovanni by reciting a ridiculously long list of women whom Don Giovanni is supposed to have bedded. Topics like this often end up in fights on modern daytime television, and Mozart's audiences during the Classical period were just as excited, titillated, and enthralled.

Opera in the Classical period continued to be the ultimate art form, combining almost all of the arts in the way of Baroque opera. Audiences flocked to them the way we go to movies today. Mozart's music was incredible. In addition, he understood his audience and delivered entertainment in the same way that a big budget Hollywood release does today. In *Don Giovanni*, special effects, sword fights, rape, a ghost, and demons from hell that carry away the main character at the end are all part of the story. The character Don Giovanni may have been the equivalent of a modern day "player," but he met an end appropriate to the way he lived—much as in today's society.

GUIDED LISTENING 4.01

Mozart and Classical Period Opera

Classical opera moved away from stories of mythology and gods. Mozart included elements to better entertain and engage his audiences, including fanciful stories and comedy. Listen for a solo performer, recitative followed by aria, and topics that would keep audiences listening and paying to come back for more.

Music listening may be accessed from www.ourworldourmusic.com

Figure 4.06

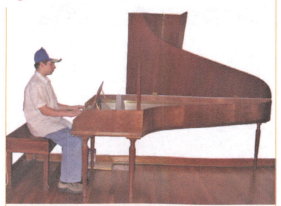

The pianoforte used a more advanced internal mechanism than the harpsichord, allowing for more expressive performance. With fewer keys and strings, the pianoforte was smaller than a modern piano.

Rise of the Piano

The parlor instrument of the Baroque period, the harpsichord, had several limitations. One was that it could only play at one dynamic level, regardless of how violently or gently the keys were struck. In addition, not only was it no t loud, but the bass sounds were extremely weak. Often the harpsichord was paired with a bass instrument and used as part of the basso continuo unit that was discussed in Chapter 3. In the Classical period, a new instrument became dominant. This new instrument was capable of playing both soft (*piano*) and loud (*forte*), based upon how the performer depressed the keys. The instrument was called the *pianoforte*, but the name was shortened over the years into today's *piano*. The Classical period piano could play more expressively than the Baroque's harpsichord due to its more responsive keyboard mechanism. Pianos of this period had about 60 keys, as opposed to today's instrument with 88 keys. Composers wrote an enormous amount of music for this instrument.

Chamber Music

As the concentration of wealth in the hands of a relatively few members of the aristocracy waned, more people found better ways to live than they had before. Better living included time and opportunities to practice hobbies. One of the hobbies that many people pursued was making music at home in small groups. Publishers responded by releasing compositions for these groups. One of the most common small groups was the string quartet. In many ways, the Classical period string quartet was like modern garage bands: the performers were all amateurs who simply enjoyed playing music, the music that was played was challenging but not overly difficult, and few of these ensembles found themselves on stages before large numbers of people. String quartets were made up of two violins, a viola, and a cello. Other chamber groups were also common and were made up of different combinations of instruments.

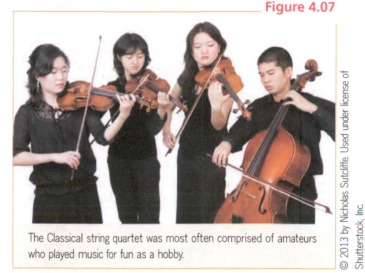

The Classical string quartet was most often comprised of amateurs who played music for fun as a hobby.

© 2013 by Nicholas Sutcliffe. Used under license of Shutterstock, Inc.

Standardization of the Orchestra

The term *orchestra* refers to a specific group of people who play music together. During the Baroque period, the makeup of an orchestra was determined by the interests, preferences, and resources of the aristocrat who funded a private court orchestra. Music written at one palace was often unplayable at another due to available instrumentation. In the Classical period, the makeup of the orchestra became standardized. The common makeup was violins, violas, cellos, and double basses; pairs of flutes, clarinets, oboes, bassoons, trumpets, and horns; and timpani. Brass instruments were limited in their use, primarily

Today's modern orchestra (pictured) is a larger decendent of the Classical period's standardized orchestra.

© 2013 by Ferenc Szelepcsenyi. Used under license of Shutterstock, Inc.

because these instruments did not yet have valves and so were not capable of playing most melodies. Music written for one Classical orchestra could easily be played by another.

MUSICAL FORMS

During the Baroque period, much of the harmonic vocabulary and structure used today was developed, along with continuing ideas such as the operatic concept of solo voice with instrumental accompaniment. The Classical period was the time of the development of many formal musical forms that are still used today. Much of today's music is based upon, or derived from, these Classical forms. While we freely alter these forms in today's music, during the Classical period, forms were somewhat rigid and were seldom altered, making them rather easy for us to follow.

Sonata Form

One of the favorite compositional forms of the Classical period was *sonata form*, also known as *sonata–allegro form*. This form was for a single song or movement of instrumental music. Vocal music did not use sonata form. A piece of music in sonata form was complete in itself. Sonata form is a ternary form, with three main parts.

The first part in sonata form is called the *exposition*. This is the section of the music in which the two melodies most important to the work are "exposed" to the listener. Exposition sections usually come to a complete ending, and pieces in sonata form usually repeat the entire exposition before continuing, just to be sure that the listener remembers the main melodies.

The second section in sonata form is called the *development*. This is the playful part of a composition in which the composer draws upon the main melodies, twisting, turning, and weaving them into something quite different from their original forms. This is also the section in which the composer creates the most tension.

Resolution of this tension occurs in the third section, the *recapitulation*, in which the original melodies are restated. (Our modern word *recap*, meaning "to summarize," comes from the word *recapitulation*.) In sonata form, the recapitulation brings the listener full circle to the music that started the piece.

After the recapitulation has concluded, an ending, called a *coda*, is added. This ending is the basis of our modern popular song tag-out ending. The coda often contains a snippet of material from earlier in the piece, just as the tag-out usually takes a snippet of the song and creates an ending from it.

GUIDED LISTENING 4.03

Sonata Form

One of the new instrumental structures of the Classical Period was Sonata Form, primarily an ABA form with a tagged on ending call a coda. The A section exposed the listener to the melodies and then was repeated to assure melodies were remembered. The B section played around with the melodies and developed them, and then the A section recapped and reminded the listener of the melodies. The coda provided an ending for the piece, similar to today's song endings. Listen for sonata form in this music.

Music listening may be accessed from www.ourworldourmusic.com

Rondo Form

The second most commonly used form during the Classical period was *rondo form*. Like sonata form, rondo form was used only in instrumental music. Vocal music in the Classical period did not use rondo form. Rondo form was a format for creating a piece of music based upon both contrast and repetition.

Rondo form had two common varieties, the large rondo and the small rondo. The large rondo used a structure of A B A C A B A. Notice that a ternary A B A format is balanced on each side of a contrasting C section. This structure offered an A section with multiple repeats, a contrasting B section that repeats, and a quite different C section. The small rondo used a simplified A B A C A structure. (Notice the removal of the final B and A sections.)

A slight variation in rondo form evolved during the Classical period. A hybrid form, called *sonata–rondo form*, came into common use. This form combined characteristics from both of these forms. Strict rondo form called for new, contrasting material to be created for each of the A, B, and C sections. Sonata–rondo replaces the new material in the C section with a development section like the one found in sonata form.

Rondo form eventually evolved into the modern popular song format. The A and B sections became the verse and chorus sections of the song, and the contrasting C section came to be called the bridge. Sometimes the bridge is made up of new material, like strict rondo form, and sometimes it contains an instrumental solo based upon some melody that was heard earlier in the piece, as in sonata–rondo form. While rondo form was initially intended for use only with Classical period instrumental music, modern popular music combines instruments and voices and fits them into variations of this form.

GUIDED LISTENING 4.04

Rondo Form

Rondo, an instrumental form, balances repeated sections around a central, contrasting section: ABACABA. An ABA on each side of a contrasting C section is common rondo. Sometimes rondo is shortened by leaving off the final BA sections. Modern song form is a derivitive of rondo form. Listen for rondo form in this music.

Music listening may be accessed from www.ourworldourmusic.com

Minuet and Trio Form

For whatever reason, humans seem to love things that occur in threes. Religions often have deities in groups of threes: Father, Son, and Holy Ghost in Christianity; Vishnu, Brahma, and Shiva in Hinduism, the world's third largest religion. We often think of things as having a beginning, middle, and end. Sonata form has three main parts. Rondo form also has three contrasting parts. *Minuet and trio form* is a ternary form in which each of the three parts is also ternary. We can represent the three main parts as A B A and the interior subparts as follows: a b a, c d c, and a b a. While sonata and rondo forms were commonly used in many ways during the Classical period, minuet and trio, a dancelike form, was almost completely limited to use in the third movement

Figure 4.09

Minuet and Trio Form		
Minuet	= A =	aba
Trio	= B =	cdc
Minuet	= A =	aba

Outline of minuet and trio form.

of a four-movement instrumental work. Sometimes, a faster dancelike form called a *scherzo* was used in the late Classical period.

GUIDED LISTENING 4.05

Minuet and Trio Form

Minuet and Trio, a form based upon popular dances of the Classical Period, is a ternary form. Each section is also ternary. It's a three-within-three form with a specific performance practice regarding how the sections are repeated. Listen for the form in this musical example.

Music listening may be accessed from www.ourworldourmusic.com

Theme and Variations Form

While every other musical form from the Classical period uses sections that offer either repetition or contrast to create and maintain interest, *theme and variations form* uses both of these devices within a single section. This instrumental form has only one section, often containing two brief melodies. Each time the section is played, however, something about it is changed. Sometimes the rhythm can change, sometimes it can be the harmony, sometimes the texture can change, and sometimes multiple components can be altered. The form can be represented as A A′ A″ A‴ A⁗, etc. Each iteration of the section is usually about the same length.

Classical period theme and variation form evolved and became the basic form upon which almost all jazz is based. In jazz, a melody is usually presented in its entirety, whether vocally or instrumentally. What then follows is a performance of the underlying structure of the melody with an alteration of the melody above. Often the alteration to the melody is improvised, or created on the spot while it is being played. The melody can become so altered during improvisation that it almost becomes a different melody. This is especially true when multiple players take turns improvising within the same song. The glue that holds the song together, however, is the original melody's underlying structure and harmony.

GUIDED LISTENING 4.06

Theme and Variations Form

Theme and variations form has one primary section that is simply repeated again and again, with something being different in each repeat. In the Classical Period, the primary section usually had two subsections. Theme and variations is a cornerstone of jazz, with improvisations during each repeat. In jazz, there are usually two subsections, but organized differently. Listen for the form in this music.

Music listening may be accessed from www.ourworldourmusic.com

Symphony

As noted earlier in this chapter, an orchestra is a group of musicians. A *symphony* is a large work of music. A *symphony orchestra* is a group of musicians that plays symphonies. As might be expected from any musical form arising during the Classical period, the symphony is a specific organization of sounds into music. Classical symphonies have four movements, organized in a distinct pattern. The first movement is fast, usually using sonata form. The second movement contrasts and is slow, often in sonata, rondo, or theme and variations form. The third movement is dance related, usually in minuet and trio form, and the fourth movement is again fast to make for a big finish. It usually uses sonata or rondo form.

Figure 4.10

Structure of the Classical Symphony

1st movement—Fast
 Common forms: Sonata, Rondo
2nd movement—Slow
 Common forms: Sonata, Rondo, Theme and Variations
3rd movement—Dancelike
 Common forms: Minuet and Trio, Scherzo
4th movement—Fast
 Common forms: Sonata, Rondo

Structure of the Classical symphony.

GUIDED LISTENING 4.07

The Symphony

A Classical symphony is a large scale instrumental work made up of multiple movements, usually four. These movements make use of the forms we have studied. Symphony movements are usually arranged in an order of fast, then slow, then dance-like, and finally fast. Listen for form in this musical example.

Music listening may be accessed from www.ourworldourmusic.com

Classical Concerto

Virtuosity was recognized during the Classical period in much the same way as during the Baroque period. The Classical *concerto* was an instrumental form that provided that opportunity. Unlike the Baroque concerto that usually featured a small group of instruments, the Classical concerto was a show-off piece for a single player. These pieces contrasted the power and variety of timbre within the orchestra with the virtuoso abilities of the soloist. Composers wrote for various instrumental features. At the court where Haydn worked, he would often welcome a new musician by composing a concerto to feature this performer, regardless of the instrument the newcomer played.

The form of the Classical concerto was as highly structured as other forms of the Classical period. The concerto was similar to the symphony in many ways but had only three movements; the dancelike movement was dropped. The order of

Figure 4.11

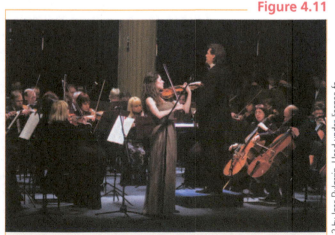

A soloist performs a violin concerto with an orchestra.

the remaining movements was fast, slow, fast. During the fast first and third movements, it was quite common for the composer to notate a place near the end of the movement when the orchestra would stop and the featured performer would play an unaccompanied solo called a *cadenza*. These solos were usually not notated, and players were expected to improvise their solos.

Another difference between the concerto and the symphony can be found in the approach to the exposition section within sonata form. In the symphony, when the orchestra reached the end of the exposition, the players simply repeated it. The concerto was written with a double exposition that did not use direct repeats. The orchestra usually began and played through to the end of the exposition. The second time that the exposition was heard, it would be played by the soloist, providing a bit of contrast within what would have been a repeated section.

GIANTS OF THE CLASSICAL PERIOD

Three composers stand out as giants during the Classical period. They were of different generations, and all knew one another and one another's music. All came to live in Vienna, the musical center of the Western world during that time. Despite these similarities, they led very different lives. The changes in society during the Classical period can be marked not only in the music of these men but also in the lives that they led.

Franz Josef Haydn

The father of the Classical period was Franz Josef Haydn (1732–1809). Living a long life, he was active for most of the period, leaving his mark on almost all music of the time. Born the son of a wheelwright, the equivalent of a modern mechanic, Haydn came from a working class background. Since women were not allowed to sing in church at that time, young boys were trained to sing the high parts. Haydn sang in his local church and displayed such a fine singing voice that he was offered the opportunity to attend a prestigious boarding school in exchange for singing in their choir, what we know now as the Vienna Boys Choir. He was forced to leave school when his voice changed, and he made his way playing music around Vienna while he studied music wherever possible. He was known to play at three different church services on Sunday mornings, hastening between churches to make most of his living. He eventually went to work for the Esterhazy family, an aristocratic family known for their ostentatious lifestyle and support of the arts. Haydn's terms of employment indicate that he was considered to be a skilled servant, nothing more.

The refinement of the printed music process during Haydn's lifetime, coupled with his employment with a family known for appreciation of the arts, led to a lucrative relationship with a publisher, resulting in Haydn being one of the best-known musicians in Europe but also being unable to leave his position to go on tour. During most of Haydn's lifetime, the aristocrats were so powerful that a person could not leave a job without their permission. After thirty years, upon the death of Nicholas Esterhazy, Haydn was released from service and immediately moved to Vienna, where he became friends with a young composer, Wolfgang Amadeus Mozart. When Haydn was approached to do a concert tour of Europe and London, he tried to talk Mozart into joining him. Mozart declined. On the night before leaving, as Haydn and Mozart had a drink to say their farewells, Mozart stopped and

asked Haydn not to go, saying that he would never see him again. Haydn scoffed at the remark, replying that he was old, but not that old. It turned out that the remark was prophetic, because Mozart was dead in less than a year.

During a tour, Haydn was approached by a teenager who showed him some music that he had written. The young man asked to come to Vienna to study with Haydn. Haydn replied that the young man should meet him there at the conclusion of Haydn's tour. When Haydn returned to his home in Vienna, his new student, Ludwig van Beethoven, was waiting for him.

Haydn is credited with developing most forms in use during the Classical period. His music represents that transition from the Baroque period. Much of his early music continued to use basso continuo as the foundation of his orchestra, in the same manner as in the Baroque period. Haydn played a role in helping to determine the makeup of the orchestra. He also became the example of how to compose music in the new style. Creative, playful, loved by his musicians, and unfortunately badly married to a woman whom few could love, Haydn was both a giant and a normal person—one who changed music in ways still felt today.

GUIDED LISTENING 4.08

Franz Josef Haydn and The Classical Concerto

A Classical concerto was a show-off piece for an individual instrumental performer and a larger group, usually an orchestra. The organization was much like that of a symphony and used the forms discussed previously, however the symphony's third, dance-like movement was not included. The result was a three movement work, organized as fast-slow-fast. Listen for alternating sections of soloist and orchestra and for form.

Music listening may be accessed from www.ourworldourmusic.com

Wolfgang Amadeus Mozart

The son of a professional violinist who worked in the court of the archbishop of Salzburg, Wolfgang Amadeus Mozart (1756–1791) possessed a once-in-a-century mind. He blossomed early, quickly learning to play the keyboard by listening to his older sister's lessons. By the age of six he could play piano and had learned violin from his father. At that same age, he made his first concert tour as a child prodigy. He spent most of the next decade on various tours and had the opportunity to hear and experience music of several areas. At the age of fifteen, he received an appointment to the archbishop's orchestra. Unfortunately, since Mozart's father was also employed in that orchestra, and since the archbishop felt that he did not need to pay two Mozarts who lived in the same household, Wolfgang's appointment was without pay.

Mozart tried to escape the archbishop but was not allowed to leave. During one of the archbishop's trips to Vienna, Mozart had an opportunity for his music to catch the ear of an even more powerful man, the emperor of Austria. The emperor asked Mozart to come to Vienna, and Mozart escaped Salzburg.

Mozart was immediately successful in Vienna. His music was extremely well received, and he had a supporter in the emperor. Unfortunately, the people of Vienna were fickle

and had short attention spans. Mozart's music did not remain as popular as it was initially. In addition, Mozart began a downward spiral, possibly related to overwork, disease, and/or drugs and alcohol that helped to bring about his death at the age of thirty-five..

He composed constantly, writing music as if he heard it already completed in his head. His skills were such that he could hear a piece of music only once and then play or write it entirely from memory. His somewhat abrasive personality made it difficult for him to maintain students, so often his only income was from writing and performing. Composing on his death-bed, he left a setting of the Requiem, a funeral mass, unfinished. His wife Constanze had Mozart's student complete it so that performances could help to bring in money to support the family. Accounts vary concerning Mozart's death, some stating that it was due to a lingering illness or other physical cause. Other accounts relate a quickly advancing disease, possibly even brought on by tainted food. Most agree, however, that Mozart was buried in the rain somewhere outside of Vienna in a commoner's, possibly pauper's mass, grave. We are not quite sure where.

Mozart changed opera through his ability to bring strong and shifting emotional content to his works. He developed new techniques for using woodwinds that capitalized upon the individual strengths of the instruments. In his short lifetime, he completed masterpieces in every Classical period musical form.

GUIDED LISTENING 4.09

Music of Wolfgang Amadeus Mozart

In his short life, Mozart wrote masterpieces in every form of Classical Period music. He not only brought new ideas to opera, as previously discussed, but also to approaches to composing instrumental music. He used instruments in new, intuitive ways, helped to clarify musical forms, and created melodies that are still heard today. Listen for familiar melodies and for form.

Music listening may be accessed from www.ourworldourmusic.com

Ludwig van Beethoven

Working at the end of and beyond the Classical period, Ludwig van Beethoven (1770–1827) wrote music that served as the high point of the Classical period and as the bridge to the next period. The son of a professional singer, Beethoven grew up in an abusive household. His father, an alcoholic, would often come home and beat the family members. Music became Ludwig's escape, initially not because of a great love of the art form but because his father, who wanted Ludwig to tour and make a lot of money for him just like Wolfgang Amadeus Mozart had done for his father, would leave him alone as long as Ludwig was sitting at the piano practicing. Hours of practice led to the development of skills that were supported by talent. When he made his first concert appearance, his father advertised him as being even younger, leading to years of confusion about his real age.

As a teenager, Beethoven played for Wolfgang Amadeus Mozart, who remarked, "Keep your eye on this young man. He's going to make a big noise in the music world, someday." Beethoven later played for Haydn, who invited him to come to Vienna to study. Beethoven's brooding, aggressive personality did not blend well with Haydn's playful, easygoing nature. Beethoven would not listen to Haydn's remarks, and the lessons soon ceased. Later, when

Beethoven had his first publishing opportunity, the publisher wanted to note on the music "Beethoven, a student of Haydn" in an effort to sell more copies. Beethoven refused, stating that Haydn had nothing to teach him.

Beethoven saw the decline of the aristocracy, the rise of democracy, Napoleon's bombardment of Vienna, and many changes in society. He wrote his third symphony and initially dedicated it to Napoleon. When he and many became disillusioned with Napoleon, he scratched out the dedication from the conductor's score of the music.

Beethoven wrote musical masterpieces in almost every Classical period form. His only attempt at opera, however, was unsuccessful, prompting him to never again attempt opera. His symphonies called for ever-larger orchestras and the addition of more wind instruments.

In his late twenties, Beethoven began to lose his hearing. Before long, he was completely deaf. His later works were possibly written for larger orchestras and more woodwinds and brass to help compensate for his disease. He wrote much of his music from what he only heard within his head. Despite this, he was financially successful and lived a life independent of control by aristocrats and court. He loved several women but never married. He left behind writing speaking of his "Immortal Beloved," but no one knows who she was. He died in Vienna during a thunderstorm, and a crowd of 10,000–30,000 people attended his funeral.

Beethoven's music built upon the advances made by Haydn and Mozart. His additions to Classical style included enhancing the emotional content and exploring the boundaries of harmonic understanding. Beethoven became the role model for musicians of the nineteenth century. His final symphony, one written by a musician who had gone deaf, was a celebration of the joys of life.

GUIDED LISTENING 4.10

Music of Ludwig van Beethoven

As the third of the three giants of the Classical Period, Beethoven was able to build upon the advances of Haydn and Mozart. He represents the highest point of music in this period and also provides a preview of the extreme emotionalism that will rule the next period in music. His music continues to move us today, two hundred years after it was written. Listen for familiar melodies, emotional approach, and for form.

Music listening may be accessed from www.ourworldourmusic.com

For learning activities, practice quizzes, and other materials,
visit: www.ourworldourmusic.com

Name: _____

1. What is the time period of the Classical period?

2. What was the major contributing factor that changed society during the Classical period?

3. What factor contributed to the decline of the aristocracy at this time?

4. Describe the Age of Enlightenment and its influence on this time period.

5. Why was Napoleon Bonaparte deposed?

6. How does the Age of Enlightenment affect how we live today in America?

7. What deadly invention was first built by a harpsichord maker?

8. During the Classical period, elaborate and ostentatious displays of artwork gave way to art with the main characteristics of _____ and _____ .

9. Musical activity began to shift from the _____ in the Classical period.

10. Name the three leading composers of the Classical period in the order of their appearance.

11. Since the aristocracy lost their influence and fortunes, composers needed to find new audiences or patrons. How did composers derive income during the Classical period?

12. Name and discuss at least two components of Classical period music that can still be found in the music of today.

Name: _____

1. Describe the differences between Baroque and Classical melodies.

2. How did opera change in the Classical period?

3. Who wrote the opera *Don Giovanni?* Describe the story.

4. Which new instrument became dominant in the Classical period? Why?

5. Pianos of the Classical period had about _____ keys. Today's pianos have _____ keys.

6. Which instruments made up a string quartet?

7. The term _orchestra_ refers to _____

8. The common instrumental makeup of an orchestra in the Classical period was

Name: _____

The Classical period was the time of the development of many formal musical forms that we use today. Describe and discuss each of the following musical forms:

1. Sonata form

2. Rondo form

3. Minuet and Trio form

4. Theme and variations form

5. Symphony

6. Classical concerto

4.4 Worksheet

Name: _____

1. Name the three giants of the Classical period.

2. The three giants of the Classical period knew one another. Explain their relationship to one another.

3. Why is Franz Josef Haydn called the Father of the Classical Period?

4. Wolfgang Amadeus Mozart was a child prodigy. How old was Mozart when he made his first concert tour?

5. How was Mozart able to escape to Vienna?

6. Although Mozart was still composing on his deathbed, he died at a relatively young age. How old was he when he died, and what contributed to his early death?

7. Ludwig van Beethoven also began playing and writing music at an early age. Music was his escape from

8. Beethoven was a student of _____ for a time.

9. What is one remarkable fact about Beethoven?

Exploring Emotion, Imagination, and the Inner Self

ROMANTIC PERIOD

In Western music, the Romantic period, 1820–1900, followed the Classical period. Both of these periods were quite short when compared to the periods that preceded them. Western society underwent significant changes during the Romantic period, precipitated partly by the decline of the aristocracy during the Classical period. Music, reflecting the society of the Romantic period, also changed. Unfortunately, we do not have the same historical record of development for non-Western music as for Western music for two reasons: (1) As noted in a previous chapter, music notation did not develop in most non-Western cultures, and (2) recorded music was primarily a phenomenon of the twentieth century.

Romantic Period Society

Perhaps the most significant event to affect Western Romantic period society was the Industrial Revolution. This event was driven primarily by first one and then another new power-source technology: the steam engine and then the electric motor. Animals and waterwheels were no longer required to provide mechanical power. These new power sources, both fueled primarily by the burning of coal, resulted in the rise of manufacturing and the development of factories—along with the beginning of modern pollution issues. Employment opportunities in factories led to many people abandoning agricultural-based livelihoods and crowding together to live near their new employers. For the first time in American history, a shift began that would eventually result in more people living in cities than in the country, and these new wage-earning workers became a new group in society: the working middle class. Romantic period society resembles modern society more closely than any other society that came before, primarily because of the rise of the middle class. Unfortunately, then as now, most members of the working middle class struggled to earn a living. Working conditions were far more harsh than today, and the living conditions that wages allowed were often limited at best.

Significant Events

Many societal, governmental, and scientific events occurred during the Romantic period. Throughout most of the Romantic period, the banding together of several city-states finally led to the creation of the country of Italy and the unification of its citizens. In America, however, two groups of people suffered.

Figure 5.01

Smokestacks polluting Pittsburgh.

© Bettmann/Corbis

In 1830, President Andrew Jackson authorized the removal of Native Americans from their homelands in the American Southeast and their movement to what is now the state of Oklahoma. This forced removal came to be known as the Trail of Tears, in which five American Indian nations were gathered and forced to walk from the green lands that they knew to the desert lands of the south-central United States. One nation, the Cherokee, left with fifteen thousand members. Of those, four thousand died during the forced march.

Figure 5.02

The American Civil War claimed more American lives than any war before or since and changed the nation's outlook from "these United States" as a group of separate, equal State partners to "the United States" as a single entity.

Figure 5.03

The steam locomotive and railroads greatly increased the speed of travel, of transporting goods and people, and contributed to increasing the pace of our world.

Another group also suffered in the Romantic period. Although the importation of slaves from Africa to America had been outlawed in the early nineteenth century, slavery had not. Those who already lived in slavery in American continued to do so. Northern industrial society demanded an end to the practice. Southern agricultural society refused. When no solution could be found to satisfy both groups, the bloodiest war in American history was fought; more Americans died in the American Civil War (1861–1865) than in any other war before or since. Northern dominance in the struggle finally ended the practice of slavery in America.

Settlers had been trickling into the American West for years. At the conclusion of the Civil War, freed slaves looking for opportunities left the South, moving to the industrialized North and the open spaces of the American West. Technological advances that made the steam engine portable resulted in it being placed on wheels and the wheels being placed on heavy metal bars capable of supporting tremendous weight. The steam locomotive and the railroad were born, opening easy inland transportation of people and trade goods. When transcontinental rails finally connected from the Atlantic Ocean to the Pacific Ocean in 1869, the American West was fully opened for settlement. One of the trade goods often shipped via railroad was cattle for processing into food. These cattle, raised in the wide open ranges of the West, could be quickly transported to slaughterhouses, and the product could be just as quickly delivered to market almost anywhere in the country. Raising these animals in the West were cowboys, many of whom were freed slaves and other people of color.

Trade throughout the world continued to grow, fueling cycles of economic growth and economic bust throughout the period. Scientific advances, leading to technological applications, helped to drive much of this growth.

In 1859, Charles Darwin published *On the Origin of Species*, in which he theorized that living things evolve over time through the process of natural selection, or survival of those

best equipped for the given environment. He also theorized that by considering the development of living things in a branching arrangement, it was possible to trace living things with common characteristics backward to common ancestors. This theory became the foundation of modern evolutionary biology.

Other important and more immediately applicable advances resulted in instantaneous long-distance communication through first the telegraph and later the invention of the telephone. Important to music was Thomas Edison's 1877 invention of the phonograph, the first machine capable of recording and playing back sound.

Arts in Romantic Period Society

The fantasy world within the mind intrigued Romantic period society. The dark and grotesque, the fantastic and supernatural, and the stuff of everyday life were all common topics and settings for Romantic period literature. Victor Hugo's *The Hunchback of Notre Dame* (1831), Edgar Allan Poe's *The Raven* (1845), and Bram Stoker's *Dracula* (1897) all qualify as entrants into a new genre of literature, still with us today, called horror. Also to be included should be Mary Shelley's *Frankenstein* (1818), although it technically misses the cutoff date by two years. Other fantasy-based literature of this period includes Charles Dickens's *A Christmas Carol* (1843) and the early science fiction work of Jules Verne, such as *A Journey to the Center of the Earth* (1864) and *Twenty Thousand Leagues Under the Sea* (1869). Lighter topics and settings may be found in works such as Alexander Dumas's *The Three Musketeers* (1844) and Mark Twain's *The Adventures of Huckleberry Finn* (1884). Interestingly, all of these Romantic period stories are still common in modern culture, and all have repeatedly been made into motion pictures, paying tribute to the quality and staying power of the tales.

The visual arts of the Romantic period reflected society's concept of nature as a reflection of the human soul. The beauty and peace within the person were seen reflected in the world. Conflict and passion were also reflected. Visual artists often used nature's settings to convey emotional content within their work, as in Figure 5.04. Also common in the visual art of the Romantic period is the depiction of introspection. Art and literature were not the only disciplines to turn inward during the Romantic period; the new areas of behavioral sciences and psychology saw the launching of the early work of Sigmund Freud, perhaps the most famous early pioneer in the field of psychotherapy.

Figure 5.04

The Slave Ship by Joseph Mallord William Turner.

© Burstein Collection/Corbis

Music in Romantic Period Society

A key concept that must be kept in mind throughout study of the material presented in this book is that the music under discussion was the popular music of its time. *Popular* may mean "most often heard," as was the case for Gregorian chant being almost the only music heard by the majority of people during most of the Middle Ages. *Popular* may mean "new secular music," as in the secular instrumental music that exploded during the Baroque period.

Popular may also be interpreted to mean "music that most people pay to hear." This last definition is certainly the case for music from the Romantic period through today. Since no means of recording music existed for most of the Romantic period, and no widespread availability to recorded music occurred until the next century, most music was heard live. People bought tickets to hear music. The more popular the music, the more tickets sold.

Composers and Their Audiences

With the demise of the patronage system due to the aristocracy's decline of resources and power during the previous period, and with the development of ticket-buying audiences from nonaristocratic classes, a major shift in composer–audience relations occurred during the Romantic period—a change still with us today. For the first time in history, composers and their audiences came from the same socioeconomic class; no longer were the creators of music considered to be simply skilled servants who worked in the palaces of their betters. Since composers and audiences shared a common cultural awareness, the music that was created resonated more fully with the society in which it existed. In today's music, artists who share a common background with their audiences are able to connect more fully, and their music resonates within that audience in ways that were not possible before the Romantic period.

During the Romantic period, the concept of the "starving artist" arose. This persona included the idea that truly gifted artists were poorly understood by society around them, were often unsuccessful economically, and suffered for their art. The idea came to include the belief that without this suffering true art could not be produced. In music, this persona was modeled upon Ludwig van Beethoven, an icon to Romantic period composers, who saw in Beethoven the true rebel who did what he wanted, said what he wanted, and wrote what he wanted, all while creating great art.

Fascination with Virtuosity

A trait that Romantic period audiences shared with modern audiences was their almost over-the-top appreciation for those individuals who could do something extremely well. Nowhere was this more evident than in Romantic period audiences' admiration for instrumentalists who were extraordinary musical performers. The first true pop stars may be found in the Romantic period.

City versus Country Living

The societal shift from agricultural to industrial economies and the physical movement of people from the farm to the city in search of employment in factories affected many parts of life. Many people no longer worked from dawn to dusk in maintaining small land holdings. Factories, and the new concept of working a "shift," provided the new working middle class with time and opportunities

Figure 5.05

Romantic period audiences' facination with standout performers led to an increase in solo performances along with soloists (not groups) who toured to perform.

for leisure activities that had previously been the purview of aristocrats. The geographic concentration of a lot of people, each with a little bit of wealth, provided opportunities for musicians and other artists to reach larger audiences. Greater access to arts and music was an aesthetic advantage for all involved.

Instrument Manufacture

Factories developed that could more quickly and less expensively manufacture almost anything. Musical instruments, previously made by hand by trained craftsmen, began to be manufactured in factories. Cost of ownership declined, and opportunity for ownership increased. Working-class families, who wanted their children to have the same educational opportunities previously enjoyed by aristocrats, included music lessons in their children's experiences. Manufactured musical instruments found their way into many homes, and the number of amateur musicians increased dramatically.

Conductor as Artist

Not until late in the Classical period was it common to find people conducting ensembles who were not also playing in the group. During the Romantic period, the conductor became more common, and many not only kept the musicians or performers together but also began to interpret the written music. Conductors of this type were, for the first time, regarded as artists in their own right, and the field of conducting came to be regarded as an artistic undertaking.

Music Center

During the Baroque period, Florence in particular and Italy in general came to be regarded as the musical capital of the Western world. During the Classical period, the Western musical center shifted to Vienna. The Romantic period saw yet another shift. Europe stayed at the forefront of Western musical development as Paris came to be regarded as the Western world's musical capital, drawing many of the greatest musicians of the period to that city.

Music in America

While Europe was engaged in the musical advances that defined the Romantic period, America was focused upon the far more basic issue of creating a place in which to live. John Adams, America's second president, once said that he studied politics and war so that his

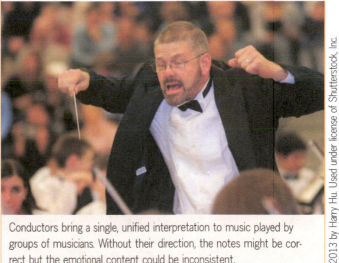

Figure 5.06

A man inspecting a row of frames and installing bracing at the Steinway & Sons piano factory in New York. Their piano manufacturing process is still done much as it was during the Romantic period.

Photo courtesy of Steinway & Sons / Photographer: Chris Payne

Figure 5.07

Conductors bring a single, unified interpretation to music played by groups of musicians. Without their direction, the notes might be correct but the emotional content could be inconsistent.

© 2013 by Harry Hu. Used under license of Shutterstock, Inc.

Figure 5.08

America's westward expansion was driven by the opportunity for free land, escape from the Civil War, and the gold that had been found in California and the Black Hills of what would become South Dakota and Wyoming.

children could study math, geography, and history, so that their children might study visual, literary, and musical arts. America's continuing westward expansion, its disagreements between its North and South, and its devastating but decisive war in the 1860s left little time or energy to participate in the artistic activities of Europe. Despite these nation-building activities, two significant musical events took place in America during the Romantic period and both reflected nineteenth-century American culture.

Stephen Foster

Perhaps the most well-known and widely published composer in America during the 1800s was Stephen Foster (1826–1864). He wrote lighter music that was popular throughout the period and served as the music of the California Gold Rush (1848–1849). His works include *Camptown Races, My Old Kentucky Home, Oh! Suzannah, Old Folks at Home (Way Down Upon the Swanee River), I Dream of Jeannie with the Light Brown Hair,* and *Beautiful Dreamer.* Although his music was extremely popular, American copyright laws were weak at the time; unfortunately, he often received no money when his music was published.

GUIDED LISTENING 5.01

Music of Stephen Foster

Composer of many popular songs during the 1800s, Stephen Foster saw very little reward for his work due to weak copyright laws. There was no recorded music so there was no payment for selling recordings. Music was distributed in print form. At one point, 25 publishers listed themselves as copyright holders for his music and none were obligated to pay royalties to Foster for the money made from publishing and distributing his music.

Music listening may be accessed from www.ourworldourmusic.com

The Spiritual

The other significant American musical event of this period was the development and preservation of the Negro Spiritual, also known as the Spiritual. This art form is unique to America and was created by African-American slaves. The spiritual did not develop in other places where slaves had been imported from Africa. The art form combines elements of African heritage with European music and religion. Favorite topics included Moses leading the Jews from bondage and Jesus returning to rescue his believers. The text of these songs spoke as much about religion as it did about liberation, and it has been argued that instructions for escaped slaves may have been hidden in the lyrics. Spirituals, sometimes called Jubilees, entered the musical literature as an art form after some were gathered, written down, and sent to Fisk University, where they were arranged for choir and first presented in concert. This choir came to be called the Fisk Jubilee Singers.

GUIDED LISTENING 5.02

The Spiritual

Created by slaves during a dark period in American history, Spirituals were often used as work songs to help the day pass more quickly. These sacred songs often made references to rivers and railroads, common metaphors of barriers and passages to heaven or to a better place. Sometimes these songs carried instructions to aid in escaping such as "Follow the Drinking Gourd" (the Little Dipper constellation near the North Star) or "Wade in the Water" (to confuse dogs used in tracking them).
Music listening may be accessed from www.ourworldourmusic.com

ROMANTIC PERIOD MUSIC

While America remained a musical backwater throughout the nineteenth century, musical advances in Europe continued and firmly defined the Romantic period. The number of significant composers was much larger than in any previous period. These composers tended to follow different paths and to create music that was different from that of their peers. The performance media resources that they required varied greatly, too. Some composers focused primarily upon solo piano work; others worked upon the short, two-person art song; and others wrote for gigantic productions that required incredible resources. Most composers, however, continued to use, build upon, and individually modify the harmonic vocabulary that had been established in the Baroque period and the musical forms that had been worked out in the Classical period.

Expressive Topics and Approaches

The primary goals of most Romantic period composers were increasing emotional content and infusing it into the harmonic concepts from the Baroque period and structural forms of the Classical period. To accomplish this increase in passion and emotional content, composers and performers tried many things. One approach extended the range of notes commonly used on an instrument. One example is that additional keys were added to each end of the piano keyboard, resulting in the 88-note keyboard that is still used today. Another approach was to carefully notate exactly what the composer expected from the performer.

Frederic Chopin

Frederic Chopin (1810–1849) was a somewhat shy man who wrote mostly piano music and preferred not to play in large concerts. He was born and educated in Poland and moved to Paris at age 21. He had a famous love affair with the author Aurore Dudevant, who wrote and published under a male pen name, George Sand. Unfortunately, Chopin struggled with poor health all of his short life. His music, however, displayed no weakness. In an effort to specify how his music should sound in performance, he was the first to notate instructions to the performer about when to depress and release the foot pedal on the piano. The result is a performance, even today, that more closely resembles the expectations of the composer.

GUIDED LISTENING 5.03

Music of Frederic Chopin

The piano reached maturity during the Romantic Period. Frederic Chopin wrote music that took artistic advantage of the evolved mechanism. To aid in communicating his musical performance intentions to players, he began to notate instructions about when to press and release pedals while playing.

Music listening may be accessed from www.ourworldourmusic.com

Emotional Content

In addition to employing musical devices such as expansion of harmonies and pitch ranges, composers greatly increased the range of dynamics in their works. Dynamic indications such as *pppp* and *ffff* came into use. Beyond musical devices, some composers reached into the growing trend of patriotism and applied it to their music.

Nationalism

Composers in the Romantic period sometimes used music to celebrate national identity. This patriotic approach sometimes involved using folk melodies within their compositions. At other times, a work's title or text could convey the emotional and patriotic linkage. Music celebrating a nation's heritage or identity was composed and performed in the Romantic period as it still is today.

GUIDED LISTENING 5.04

Nationalism

When the aristocracy declined in the Classical Period and people began to select their own rulers, pride of ownership in a country--patriotism--grew. Composers celebrated national identity in their music in a movement called nationalism.

Music listening may be accessed from www.ourworldourmusic.com

Exoticism

Sometimes, composers attempted to evoke the idea of other lands in their music. This was an idea that Wolfgang Amadeus Mozart had used in the Classical period when he employed additional percussion and wind instruments to imitate a Turkish band in his opera *Abduction from the Seraglio*. Romantic period composers also used this device to draw emotional connections from their listeners. Composers setting music in their own land were practicing *nationalism*. Setting music in other lands was *exoticism*. Both approaches were common in the Romantic period, and both approaches are still used today.

Art Song

One of the miniature types of music to come from the Romantic period requires only a solo voice and a solo piano. This form, called the *art song*, used the enormous catalog of new poetry being published. The art song differed from the music for solo voice and accompaniment that had preceded it. One difference was that, in this new form, the voice and the piano were equals, with neither in an accompanying role. Another difference was that this new form had no room for embellishment or other show-off vocal performances. Composers intended for singers and pianists to perform exactly what was written. Usually, art songs had a short section at the beginning during which the piano established the mood of the piece and another short section at the end when the piano brought the piece to conclusion. Art songs were short, usually around three minutes, and had meaningful words. In many ways, they lay the foundation for the modern popular song. Composition could be in *strophic form*, using the same music under words that change for each verse, or they could be written in *through-composed form*, in which new music is written for each verse to better enhance the text. Groups of art songs that were linked by text or some other device were called *song cycles*.

Figure 5.09

Art songs, usually written for one singer and a pianist, presented a dialog between the two rather than a leader and accompanist. Modern jazz and pop songs find some roots in Romantic period art songs.

© 2013 by bikeriderlondon. Used under license of Shutterstock, Inc.

Franz Schubert

An Austrian composer, Franz Schubert (1797–1828) had such a short life that he barely had time to grow up, become productive, and work in the Romantic period. Fortunately, he was such a gifted and creative young man that he outproduced many who lived more than twice his years. Born into a musical family, although not to professional musicians, his musical training began at a young age and produced early results; before he reached his twentieth birthday, he had written hundreds of pieces of music. Before his death from complications of the disease syphilis, he had written six hundred art songs and nine symphonies, along with operas, chamber music, works for solo piano, and sacred music, including a setting of the Mass.

GUIDED LISTENING 5.06

Franz Schubert and the Art Song

The art song is a precursor of the modern pop song. It is poetry set to music, uses a solo singer, and has accompaniment that is as important as the vocal part. It is usually just a singer with a piano and usually lasts about three minutes. Franz Schubert wrote 600 art songs during his short life. The art song format continues to survive and thrive today.

Music listening may be accessed from www.ourworldourmusic.com

Figure 5.10

Advances in mechanical design resulted in instruments that could be played more musically and with more emotional content. Note the metal soundboard and felt hammers in this piano mechanism.

Refinement of the Piano

As noted earlier in this chapter, the piano continued to evolve during the Romantic period. Not only was the keyboard extended to increase the range of available notes, but the internal mechanism also improved in design. One improvement was abandoning leather for covering the hammers that struck the strings and adopting felt instead. The softer material provided a less percussive attack to the beginning of the sound and allowed for a richer and warmer timbre. Another improvement was simply beefing up the mechanism, allowing for more aggressive approaches to playing.

Franz Liszt

Perhaps one of the most aggressive pianists of all time was Franz Liszt (1811–1886). A touring sensation and showman of piano playing, he was one of the pop stars of the Romantic period. People, especially women, followed him from city to city during his tours, precursors of those who would be known as "groupies" in the twentieth century. Born in Hungary, Liszt's father worked for the Esterhazy family, the same family for which Franz Josef Haydn had worked. Liszt had the opportunity to study music there and in Vienna before going to Paris. His performing abilities were envied by both Chopin and Schubert. Liszt's approach to composition was much like his approach to performance—showy and a bit over the top. He was able to perform things with ease that others often could not play. After years on the road touring, he abandoned it, settled in Weimar, the city where Johann Sebastian Bach had once worked, and then in Rome, where he became a teacher and later an ordained cleric, giving up his previous life as a ladies' man and pop star. He was a key supporter of Richard Wagner's career and wrote books and articles about his late friend Frederic Chopin.

GUIDED LISTENING 5.07

Franz Liszt and the Piano

The piano of the Romantic Period was an evolution of the Classical piano. More notes, greater range of dynamics, and a more responsive key and hammer mechanism allowed musicians to make music that was previously impossible. When an unusually skilled performer such as Liszt encountered a superior instrument as the Romantic piano, the result is one that still amazes us today. Listen for lightning fast playing and dramatic tempo and dynamic changes.

Music listening may be accessed from www.ourworldourmusic.com

Opera

Romantic period opera reflected the interests of Romantic period society. The topics of operas were similar to the topics of literature and the visual arts. Settings ranged from the mundane, real world to fantasy lands with heroes, magical swords and rings, and damsels in distress. One practice that evolved throughout the late Romantic period was an attempt to add realism and somehow make operatic presentation true to life. The word used was *verismo*, which translates as "real." One way that composers addressed this was to avoid stopping for individual songs, instead making the opera presentation one long, continuous song and having characters sing lines back and forth in dialogue. Violence, too, was a component of this style. Always, however, opera composers attempted to create stories that would hold the attention of their audiences and songs that audiences could be heard singing as they left the theater.

Richard Wagner, Giuseppe Verdi, and Giacomo Puccini

Three giants of opera during the Romantic period were the German, Richard Wagner (1813–1883), and two Italians, Giuseppe Verdi (1813–1901) and Giacomo Puccini (1858–1924). Although Puccini's life extended beyond the technical boundary dates of the Romantic period, his style of composition remained firmly rooted in the nineteenth century, avoiding twentieth-century changes in music.

Wagner lived most of his life in debt or running from debt. He fled from one place to another to avoid creditors or to avoid the consequences of his political activities. His personal life also suffered from marriage to an unfaithful wife and his own infidelities. Somehow, with all of this baggage, Wagner always managed to find patrons to support his latest production. Along with music and opera, Wagner was intensely interested in the writings of Carl Marx. He found a way to bring all of this together in a cycle of four operas all bound by the telling of a story based somewhat upon Norse mythology but also containing elements of a morality play about the plight of the poor and the ideals of communism. The story includes magical powers, a brother and sister separated at birth who come together and do not know their relationship at first, and a warrior frozen in ice (this is the stereotypical operatic character, Brunhilda, who wears horns on her head and armor in the form of a metal brassiere). Also present in the story is a sword of power and an absentee father with godlike powers. Known collectively as *The Ring Cycle*, elements of the storyline for this multipart production bear some resemblance to a more recent multipart cycle of movies called *Star Wars*. One of Wagner's compositional devices, called *leit motif*, is also present in the *Star Wars* movies. Leit motif approach assigns a melody to specific characters, places, and events within the story. When a character comes onstage or is discussed by other characters, the arriving character's theme is heard. This device has commonly been used since the first movies with sound.

Verdi was a nationalistic Italian composer who was extremely popular, and economically successful, during his lifetime. He avoided the expanded approaches to harmony that were

Figure 5.11

Perhaps the best known stereotype or caricature of opera is Brunhilde, the warrior woman of Nordic folklore who helps the brother/sister pair in Wagner's *Ring Cycle*, becomes frozen, and later returns to life thanks to the actions of a hero.

Figure 5.12

Aida by Verdi is a fantasy set in ancient Egypt, revolving around the slave Aida who is secretly an Ethiopian princess, an Egyptian general who is in love with her, and Pharoah's daughter who loves the General. The love triangle plays out during a war, includes intrigue and deceptions, and ends with Aida and the General sealed up together alive within an Egyptian tomb.

common during the Romantic period, choosing instead to let his melodies carry the rest of the music. His life was considered to be somewhat scandalous due to his choice, after the death of his first wife, to openly live for many years with his lady-friend before they married. He is primarily known for his operas, having written between twenty-five and forty, depending upon how they are counted. His operas included social commentary disguised as comedic elements. Often, songs from his operas became the popular music of the time.

Puccini was also an extremely popular and prolific composer of the Romantic period. He was inspired to try his hand at opera after seeing his first performance of a Verdi opera. Both Puccini and Wagner became adherents of the *verismo* style of opera, although Puccini later returned to more traditional approaches. Unlike Wagner and Verdi, Puccini was not involved with politics. He did, however, follow Wagner's approach to orchestration, but he coupled it with Verdi's approach of "melody first" in constructing music. Living and working at the end of the Romantic period and beyond, Puccini represents the culmination of Romantic period opera.

Figure 5.13

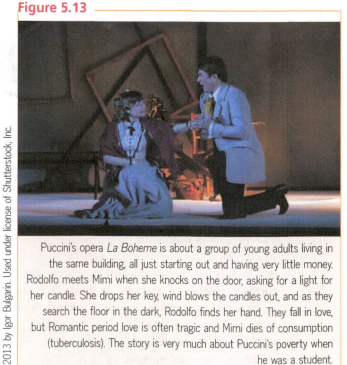

Puccini's opera *La Boheme* is about a group of young adults living in the same building, all just starting out and having very little money. Rodolfo meets Mimi when she knocks on the door, asking for a light for her candle. She drops her key, wind blows the candles out, and as they search the floor in the dark, Rodolfo finds her hand. They fall in love, but Romantic period love is often tragic and Mimi dies of consumption (tuberculosis). The story is very much about Puccini's poverty when he was a student.

Program Music

While the art song and opera could easily convey images and ideas through text, instrumental music was more limited. During the Romantic period, a means of conveying images and ideas in instrumental music was developed. Composers began to provide written notes for audiences to read before listening to musical works. This type of music came to be called *program music*, because reading about the composition in the printed program helped listeners to better understand the instrumental music that was performed.

Hector Berlioz

Born in France, Hector Berlioz (1803–1869) was the son of a medical doctor. As a young man, Berlioz was sent to Paris to study medicine, although the musically self-trained Berlioz had other ideas, spending more time in the library of the Paris Conservatory of Music than at his medical school. Eventually abandoning medical study, Berlioz became a student at the conservatory. As a young music student at the conservatory, he had the opportunity to experience Beethoven's symphonies and string quartets while the composer was still alive, leading to Berlioz's lifelong admiration for Beethoven's music. In many ways, Berlioz was as excitable and unpredictable as Beethoven. Berlioz was known to have plotted to kill his ex-fiancé after she had called off their wedding (he did not follow through). He later married an English woman who spoke no French (Berlioz spoke no English), with Liszt as a witness at the wedding. Berlioz became the first famous conductor, foreshadowing a movement that continues today, and toured extensively to conduct orchestras in many countries. He wrote a book on orchestration (how to decide which instrument played which part in a piece of music) that became the guidebook for composers for almost a century. He also pioneered an approach called the *idée fixe* that assigned a melody to an individual character. This approach would later be developed by Wagner into his leit motif concept. Berlioz's personal life was filled with boom-and-bust financial cycles that often forced him to go back on tour to pay his debts. He outlived two wives and died in his Paris home following an extremely successful concert tour.

Figure 5.14

Flugelhorn, an instrument created by Adolph Sax.

Expansion of the Orchestra

Throughout the Romantic period, the makeup of the orchestra continued to grow. Partly, this was fueled by composers calling for vast resources in the presentation of their work. Another factor was technological advancements in the design of wind instruments. Perhaps the single design change that most affected the use of winds in music was the addition of valves to brass instruments at the beginning of the Romantic period. This advance allowed brass instruments to play melodies that had previously been impossible to play. Composers began to use brass instruments in ways never before imagined, and instrument makers worked to design new instruments. The tuba was one instrument that came into being during this time.

Perhaps the best known wind instrument maker of the Romantic period was Adolph Sax, who lived and worked in Paris. Sax created the *flugelhorn*, a mellow sounding cousin of the trumpet. He also designed a combination brass-woodwind instrument that bears his name: the *saxophone*. This instrument, while never being truly accepted as an orchestral instrument, became one of the primary components of a type of music that would come into being in the next century: jazz.

ADDITIONAL ROMANTIC PERIOD COMPOSERS

Many composers, with many individual styles, were active during the Romantic period. Most of these musicians knew one another or were linked in some way.

Robert Schumann, Clara Wieck Schumann, and Johannes Brahms

A productive composer of the early Romantic period, Robert Schumann (1810–1856) created music with beautiful melodies set within haunting harmonies. He was one of the first to create music in the new, more expressive and emotional Romantic period style. Originally hoping for a career as a concert pianist, Schumann damaged his hands through the use of a machine that he hoped would extend the reach of his fingers. He then turned to composition, eventually completing symphonies; choral, chamber, and other orchestral works; and an opera. Schumann derived a significant part of his income from his literary work as a critic. He eventually married his piano teacher's daughter, Clara Wieck, who was also a pianist and a composer nine years his junior. He and his

wife became friends with a young musician, Johannes Brahms. Robert Schumann suffered from psychotic visions that resulted in his final years being spent in an insane asylum, where he eventually died.

Clara Wieck Schumann (1819–1896) was one of the few female concert performers before the twentieth century. She played from memory, without printed music in front of her. Not to be outdone, the male concert pianists followed her lead. Even today, solo pianists play from memory because of Clara Schumann. She was also a composer of some merit; however, upon the death of her husband, she abandoned composition and spent the remainder of her life performing Robert Schumann's music so that it would not disappear from use. While Robert was in the asylum, their good friend Brahms came to watch over Clara and help with her children. He continued to be involved in her life until her death.

Johannes Brahms (1833–1897) wrote orchestral, chamber, vocal, and piano works. He was a student of Robert Schumann and a lifelong friend to Clara Wieck Schumann, who was 14 years his senior; Brahms never married. He represents the culmination of Romantic period instrumental music. His music uses the counterpoint devices of the Baroque period, the forms and structures inherited from the Classical period, and the harmonic advances of the Romantic period, resulting in an approach that is both traditional and innovative. A perfectionist, much of the music written by Brahms over his lifetime was also destroyed by him. He regularly discarded any of his music that he felt was inferior, regardless of the public reception it had received. A friend and supporter of many younger musicians, Brahms left a body of work and a harmonic legacy that many composers in the next generation would study in preparation for their own careers.

GUIDED LISTENING 5.10

Robert Schumann, Clara Wieck Schumann, and Johannes Brahms

Linked in life, these three composers spanned the Romantic period. Robert Schumann was the teacher of Clara Wieck and of Johannes Brahms. Clara became Clara Wieck Schumann when she married Robert. Johannes Brahms continued to be Clara's lifelong friend following the death of Robert. This close relationship fostered the musical creativity of all three. Listen for flowing melodies and form.

Music listening may be accessed from www.ourworldourmusic.com

Felix Mendelssohn

During the early part of the Romantic period, Felix Mendelssohn (1809–1847) was regarded as a child prodigy, in much the same way that Mozart had been regarded during his childhood. Mendelssohn presented his first public concert at age nine and had written twelve symphonies by the age of fourteen. He continued to be incredibly productive during his teen years, but when his opera was performed during his eighteenth year and failed to garner audience acclaim, he turned his back on opera composition and focused from that time on other genres of music. At the age of twenty, Mendelssohn helped to revive performance of the music of Bach, bringing it from forgotten obscurity and helping to make it a staple of music listening and study from that time forward. Traveling and touring brought

recognition and rewards; however, Mendelssohn always joyfully returned to his wife and family. He lived a life with fewer notorious and scandalous events than many of his contemporaries, although he was not left untouched by rumors. Despite his being a convert to Christianity, Mendelssohn's Jewish heritage resulted in suppression of his work by Wagner and others who were staunch anti-Semitics. It took almost a century for his music to receive the recognition that it deserves.

GUIDED LISTENING 5.11

The Concerto: Felix Mendelssohn and Beyond

The concerto of the Romantic period was much the same as that of the Classical period; it was a showoff piece for a solo instrumentalist performed with an orchestra. The differences are evident in the dramatically increased demands placed upon the soloist and the extremely enhanced emotional content of the entire piece. Listen for stellar playing, tempo changes, and emotional devices. Many of these devices can be found in more modern music.

Music listening may be accessed from www.ourworldourmusic.com

For learning activities, practice quizzes, and other materials, visit: www.ourworldourmusic.com

5.1 Worksheet

Name: _____

1. What are the dates of the Romantic period?

2. Name two inventions that helped to spur the Industrial Reolution. How did they do this?

3. During this time, for the first time in history, more people lived in cities than in the country. Why?

4. Identify a European country that was created during the Romantic period.

5. The Civil War in the United States lasted from 1861 to 1865. Briefly discuss the reasons for and the outcome of this war.

6. What was the result of the United States having a transcontinental railway?

7. Name three other important inventions of this era.

8. What did both visual arts and literature of the Romantic period represent? Discuss.

9. What would the term *popular music* represent for the Romantic period?

5.2 Worksheet

Name: _____

1. Compare the composer–audience relations of the Romantic period to those of the Baroque period.

2. Describe the concept of the "starving artist." Who was this persona modeled upon during the Romantic period?

3. Which trait did Romantic period audiences share with audiences of today?

4. How did the opportunity to have an instrument become more convenient for working-class families during this time?

5. Explain how conductors of the Romantic period became known as artists.

6. During the Romantic period, which European city became the Western world's music capital?

7. Name and discuss two major musical events in America during the Romantic period.

5.3 Worksheet

Name: _____

1. Many more significant composers worked during the Romantic period compared to the previous period. Why do you think this happened?

2. Name two things composers, as well as performers, did in the Romantic period to increase emotional content and passion toward the musical experience.

3. Frederic Chopin was the first composer to _____

_____ .

4. What is nationalism?

5. Explain exoticism.

6. Give three characteristics of art songs and discuss them.

Name: _____

1. List several of Franz Schubert's accomplishments as a composer.

2. This "pop star" of the Romantic period had many "groupies" and was envied by Frederic Chopin and Franz Schubert. After years of touring, he gave it all up to be a teacher and ordained cleric. Who was he?

3. How was opera made more *verismo?*

4. Name the three giants of opera during the Romantic period.

5. One of Richard Wagner's compositional devices is called _____ .
 Explain its use.

6. Giuseppe Verdi was known for his _____ .

7. _____ , an Italian, represents the culmination of Romantic period opera.

8. Define and describe program music.

9. Hector Berlioz became the first famous conductor. Give two facts about his life.

10. Define and describe the concept of *idée fixe*. Who pioneered this approach?

Name: _____

1. The single design change that most affected wind instruments was the addition of _____ to brass instruments.

2. The best-known wind instrument maker of the Romantic period was _____ .

3. He designed a brass-woodwind instrument that bears his name. It is the _____ .

4. This instrument was never truly accepted as an orchestral instrument but became a primary component of a type of music, _____ , in the next century. Name the instrument _____ .

5. Name the following composers of the Romantic period:

 He initially hoped for a career as a concert pianist but came to create music with beautiful melodies set to haunting harmonies. He married his piano teacher's daughter. He died in an insane asylum. His name is

 _____.

 She was a concert performer who played from memory. After her husband's death she performed his music so it would not disappear from use. Her name is _____.

 He was a friend to the two composers noted above. He was a perfectionist who discarded his own music if he felt it was inferior. His name is _____.

6. _____ was a child prodigy like Wolfgang Amadeus Mozart.

7. It took almost a century for his music to receive the recognition it deserves because _____

 _____.

Using the captions throughout Chapter 5, answer these questions:

8. Which piano manufacturer makes their instruments much as it was done in the Romantic period?

9. Which war claimed more American lives than another other in history?

10. In the Romantic period, much as today, audiences really appreciated _____ performers.

11. What is the purpose of a conductor?

12. What is the setting for Verdi's opera *Aida*?

13. Who was Brunhilde?

14. Discuss the setting, characters, and story of Puccini's opera *La Boheme*.

5.6 Worksheet

Name: _____

Define the following terms:

1. Industrial Revolution _____

2. starving artist _____

3. conductor _____

4. spiritual _____

5. nationalism _____

6. exoticism _____

7. art song _____

8. song cycle _____

9. *verismo* _____

10. *leit motif* _____

11. *idée fixe* _____

12. tuba _____

13. flugelhorn _____

14. saxophone _____

Change and Violence 6

FIRST HALF OF THE TWENTIETH CENTURY

The twentieth century is sometimes called the American century. Events during the first half of that century developed the military power and industrial strength of America. These events also drove the nation toward an economy and society that eventually moved from industry and manufacturing as its foundation. Music continued to reflect society and its changes.

EARLY TWENTIETH CENTURY SOCIETY

During the early twentieth century, advancements in science and technology occurred at an unprecedented rapid pace. In 1903, the brothers Orville and Wilber Wright succeeded in the first controlled powered flight. The same year, Henry Ford and his financial partners founded what would become the Ford Motor Company to mass-produce automobiles. Two years later, Albert Einstein presented his theory of relativity, changing the field of physics forever. One part of this theory included the famous equation $E = mc^2$, a fundamental component for understanding and using atomic energy. These and other advances in science and technology were not always applied solely to peaceful purposes.

Figure 6.01

The Wright brothers initial controlled powered flight at Kitty Hawk, North Carolina.

© Bettmann/Corbis

The second decade was the time of World War I (1914–1918). At the time, it was seen as the war to end all wars. Fought mostly in Europe, the two sides were dug into trenches, with soldiers shooting across the fields between. When attacks and counterattacks across the killing fields proved to be unsuccessful in routing one side or the other, different tactics were applied. One of these tactics was the use of poison gas, what we now refer to as chemical warfare. More than fifteen million people died

Figure 6.02

Postcard depicting US soldiers wearing gas masks in trenches in France. Fear of chemical attack was always present.

during the conflict. The final treaty that was signed imposed such punitive measures on Germany and the other losing nations that their chafing later erupted into another war. During World War I, one of the nations, Russia, experienced a revolution. The tsar and the ruling family were overthrown and assassinated. A new communist government took power and withdrew their support of the war with Germany, signing a separate treaty with them, the United States, and the Allied powers.

Following the war, a period of economic boom called the Roaring Twenties boosted the fortunes of the United States and our world. New laws had significant impact upon American society. In 1920, the Nineteenth Amendment to the U.S. Constitution was passed, granting women the right to vote. This amendment was preceded by the Eighteenth Amendment that banned the manufacture, transportation, and sale of alcohol for consumption in the United States. Sometimes called the Noble Experiment, or Prohibition, the result of this law was to drive the use of alcohol underground, along with those who supplied it. Organized crime in America became firmly established during this time as "bootleggers" made, transported, or sold the illegal product. In 1933, the Twenty-first Amendment reversed the Eighteenth Amendment, once again making alcohol legal in the United States.

Beginning with the period following the American Civil War in the 1860s, laws were routinely enacted, especially in the American South, that limited access by people of color to

Figure 6.03

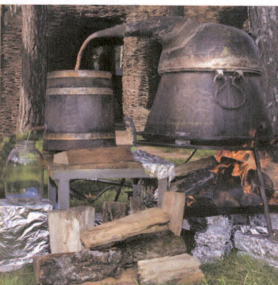

Often made in the woods to hide the smell and under cover of darkness to avoid detection, illegal whiskey came to be called "moonshine."

Figure 6.04

This modern scene was almost impossible in the first half of the 20th Century as a result of the 1896 US Supreme Court ruling that separate but equal was constitutional. In 1954 the Court reversed this ruling, abolishing legalized racial segregation.

services, whether publicly or privately funded. These were called Jim Crow laws, and they continued throughout the first half of the twentieth century and into the 1960s. Separate but equal systems of education were created for primary and secondary grades. Separate public and private colleges and universities were established in every Southern state and in many other parts of the United States. These institutions, because of their unique heritage, are known today as Historically Black Colleges and Universities. Other limitations of access to services included separate bathrooms, drinking fountains, and seats on busses for whites and blacks. In 1954, the U.S. Supreme Court ruled against this practice in education, stating that separate was "inherently unequal." School integration followed. While other activities associated with the civil rights struggle will be noted in Chapter 7 of this text, it is important to note that not all limitations to access were based upon laws. In both opera and orchestral performance companies, opportunities for black performers

Figure 6.05

In 1896, the U.S. Supreme Court, in a 7-1 decision, ruled that racial segregation was legal. This was the law during the first half of the 20th Century until the Supreme Court reversed itself in 1954.

were severely limited in both the North and the South. A movement in the 1920s and early 1930s called the Harlem Renaissance provided an outlet for creative work by blacks in literature and in the arts.

William Grant Still

Born in Woodville, Mississippi, and growing up in Little Rock, Arkansas, William Grant Still (1895–1978) was a part of the Harlem Renaissance and a major figure in music of the first half of the twentieth century. A violinist, he was educated at Wilberforce University, Oberlin Conservatory of Music, and the New England Conservatory. Still represents many "firsts" in music, including being the first African American to

- Have a symphony played by a professional orchestra
- Conduct a major American orchestra, the Los Angeles Philharmonic Orchestra
- Conduct a major orchestra in the South, the New Orleans Philharmonic Orchestra
- Have an opera performed by a major company, the New York City Opera (his *Troubled Island* tells the story of the Haitian slave rebellion)
- Have an opera performed on national television

Still brought components of his African-American heritage and melded them with the traditional European approaches to harmony and form that he studied while at university. Besides his work in art music genres, he spent time working with W. C. Handy in Memphis, Tennessee, writing popular music, as well as working in Los Angeles writing music for motion pictures.

GUIDED LISTENING 6.01

William Grant Still

A product of the Harlem Renaissance and a musical pioneer, Still incredibly broke through many barriers of the legally segregated first half of the 20th Century. Never leaving his cultural roots behind, he proved not only that race was not a factor in making music, but also that bringing in previously unused cultural elements could greatly enhance and freshen orchestral music.

Music listening may be accessed from www.ourworldourmusic.com

LATER IN THE FIRST HALF OF THE TWENTIETH CENTURY

Near the end of 1929, the stock market collapsed. The causes, primarily involving misuse and overextension of credit, were similar to those that triggered the economic events of 2008. By the time the 1929 crash bottomed out in 1932, stocks that had been worth one dollar before the crash had dropped to a value of only eleven cents. Credit had dried up, restricting the ability of companies and individuals to purchase. Reduced sales forced manufacturers to reduce production,

Figure 6.06

The Works Progress Administration (WPA) was a US government program that employed many out of work people in the 1930s, usually in construction jobs. This sign is from a campus building still in use. Can you find similar signs on your campus or in your area?

Figure 6.07

The Hoover Dam across the Colorado River was one of the federally funded infrastructure projects carried out during the Great Depression. Note the size of the road and cars in the upper left of the photo.

© 2013 by Tom Grundy. Used under license of Shutterstock, Inc.

Figure 6.08

© 2013 by Naci Yavuz. Used under license of Shutterstock, Inc.

To assure that everyone could tell Jews from others who looked alike, the Nazi government required that identifying yellow stars be sewn onto their clothing.

and a record number of Americans found themselves unemployed as their former employers went bankrupt. This downward spiraling cycle threw the United States and the world into an economic crisis known as the Great Depression. To help combat this event, the federal government embarked upon a series of infrastructure construction projects to provide jobs and help stimulate growth in the U.S. economy. Many dams, roads, bridges, and schools were built during this time. Also accomplished with federal funds during this time were the construction of the nation's electrical power grid and the electrification of rural areas.

In 1933, the Nazi Party came into power in Germany and Adolph Hitler was named chancellor. Gaining strength through playing up German frustrations with economic conditions and the conditions of the World War I peace treaty, the Nazi Party grew into a fascist, totalitarian regime. Celebrating Germany's past, the Nazis promoted previous Austrian and German composers such as Johann Sebastian Bach, Wolfgang Amadeus Mozart, and Ludwig van Beethoven. They also began a program of blaming economic and other societal problems on Jewish people. Jews were forced to sew a six-pointed Star of David into their clothing so that they could be

identified in public. Jews were forbidden access to services and denied entry into stores, restaurants, and other places in much the same manner as blacks in the American South. As persecution continued, many Jews fled Germany for western Europe and eventually for America. The United States benefitted by gaining such new citizens as the scientist Albert Einstein and the composer Arnold Schoenberg. Most Jews were not fortunate enough to flee and became victims of increased persecution. The Nazis forced the Jews into ghettos, and built walls around them. Finally, they began loading the Jews onto railroad cars and transporting them to camps where they were housed, worked, and then put to death. This genocide event is called the Holocaust. More than six million Jews were killed in the state-sponsored extermination program. Germany invaded European countries one at a time, continuing to gain strength. The United States entered World War II in 1941, following the attack upon Hawaii by Germany's ally, Japan. The war lasted until 1945, ending when the United States deployed a new weapon, dropping nuclear bombs on the Japanese cities of Hiroshima and Nagasaki. This was our world's only wartime use of nuclear weapons, ever.

The remainder of the first half of the twentieth century saw soldiers returning home, the dismantling of the world's war machines, and the beginning of a period of prosperity. The peace was uneasy, as other countries raced to develop their own nuclear weapons. An arms race began, primarily between the United States and Russia. Many technological and scientific advances that had begun the century with great hope had found dark and violent uses during the first half of the century.

Figure 6.09

An atomic bomb mushroom cloud rises more than 60,000 feet into the air over Nagasaki, Japan after an atomic bomb was dropped by the US bomber "Enola Gay", Aug. 9, 1945, ending WWII and letting our world know that World War III could never be allowed to happen.

© Shutterstock, Inc.

Figure 6.10

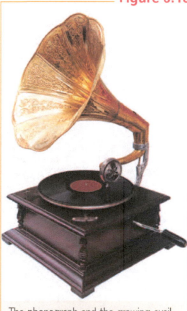

The phonograph and the growing availability of phonograph records of music of different genres greatly expanded access to on-demand music for many people.

© 2013 by Dja65. Used under license of Shutterstock, Inc.

TECHNOLOGY AND MUSIC

Near the end of the 1800s, Thomas Edison had invented a machine that could record sound. His cylinder-based recording process was quickly converted to a disk-based process, and the phonograph record was created. Beginning with the first decade of the twentieth century, consumers bought record players and disks of recorded music at an ever-increasing rate, changing forever how people experienced music.

Before recorded music, the only way to hear music was for it to be played live. Not only was access to music bound by availability of concerts, but an investment of money had to be made every time music was heard. The invention and proliferation of recorded music allowed for a one-time investment in the record player and a one-time investment in a phonograph record to yield an almost unlimited number of music listening experiences. Music could be heard whenever desired for no additional cost. For the cost of a single phonograph record, an entire family could spend many evenings listening to music, a significant reduction in expense when compared to purchasing multiple concert tickets for the privilege of each single opportunity to listen.

Figure 6.11

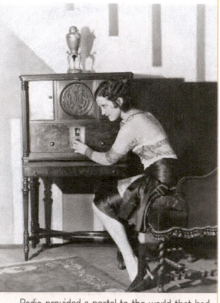

Radio provided a portal to the world that had never before been available and young people embraced it, as they do new technologies today.

Radio

During the 1920s, a new technology became commercially available and affected how people experienced music. The new technology, radio, was more cost-effective than the phonograph. For a single investment in a piece of equipment, a family could listen to an almost unlimited selection of music, entertainment, and news. As electrification became more widespread in the 1930s, the popularity of radio increased.

Both radio and phonograph affected how people in our world experienced music. The phonograph provided a luxury that only a few, rich aristocrats had previously enjoyed: on-demand music. The radio became the central device for gathering news, experiencing entertainment in the form of radio plays and shows, and hearing various types of music. In many ways, it was as much of a central device to people of the first half of the twentieth century as the computer is to people of the first part of the twenty-first century, in that it was the portal that provided access to various experiences. Two direct results of radio's influence were that people began to listen to many types of broadcast music that would previously have been unavailable to them and that the performer and the song became more important in popularity than the composer.

Instruments

Recorded music brought access to music that many people in small towns and rural areas had never enjoyed. They sampled many types that were new to them. Recorded music also brought access to music that was new to even the most jaded listeners in large cities. Recordings of music from throughout the world brought the sounds of new instruments to Western listeners. As a result of the two world wars, many soldiers had opportunities to hear new types of music and new instruments. Composers learned of these new sounds and instruments and began to incorporate them into their music.

New, electric instruments also contributed to the palate of sounds upon which composers could draw. One was the *theremin,* an instrument that was discussed in Chapter 1 of this textbook.

MUSIC IN THE FIRST HALF OF THE TWENTIETH CENTURY

The twentieth century, especially the first half, was one of the most radical periods in music since the beginning of the Baroque period. Composers experimented with new approaches, harmonic devices, and presentation methods in the Baroque period. Composers in the

twentieth century were equally bold, and various compositional approaches and styles developed. Approaches, styles, and sometimes even musical languages became unique to individual composers. No single approach can be called "twentieth-century music" because no two composers seemed to use the same devices.

Continuation of Romantic Period Approaches

Near the turn of the twentieth century, most new music was indistinguishable from Romantic period music. Harmonic, melodic, and rhythmic approaches continued to find use and to attract audiences, not only at the beginning, but throughout the century. Just as Romantic period composers found ways to extend Classical period harmonies and approaches, many twentieth century composers found ways to apply new harmonies, styles, and influences as extensions and expansions of musical ideas that were still clearly within Romantic period style.

Clarence Cameron White

Often identified as a composer who continued the traditions of the Romantic period, Clarence Cameron White (1880–1960) was born in Clarksville, Tennessee, and grew up in Oberlin, Ohio; Chattanooga, Tennessee; and Washington, D.C. He studied at Howard University, Oberlin Conservatory of Music, and the Hartford School of Music, and he taught music in the public schools of Washington, D.C., at the Washington Conservatory of Music, at West Virginia State College, and at Hampton Institute (now Hampton University). He wrote both vocal and instrumental music; his opera *Ouanga* is based upon the Haitian slave rebellion. White's music, initially European in its form, structure, and inspiration, evolved to include folk songs from his African-American roots. A violinist, he brought his classical training to bear upon these folk melodies and their traditional performance using informal fiddling techniques. The result is a blend of traditional melodies, expanded harmonies, and technically demanding music that is wrapped up in Romantic period structural elements.

GUIDED LISTENING 6.02

Clarence Cameron White

Blending elements of Spirituals with Western art music, White brought a new sound yet continued to write in a style that looked more to the practices of the Romantic period than to the widely varying practices of the 20th Century. Listen for clearly defined form, traditional Romantic period harmony, and fragments of Spiritual melodies.

Music listening may be accessed from www.ourworldourmusic.com

Opera

Most opera in the first half of the twentieth century continued in the Romantic period style. Giacomo Puccini was still active for the first quarter of the century, and he continued as the successor to Richard Wagner and Giuseppe Verdi. Other opera was influenced by society and new musical sounds. One of these new sounds in the early twentieth century was American jazz. The first opera to be produced with an entirely African-American cast was *Porgy and Bess* by George Gershwin. First presented in 1935, it tells a story of life in the slums of a Southern town during the 1920s. Controversial, disregarded as not operatic by some, and even perceived by others as racist, *Porgy and Bess* provided one of the first opportunities for classically trained African-American singers to mount a Broadway stage as theatrical stars, rather than portraying stereotypical characters.

GUIDED LISTENING 6.03

Opera

Early 20th Century opera closely resembled that of the Romantic period. The new American music, jazz, was a fresh sound and was being adapted into opera and many other genres. Listen for Romantic influenced approaches to melody and harmony, while also listening for elements of jazz.

Music listening may be accessed from www.ourworldourmusic.com

Figure 6.12

Impression: Sunrise by Claude Monet.

Erich Lessing/Art Resource, NY

Rise of Impressionism

While some composers followed Romantic period approaches or infused these approaches with twentieth-century ideas, other composers looked for new ways to write music. Some of these composers, rebelling against the exceedingly emotional approaches of many Romantic period composers, pursued new directions. Claude Debussy, one of these early twentieth-century composers who wanted something new, once said, "The century of the airplane should have its own music."

One of the types of music that developed attempted to portray an atmosphere or an ambiance, rather than an extreme emotion. Just as light reflecting upon water creates a fleeting, impermanent view, these composers attempted to capture that fleeting moment in music. These composers became known as Impressionists, a name given to them based upon a painting by Claude Monet in the 1870s that was titled *Impression: Sunrise*. In the painting, Monet attempted to capture atmosphere, mist, ambiance, and a fleeting moment in his depiction of the sun rising over a body of water. This style of painting avoids sharp edges and usually looks most realistic when viewed from a distance.

Claude Debussy

Claude Debussy (1862–1918) is one of the names most often associated with music in the Impressionism style, although the French composer hated to have that title applied to his work. Showing exceptional musical abilities at an early age, he was admitted to the Paris Conservatory of Music as a scholarship student at the age of ten. He later studied in Italy and then spent time in Russia. A figure often embroiled in scandals involving other men's wives or frequent changes of his own wives, he was even more famous for his music. His early work is distinctly of the Romantic period. He followed his interest in experimentation during his middle years and created music in his own style during his later life. He died in Paris in 1918 during the German bombing near the end of World War I.

GUIDED LISTENING 6.04

Claude Debussy and Impressionism

Looking for new approaches to making music in the early 20th Century, Claude Debussy took inspiration from a style of visual art called Impressionism. This music attempted to create an atmosphere or feeling rather than to create motion. Listen for harmonies that tend to float along rather than to resolve from dissonance into consonance.

Music listening may be accessed from www.ourworldourmusic.com

New Approaches to Dissonance

During previous musical periods, harmonic sounds were perceived as either consonant or dissonant and motion in music was derived by moving from dissonant sounds to consonance. Fundamental to music is the concept of establishing stability, creating tension, and then resolving the tension. Twentieth-century composers expanded upon the device of moving from dissonance to consonance by redefining *consonance*. In the new approach, the resolution of dissonance did not have to be to traditional consonance; a sound that was less dissonant than the previous sound was accepted as a resolution. Under this approach, composers felt less bound to traditional harmonic progression and experimented with new sounds, all of which may have been considered dissonant by Romantic period composers and audiences. In addition, composers began to experiment with the Baroque ostinato device by using it with a repeating rhythm rather than with a bass line or other repeating melody. The result was music that was quite new to the ears of early twentieth century audiences.

Igor Stravinsky

The Russian composer Igor Stravinsky (1882–1971) is considered one of the most influential creators of music in the twentieth century. He wrote in almost every style that developed during his lifetime, and his music was viewed as being definitive in each of these new approaches to composition. The son of a professional singer, Stravinsky began musical study at an early age and later studied with the famous Russian composer Nikolai Rimsky-Korsakov. Following the Russian Revolution, Stravinsky moved to France in 1920. In 1940, after the outbreak of war in Europe, what would become World War II, Stravinsky moved to the United States and made Los Angeles his home for the remainder of his life.

Audiences did not always respond positively to composers' new ideas. One of the most famous of these responses was at the first performance in 1913 of Stravinsky's *Rite of Spring* in Paris. The music was composed for a ballet that told the story of a prehistoric tribe's celebration of the return of spring after a grueling winter. The piece begins with the dawning of spring and the first timid growth of plants. As the story progresses, the tribe dances to music that was intended to sound primitive. The story culminates with the sacrifice of a young virgin to the gods of spring. Stravinsky's portrayal of this story used musical devices different from those to which audiences were accustomed. Before intermission at the first performance, police had to be called in to settle a quarreling crowd, divided in their opinions of the new music, and settling their disagreements with fistfights during the performance. When the performance resumed, police could no longer keep order and a full-scale riot occurred, all caused by the performance of a piece of music.

GUIDED LISTENING 6.05

Igor Stravinsky and Dissonance

Early 20th Century music approached dissonance differently than before. Instead of resolving dissonance into consonance to create forward motion, composers redefined resolution. They used movement from more dissonant to less dissonant to create motion, at the same time letting the dissonance avoid creation of stopping points. The result produces a feeling of instability.

Music listening may be accessed from www.ourworldourmusic.com

Charles Ives

The American composer Charles Ives (1874–1954) was not a professional musician; he made his living as an insurance salesman. Perhaps this contributed to his music being ignored by the musical establishment for most of his life. At age seventy-three, when his Third Symphony won the 1947 Pulitzer Prize, the attention paid to him increased dramatically. (He gave away the prize money, saying, "Prizes are for boys and I'm all grown up.") His father had been a U.S. Army bandleader during the Civil War who then served as the leader of his town's band in Danbury, Connecticut. Ives studied music with his father and then with a succession of teachers, including those at Yale University, where he earned his bachelor's degree. Ives's music was an unconventional mix of sounds, using polyrhythm (two or more distinctly different rhythms sounding simultaneously) and polytonality (music played in two or more keys at the same time). His busy, thick textures are discomforting to some listeners and greatly enjoyed by others. Often basing his works upon folk music, he drew upon hymn tunes and the music of Stephen Foster.

GUIDED LISTENING 6.06

Charles Ives and Dissonance

Using multiple sounds, melodies, rhythms, and keys simultaneously, Ives created instability and dissonance through sometimes overwhelming the listener's senses. He described his music as if the listener stood between two streets as two bands marched by in opposite directions. It is sometimes a challenge to follow one band's music while the other plays something different.

Music listening may be accessed from www.ourworldourmusic.com

Expressionism

Expressionism, an extremely emotional presentation that relies upon shocking topics and techniques, began during the first half of the twentieth century. Expressionism in art was meant to elicit a response from the listener or viewer. It either portrayed inner turmoil or attempted to create it. Visual Expressionist art used misshaped objects and people, as well as abrasive combinations of colors, in an attempt to portray agitation and emotion. Perhaps the most famous example of Expressionism in visual art is a painting by Edvard Munch titled *The Scream*. (The movie *Home Alone* paid tribute to this painting by having the main character strike the same pose. The horror movies in the *Scream* series also pay tribute by modeling the slasher's mask on the face in the painting.) Because of the extreme nature of Expressionist music and its topics, listeners felt uncomfortable and many audience members turned elsewhere for their listening pleasure.

Figure 6.13

The Scream by Edvard Munch.

Erich Lessing/Art Resource, NY. © 2014 The Munch Museum/The Munch-Ellingsen Group/Artists Rights Society (ARS), NY

GUIDED LISTENING 6.07

Expressionism

Seeking to position art as a means of shocking the audience, Expressionism used ugly topics, distortions of perspective, and harsh sounds to create impact. In music, sounds and structures that would have previously been discarded as being raw or unuseable became the basis of the composer's toolkit. Listen for shock value sounds and topics.

Music listening may be accessed from www.ourworldourmusic.com

Atonality

As composers continued to explore new ways of making music, one group advocated a complete break with the harmonic and melodic traditions of the past. Some members of this group began to compose music using chords that were common in earlier periods, yet the chords did not work together in the functional manner that began with music of the Baroque period. Other members created new rules, often for each piece of music, that maintained some sort of structure that was radically different from previous practices.

All of these approaches to composition resulted in music that lacked a tonal center and came to generically be called *atonal music*. In its most basic form, atonal music may simply use a freewheeling harmonic approach in which the composer puts together any sounds that seem to be pleasing, regardless of how they contribute to the process of creating and resolving tension. This approach is sometimes referred to as free atonality. Most atonal music avoids traditional tension–release harmonic movement, since this type of movement tends

to point to a specific note as the goal, or tonal center, of the music. Other types of atonal music are more structured, working within specific guidelines.

Tone Row Technique

One approach to creating music that avoided tonality was the use of *twelve-tone music* or tone row technique. This technique gives equal weight to all twelve chromatic notes in an octave (all of the black and white piano keys in an octave). The composer would create an order for these twelve notes and then build a piece of music that used the notes in that order. To avoid leading the ear toward any particular note, one of the rules was that a note could not be repeated until the entire tone row had been played. Variations on the rules allowed for the tone row to be played in its original form (prime), as well as being performed backward (retrograde), upside down (inversion), and backward–upside down (retrograde inversion). Any of these transformations of the tone row could also begin on any note, further obscuring listeners' ability to perceive that a particular pitch was a "home" or starting point. Other variations on the rules allowed notes to sound simultaneously, as long as they were notes adjacent to each other in the tone row or one of its variants.

Arnold Schoenberg—Regarded as the father of tone row technique, Arnold Schoenberg (1874–1951), a composer from Austria, was a member of that group of composers who desired a break from traditional approaches to music. His earliest music followed the practices of Romantic period composers. As he became more confident of his skills and more committed to new approaches, he moved into composition that used free atonality. Beginning in the early 1920s, Schoenberg advocated the new musical harmonic and melodic foundation that became known as tone row technique. As an instructor at the Prussian Academy of Arts in Berlin, he taught others to use this technique, creating a following of radical young composers. When the Nazis came to power in 1933, he was dismissed from his position due to his Jewish heritage (at this time, Schoenberg was a Lutheran). The Nazis grouped his music with jazz and other types of modern art that they labeled as degenerate art, banning it in favor of traditional types that promoted Germanic artistic, militaristic, and racial superiority. In 1934, Schoenberg fled to Paris and then to America, reembracing his Jewish heritage. He settled in Los Angeles, where he worked as a professor at the University of Southern California and the University of California, Los Angeles.

GUIDED LISTENING 6.08

Arnold Schoenberg and Tone Row Technique

In an attempt to abandon the musical structures and devices that had been used in music for hundreds of years, Schoenberg developed a mathematical approach that he once claimed would "...assure German domance of music for the next hundred years." Listen for lack of chords and lack of a central tone as sounds are presented in a formula designed to leave the music sounding as if no gravity or force was pulling it in any single direction.
Music listening may be accessed from www.ourworldourmusic.com

Anton Webern—One of Schoenberg's most famous students was Anton Webern (1883–1945). Born in Vienna, Austria, Webern was one of Schoenberg's strongest proponents of tone row technique. He expanded upon the tone row technique not only by systematically specifying the sequence of the pitches to be performed but also by arranging the order of dynamics, articulations, and other musical elements in a composition. Like his teacher, Webern's music was labeled as degenerate art by the Nazis, and as a result, he found it difficult to find employment. Since he was not a Jew, he did not experience the same level of persecution as Schoenberg and remained in Germany throughout the war. In 1945, near the end of the war, Webern was shot and killed by an American soldier as a result of being out after curfew in a war-torn, Allied-occupied city in Germany.

GUIDED LISTENING 6.09

Anton Webern and Tone Row Technique

Continuing in the new musical direction developed by his teacher Schoenberg, Anton Webern expanded upon the mathematical structure of tone row technique to also include rhythm, dynamics, articulations, and other elements. The result was a type of music that can leave the listener scrambling to find points of reference as the weightless, non-centered music unfolds.

Music listening may be accessed from www.ourworldourmusic.com

Neoclassicism

As a musical style, *neoclassicism* flourished in the period between the two world wars of the twentieth century. The movement looked back at the less emotional music of the Classical period with its focus upon structure. Classical period forms were used to organize compositions but were blended with twentieth century approaches to melody and harmony. The result was a type of well-organized music that sounded distinctly new.

Not all listeners could identify with the new musical practices of the twentieth century, especially the new approaches to harmony, melody, and makeup of ensembles. The result was that, for the first time in history, audiences did not clamor for new music but preferred older, familiar works. New art music had lost its audience. When a type of music ceases to resonate within a society, something new moves in to replace it. Classical art music stopped being the popular music of its time, and some other type became popular. We will explore this new popular, or pop, music in Chapter 8 of this text.

Nationalism

Like many other aspects of Romantic period music, nationalism continued in the first half of the twentieth century. One of the primary devices used was the incorporation of folk melodies into art music, much as had been practiced by Romantic period composers and Classical period composers before them. The use of familiar melodies helped to make art music more accessible to an audience that had begun to move on to other types of music. Using recording technology, composers sometimes went into remote areas to find source material.

Figure 6.14

The Hungarian composer Bela Bartok recording folk songs in Transylvania.

© The Art Archives/Corbis

Bela Bartok

The Hungarian composer Bela Bartok (1881–1945) was one of the first composers to take recording equipment into remote areas to gather folk songs, as shown in Figure 6.14. In the period before electricity was widely available, rural areas had far less contact with the rest of society and folk songs tended to remain "pure" and "pristine" in those places, without the pollution that occurs when other types of music are introduced and blended with a culture's existing music. Bartok, a child prodigy who could play many piano pieces by the age of four, began gathering folk melodies in his twenties after hearing a young nanny sing songs to the children in her care. He incorporated these melodies into his compositions, helping his audiences to experience old melodies that were new to them and to enjoy familiar melodies in a new context.

GUIDED LISTENING 6.10

Bela Bartok and Nationalism

After going into remote villages and recording folk song melodies on a portable phonograph recorder, Bartok used these melodies in his compositions to promote his country and its music. So successful was he at this approach that he was later hired by President Kemal Ataturk to teach this method of gathering and cataloging folk songs to Turkish musicians.

Music listening may be accessed from www.ourworldourmusic.com

Heitor Villa-Lobos

The Brazilian composer Heitor Villa-Lobos (1887–1959) was born in Rio de Janeiro. The son of an accomplished amateur musician, Villa-Lobos had little formal study of music, gaining most of his knowledge by watching and participating in the musical evenings that were regularly hosted by his parents. As a teenager, he worked in theater and cinema orchestras. (This was the period of the silent films, and cinemas used groups of musicians to enhance the emotional impact of the film, as well as to cover up the noise generated by early projection equipment.) In his early twenties, Villa-Lobos spent some years traveling in Brazil's Amazon interior. He returned with stories (probably untrue) of his adventures, including an escape from cannibals. He also returned with a collection of his country's folk music that he used in his compositions.

GUIDED LISTENING 6.11

Heitor Villa-Lobos and Nationalism

Mirroring Bartok's collection and use of traditional folk melodies in new compositions, Villa-Lobos traveled in his home of Brazil. It is important to note that composers were drawing upon these melodies for inspiration; they were not simply writing them down and claiming them as their own.

Music listening may be accessed from www.ourworldourmusic.com

Aaron Copland

The American composer Aaron Copland (1900–1990) wrote in many twentieth-century styles. His approach often made his music accessible to audiences, and he enjoyed continuing success. He is known as the Dean of American Composers, and his music helped to define an American approach to music. He used polyrhythm, polytonality, percussive ostinato rhythm, and tone row technique in his various compositions, but his music was often based upon folk songs and had little difficulty being embraced by audiences. One key to his success was his acceptance of the realities that the Great Depression imposed upon artists; rather than continue to write only for large orchestras, Copland began to compose for smaller groups of unusual combinations of instruments. Unlike some other composers who approached these ensembles as exotic statements of new, bizarre sounds, Copland called for groups that blended in ways that his audiences could easily understand. Another key was his continued use of American folk melodies as the basis for many of his works.

GUIDED LISTENING 6.12

Aaron Copland and Nationalism

Using American folk melodies as a basis for his work, Copland preferred less jarring, more accessible approaches to composition. The result was a type of music easily embraced by its audience. Listen for familiar forms and structure within a music that sounds modern.

Music listening may be accessed from www.ourworldourmusic.com

Jazz in Art Music

Many composers began to use the new musical art form that originated in America during the first part of the twentieth century: jazz. This musical style, discussed in more depth in Chapter 8 of this text, combined elements from traditional European music with other elements from Africa. It used a slightly modified harmonic vocabulary that sounded familiar enough to be embraced by audiences and combined that with a performance practice that was new and exciting.

George Gershwin

Born in Brooklyn, the American composer George Gershwin (1898–1937) helped to bridge the divide between jazz, viewed as an inferior popular music, and art music. In addition, Gershwin was one of the few composers who could successfully navigate the worlds of the Broadway musical and the serious concert stage. The son of immigrant Russian Jews, he quit school at age fifteen to work as a writer of Tin Pan Alley popular songs. He had a succession of hit songs during his short lifetime, including his first national hit *Swanee*, sung by Al Jolson. These were quickly followed by *Fascinating Rhythm, Lady Be Good, I Got Rhythm* (which won a Pulitzer Prize), *They Can't Take That Away from Me, Embraceable You, Someone to Watch Over Me, Summertime*, and a host of other songs, often cowritten with his brother, Ira, who supplied the lyrics. Besides popular music, Gershwin was interested in serious art music, not drawing a line between the two. He incorporated jazz and popular music elements in his concert music, resulting in pieces that were often embraced by an audience that had little interest in symphonic works.

GUIDED LISTENING 6.13

George Gershwin and Jazz in Art Music

Taking an approach of writing art music but incorporating jazz as an elemental component, George Gershwin followed a musical path somewhat similar to that of William Grant Still--if you leave out the fact that one was the son of immigrant Russian Jews and the other was an African American. Both viewed jazz as a new spice with which they could flavor their compositions to create something new. Listen for jazz elements, especially the use of traditional instruments in new and interesting ways.

Music listening may be accessed from www.ourworldourmusic.com

Exoticism

As the twentieth century began and progressed, the Romantic period practice of exoticism, attempting to make music sound as if it was from another place, evolved. Recorded and broadcast music brought authentic performances of other types of music into the homes of listeners. Composers began to adopt sounds, approaches, and instruments of non-Western cultures and to include them into their Western musical works. Dividing lines between types of music from different cultures began to blur. Fortunately, recordings from the early part of the twentieth century help to document traditional non-Western types of music and assist in their preservation.

GUIDED LISTENING 6.14

Exoticism in the Early 20th Centry

Using musical devices to make music sound as if it is from another place, Exoticism, continued in the early 20th Century. As new sounds and instruments from other places were added to the traditional template used by composers and performers, It was sometimes difficult to determine exactly where a particular piece of music originated. Listen for influences from other parts of the world.

Music listening may be accessed from www.ourworldourmusic.com

The Percussion Century

Baroque period orchestras seldom used percussion. Classical period orchestras most often used only one player who performed on two timpani drums. Romantic period orchestras slightly expanded the percussion section to create more emotional presentations, but the twentieth century marks an explosive period in the use of percussion in all types of music. Percussion instruments and styles of playing were borrowed from other cultures, especially from West Africa. Instruments that were traditional to other societies became new in Western music, especially xylophone-type instruments that have wooden or metal bars of different sizes, each bar tuned to a specific pitch.

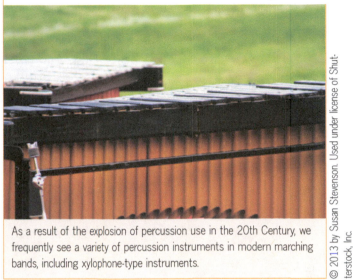

Figure 6.15

As a result of the explosion of percussion use in the 20th Century, we frequently see a variety of percussion instruments in modern marching bands, including xylophone-type instruments.

GUIDED LISTENING 6.15

Percussion in the 20th Century

Percussion ensembles developed during the 20th Century. These were art music ensembles, not the traditional drum sections that accompanied bands. In the early part of the century, the percussion ensemble contained many different noise-making devices. Later in the century, the ensemble will become more refined. Listen for a variety of percussion instruments, along with other sounds not normally associated with percussion.

Music listening may be accessed from www.ourworldourmusic.com

American Wind Bands

Historically, wind bands have been associated with military activities. The Turkish Janissaries used bands of winds and percussion to relay commands to units within the army, telling them when to attack, retreat, or execute some other maneuver. European armies often used boys playing drums to similar effect. Stringed instruments were not well suited for this purpose, due to both their fragile makeup and their inability to be heard well in an outdoor setting. As wind instruments, especially brasses, matured in

Figure 6.16

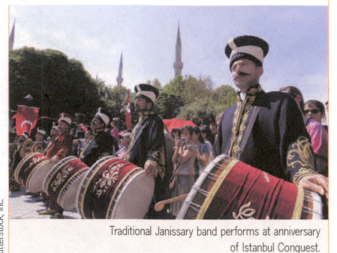

Traditional Janissary band performs at anniversary of Istanbul Conquest.

their designs and abilities to perform enough notes to play melodies, the musical repertoire available to these groups increased. Wind bands were used for ceremonial purposes, in addition to their battlefield applications. During the nineteenth century, the wind band began to standardize into an instrumentation of woodwinds, brasses, and percussion instruments. Several of these instruments trace their history and design to the mid-nineteenth century and the work of instrument maker Adolph Sax.

John Philip Sousa

The American composer and bandleader John Philip Sousa (1854–1932) was the person most associated with military wind band music and was known as the March King. Sousa's father was a member of the U.S. Marine Band, the top military band in the United States. This group is known as The President's Own and is based in Washington, D.C. Sousa was an accomplished performing musician at an early age. His father, in a move to keep him from running off with a circus band, arranged for Sousa to be enlisted as an apprentice to the Marine Band at the age of thirteen. The ploy worked, and Sousa stayed at home and in the band. After growing up, he left to conduct a theatrical pit orchestra, where he sharpened his conducting skills. In 1880, he became the conductor of the Marine Band, remaining in the position for twelve years. He then left to form his own commercial touring band. At the turn of the century and during the first half of the twentieth century, many touring "business bands" capitalized upon the popularity of wind band music.

Working with an American musical instrument manufacturer, Sousa was responsible for the instigation and design of the marching version of the tuba, known as the sousaphone (see Figure 6.17). Famous for his many wind band marches, several of which have been adapted for use by orchestras, Sousa composed the U.S. national march, *The Stars and Stripes Forever*, and is buried in Washington, D.C., in the Congressional Cemetery.

Figure 6.17

John Philip Sousa helped to work out a design for a tuba that could be easily carried and played, resulting in the sousaphone.

Evolving Repertoire

In the nineteenth century, following the development of the brass instrument valve and that instrument family's new ability to play melodies, the military band's traditional literature for marching and ceremonies began to evolve. Transcriptions of orchestral and opera works became part of the *repertoire* (commonly played musical literature). The growing body of literature allowed the band to present concerts beyond the traditional parade experience. As wind bands continued to grow in popularity in America, the beginning of the twentieth century brought with it the first important original concert work for wind. Gustav Holst, a English composer of vocal and orchestral music, wrote his *First Suite in E-flat* in 1909, elevating the wind band to an artistic ensemble and opening the door for many composers to address the repertoire needs of this group.

Wind Bands in American Society

In the late nineteenth century, the town band became popular in America. Sunday afternoon concerts in park gazebos and friendly competition among neighboring towns contributed to the enjoyment of life. Town band musicians were often a mix of professionals, semiprofessionals, and amateurs. During the last decade of the nineteenth century, about ten thousand town bands were found in the United States. Less than one hundred of these original groups are still active.

Today, school bands tend to be far more common in the United States. U.S. schools

Figure 6.18

Wind bands in America stay true to their military roots, with uniforms, loud instruments, and marching in formations while playing.

have more wind band programs than orchestra programs. In America, wind bands have become associated with athletic events as ancillary components, and marching bands have become the face of music education in American schools. In addition to performing at athletic events, school wind bands, both concert and marching units, often participate in competitions and festivals, similar to activities of the earlier town bands.

Making music in American wind bands tends to be an activity mostly enjoyed by young people. Most high school musicians do not go on to play in college bands. Interestingly, in most American college and university bands, most band members major in something other than music. Of these, many lay down their instruments following graduation.

Some adults, however, wish to continue to play wind band music as a hobby. College and military bands are usually not available to them. Community bands most often address this need. A community band is an amateur, community-based group that usually holds somewhat regular rehearsals in preparation for a few performances per year. The growth in popularity of American school wind band programs has provided a large pool of amateur performers who choose to join community bands.

Beginning near the middle of the twentieth century, a dramatic increase occurred in the amount of music written for concert use by wind bands. The driving force for development of this concert band literature was the school instrumental music program. Variety in levels and abilities of school band performers encouraged composers to write music in various difficulty levels. School athletic competitions attempt to place comparable teams in competition; through the use of graded difficulty levels of school band music, groups from large and small schools may compete on fair terms. Composers continue to write new band music, and the greatly expanded availability of band literature has benefitted community bands by providing them with options in choosing literature that is appropriate to the level of their members.

Figure 6.19

© 2013 by MIMOHE. Used under license of Shutterstock, Inc.

School bands allow opportunities for musical, team, and social experiences, aiding in the education of the whole student.

GUIDED LISTENING 6.18

Wind Bands in American Society

As the popularity of school bands in America grew, so too did the need for a catalog of literature. Since all schools were not equal in size and resources, new band music was graded based upon level of difficulty and thus better taylored for types of school bands. Listen for woodwind, brass, and percussion instruments used in a controlled, symphonic approach to performance.

Music listening may be accessed from www.ourworldourmusic.com

For learning activities, practice quizzes, and other materials,
visit: www.ourworldourmusic.com

6.1 Worksheet

Name: _____

1. Explain why the twentieth century was called the American century.

2. Who were Orville and Wilbur Wright?

3. When was the Ford Motor Company founded, and what was its purpose?

4. What famous scientist developed the theory of relativity? Write the equation we remember as part of his theory, and tell what it represents.

5. The second decade of the twentieth century was a time of war. What are the dates of World War I?

6. World War I was mostly fought where?

7. How many deaths were associated with World War I?

8. Why was chemical warfare used in World War I, and do you think it was necessary?

9. Which country had a revolution during World War I?

10. What was the result of the revolution, and how did it affect America?

6.2 Worksheet

Name: _____

1. What two new constitutional amendments were passed in the Roaring Twenties?

2. What was the result of the Noble Experiment, or Prohibition?

3. Who were bootleggers?

4. Why was the Eighteenth Amendment to the U.S. Constitution reversed? Do you agree with the decision?

5. What were Jim Crow laws?

6. Explain what you understand "separate is inherently unequal" to mean.

7. What was the Harlem Renaissance movement?

8. Who was William Grant Still? List his "firsts."

6.3 Worksheet

Name: _____

1. What events led to the Great Depression in the United States?

2. What did our government do to help stimulate growth in the economy during the 1930s, and what were some of the long-lasting results?

3. What was the "Nazi Party"?

4. When it came into power, what changes did the Nazi Party make in Germany?

5. Why were Jews forced tto wear a six pointed star on their clothes?

6. How do some societal problems in Germany during the 1930s mirror problems in America's past?

7. What is the Holocaust?

8. Why did the United States enter World War II?

9. The dates of U.S. involvement in World War II are _____ .

10. Who used nuclear weapons in World War II? Do you agree with the decision? Why or why not?

11. What is an arms race?

6.4 Worksheet

Name: _____

1. Whom can we thank for the invention that records and plays back sound? When did this happen?

2. When did the radio become commercially available to the public?

3. Discuss how both the phonograph and the radio affected how people in our world experienced music.

4. What made the first half of the twentieth century one of the most radical periods in music history?

5. Near the turn of the twentieth century, most music was indistinguishable from that of the _____ period.

6. Which African-American composer wrote the opera *Ouanga?*

7. Who acted as the successor to Richard Wagner and Giuseppe Verdi?

8. The first opera produced with an entirely African-American cast was _____ .

9. Who composed the music for *Porgy and Bess?*

10. What did Claude Debussy mean when he said, "The century of the airplane should have its own music"?

11. What is Impressionism style?

12. Debussy was involved in many scandals but is remembered for his music. Describe his music.

6.5 Worksheet

Name: _____

1. Explain how twentieth century composers changed music with regard to dissonant and consonant sounds.

2. This Russian composer moved to America following the outbreak of World War II.

3. Which performance of a piece of music caused a full-scale riot in 1913, and what was the reason for the riot?

4. This insurance salesman won the Pulitzer Prize at the age of seventy-three for his Third Symphony. Give his name and describe his music.

5. Describe Expressionism in art.

6. One of the most famous examples of Expressionism in visual art is _____

 by the artist _____ .

7. What is atonal music?

8. Describe the tone row technique for avoiding tonality.

9. Who is considered the father of the tone row technique?

Name: _____

1. The Nazis labeled Arnold Schoenberg's music as _____ .

2. Why was Schoenberg's student, Anton Webern, shot?

3. Name two types of musical styles that were popular in the twentieth century.

4. This child prodigy from Hungary was one of the first composers to take recording equipment into remote areas to gather folk songs: _____ .

5. Which Brazilian composer used some of his country's folk songs?

6. Describe Aaron Copland's approach to music.

7. During the first part of the twentieth century, which new musical art form combined European music with other elements from Africa?

8. _____ incorporated jazz and popular music elements into both his concert music and his music for the Broadway stage.

9. George Gershwin helped jazz to become _____ .

10. What does the term *Exoticism* mean in music?

11. How and why did Exoticism change in the twentieth century?

12. Compare and contrast the use of percussion in the Baroque and Romantic periods to that of percussion use in twentieth century music.

13. Where would you have found a "Janissary band" performing?

Name: _____

1. Why have wind bands been historically associated with military activities?

2. Who was known as the March King, and why?

3. What is a sousaphone?

4. Who helped elevate the wind band to an *artistic* ensemble with his 1909 composition *First Suite in E-flat?*

5. Why are school bands important in schools today and what are some of their roles?

6. In the late nineteenth century, what type of band could one enjoy on a Sunday afternoon across America?

7. Which type of wind band is most common in America today? Why?

8. Discuss the purpose of grading the level of difficulty for a piece of music and how this applies to a school music program.

9. Why was there a dramatic increase in the amount of music written for concert use by wind bands near the middle of the twentieth century?

6.8 Worksheet

Name: _____

Define the following terms:

1. $E = mc^2$

2. World War I

3. the Noble Experiment

4. bootleggers

5. Jim Crow laws

6. Harlem Renaissance

7. the Great Depression

8. Adolf Hitler

9. World War II

10. phonograph

11. Impressionism

12. polyrhythm

13. polytonality

6.9 Worksheet

Name: _____

Define the following terms:

1. Expressionism

2. atonal music

3. tone row technique

4. neoclassicism

5. nationalism

6. jazz

7. Exoticism

8. wind band

9. sousaphone

10. town band

11. community band

Our Rapidly Changing World

SECOND HALF OF THE TWENTIETH CENTURY THROUGH TODAY

Music reflects the society in which it exists, and radical changes within a society are reflected in changes to the society's music. Knowledge of societal events helps in understanding a period's music. The period from 1950 until today is the full bloom of the American century. After its deciding role in World War II, America became an industrial, technological, military, and economic world leader, termed a superpower. The other superpower for most of this period was the Soviet Union. After the fall of the Soviet Union, the United States emerged as the world's only superpower, causing it to be feared, envied, admired, and even hated to the point of becoming the target of extreme religious fundamentalists with visions of world conversion and domination.

Unprecedented Pace of Technological Advancement

Building upon the scientific and technological advances of the first half of the twentieth century, advances since 1950 have come at an exponentially rapid rate. Almost every facet of life during this period was affected by technological advances. Manufacturing in the early twentieth century changed as a result of the application of the assembly line. In the second half of the century, the implementation of automation and robotics increased productivity, reduced cost, and improved consistency of quality. These advances in manufacturing resulted in the movement of labor-intensive manufacturing to areas of the world that were less developed and where labor could be hired at lower rates. More advanced areas of our world began to shift from manufacturing to information-based economies.

Figure 7.01

Advances in technology dramatically impacted approaches to manufacturing goods, as robotic devices often took the place of low-skilled workers.

© 2013 by Nataliya Hora. Used under license of Shutterstock, Inc.

Cold War Era

After two world wars during the first half of the twentieth century and the detonation of atomic bombs in Hiroshima and Nagasaki, most world leaders feared that a third world war would end life on our planet. The two superpowers, the Soviet Union and the United States,

Figure 7.02

© 2013 by John Wollwerth. Used under license of Shutterstock, Inc.

Nuclear warhead equiped missiles sit fueled and ready in silos around the world, awaiting someone to push the launch button.

suspicious of and antagonistic toward each other, also feared the outcome of directly engaging each other in war. They built arsenals of nuclear bombs and missiles capable of destroying each other many times over, reasoning that neither would attack if there was a promise of mutually assured destruction (MAD). Each side practiced brinkmanship, similar to a game of chicken, provoking each other without crossing the line into war. Instead of fighting each other directly, the United States and the Soviet Union practiced what was termed a Cold War, openly supporting opposite sides of confrontations throughout the world as a means of testing their continuously developing weapons via proxies.

During the second half of the twentieth century, China gained the status of a major world power, based upon its military and economic strength. Near the end of the twentieth century, the Soviet Union, with its Communist-based economy, collapsed. A new government arose, and although the new Russia's economy continued to struggle, it maintained a position of power in our world, based primarily upon its stockpile of nuclear weapons and the MAD strategic balance of the past.

Half a Century of Cultural and Societal Revolution

While societal change during the first half of the twentieth century proceeded at a pace well beyond that of previous periods in history, that rate of societal evolution and revolution seems quite sedate when compared with that of the second half of the twentieth century, when each decade seemed to be dramatically different than the one before.

1950s Society

Several events influenced the shape and direction of society in the 1950s. Soldiers returning from World War II began families, triggering a population explosion. These soldiers' children make up the largest generation segment in our society and are known as the Baby Boom generation, Baby Boomers, or sometimes simply Boomers. The growing, maturing, and aging of this population bubble continues to affect American society. No other country had a similar post-war population increase and no other country has a Baby Boom generation.

Returning soldiers of color who fought for America during World War II refused to return to being second-class citizens. Seeds of discontent planted in the late 1940s grew into the civil rights movement during the 1950s. In 1951, a lawsuit was filed that reached the U.S. Supreme Court three years later. With the 1954 Supreme Court ruling in *Brown v. the Board of Education of Topeka, Kansas*, segregated schools were abolished in

Figure 7.03

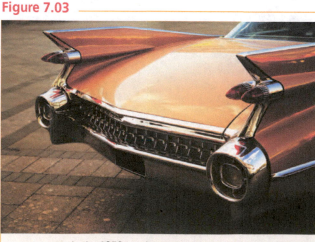

© 2013 by Sergios. Used under license of Shutterstock, Inc.

In the 1950s, rockets were on everyone's mind, including automobile manufacturers and buyers.

America. A year later, in Montgomery, Alabama, Rosa Parks's refusal to follow a bus driver's instruction to give up her seat to a white passenger fueled civil action, launched a bus boycott, and brought attention to other practices of racial segregation, including businesses that refused to serve people of color and public facilities such as restrooms and water fountains that were reserved for whites or nonwhites. A young Baptist minister named Martin Luther King Jr. became a leader in this movement.

With the nuclear arms race and contest for scientific and technological advances applicable to war, the Soviet Union and the United States sought ever more powerful weapons and means to deliver them. In 1957, the Soviet Union jumped ahead when it launched the first satellite into orbit. *Sputnik*, with its onboard radio sending out a "ping" every few seconds, was a wakeup call to the United States that weapons based in space could provide one side with a distinct military advantage. The space race began and the American education system was revised to produce more mathematicians, engineers, and scientists.

As Supreme Commander of Allied Forces in Europe during World War II, General Dwight D. Eisenhower experienced the German national autobahn high speed highway system and immediately understood its value for rapid transfer of military materials. Becoming President in 1953, he made the creation of a similar system in the United States a priority, resulting in the Dwight D. Eisenhower National System of Interstate and Defense Highways, now commonly called the interstate highway system. This system grew into the vast web of highways that we know today.

1960s Society

In his inaugural address in 1960, President John F. Kennedy set forth the American goal of landing a man on the moon and safely returning him to Earth before the end of the decade. Brinksmanship games continued, and for a few days in 1962, after the Soviet Union began to install nuclear missiles 90 miles off the coast of the United States in Cuba, the world teetered on the edge of nuclear war. The United States demanded the removal of the missiles and blockaded the coast of Cuba to prevent the Soviet Union from delivering more materials. Soviet ships took position just outside of the blockade and threatened to push through the American lines. Both sides stood firm in their resolve, came to their highest levels of war readiness, and restated their intention to follow through on their threats. Finally, the Soviets blinked. Nuclear, probably extinction inducing, war was averted and the Soviets removed the missiles.

The civil rights movement continued. At the 1963 March on Washington, King delivered his famous "I have a dream" speech that called for equality and harmony. The next year, the Twenty-fourth Amendment to the U.S. Constitution abolished taxing the right to vote. That year, the Civil Rights Act of 1964 was signed into law by President Lyndon Johnson and Martin Luther King was awarded the Nobel Peace Prize. In 1965, a protest in Selma, Alabama, turned bloody, Johnson signed the Voting Rights Act of 1965 into law, and he signed an executive order requiring equal employment opportunity by all federal contractors.

Figure 7.04

In his inauguration speech in January, 1961, President Kennedy challenged, "Ask not what your country can do for you - ask what you can do for your country." Less than three years later he was dead.

Violence continued to mark the 1960s. In 1963, Kennedy had been assassinated during a trip to Dallas, Texas. An unpopular war in Vietnam grew. Fueling the unpopularity was the military draft, a federal program that selected young men through a somewhat random process and required them to perform several years of military service, including being sent into war zones. Protests against the war and the draft grew throughout the decade, often turning violent. In 1967, two more assassinations rocked America: King was shot and killed while in Memphis, Tennessee, working in support of striking sanitation workers, and Robert Kennedy, brother of the slain president and an important figure in the civil rights movement, was shot and killed following a speech as a presidential candidate in Los Angeles.

Less dramatic but also society-changing was the shift throughout the 1960s from propeller planes to jets in commercial air travel, a move that again sped up the pace of our world. The development and placement of orbital communications satellites throughout the decade greatly improved worldwide communication. The introduction of the birth control pill, which was approved by the U.S. Food and Drug Administration in 1960, was another society-changing event. The historical dynamics of dating, living as married partners, and creating families changed radically. The decade ended with the fulfillment of the goal articulated by President Kennedy in 1960: in 1969, the United States landed men on the Moon and returned them safely to Earth.

1970s Society

The Vietnam War and the military draft both ended during the 1970s. Society became enthralled with electronic technologies that continued to be offered in consumer products. Cable television was offered in some cities, prompting some to say that it could never become popular because people would not pay for something that they could get free with a simple antenna. Videotape recorders were first offered for consumer use. These units, initially quite expensive, followed the path of most consumer electronic devices by steadily declining in cost as they increased in popularity. Videotape recorders did for entertainment what audio recorders had done for music: they enabled on-demand at-home access to entertainment by nonaristocrats for the first time in history.

Our world had some of its first experiences with limitations of available energy. When the Organization of the Petroleum Exporting Countries (OPEC) withheld exports of oil in 1973, gasoline shortages quickly followed. Prices increased dramatically, gas lines became common, and the U.S. government responded by enacting a national maximum speed limit law in 1974. The "double nickel" or fifty-five miles per hour speed limit governed all travel in America throughout the 1970s and beyond.

Figure 7.05

Our modern gas prices grew from the energy challenges that began to appear in the 1970s. This pump reflects the cost of a gallon of gasoline in 1971; it had more than doubled by the end of the decade.

1980s Society

Analog electrical devices are particularly susceptible to variations in input voltage. Atmospheric conditions, transmission of electricity over long distances, and electrical use by other devices sharing a single power source can all result in delivery of unstable voltages.

During the 1980s, our world began to shift from analog to digital technology. Today, almost all electrical and electronic devices use digital technology.

One digital device, the personal computer, was introduced by IBM in 1981. Early personal computers had only a fraction of the computing power of a modern mobile telephone yet had undergone considerable advancements. Previously, computers had taken up entire rooms. Climate had to be carefully controlled, as a change of only a degree or two in temperature could yield unpredictable results in calculations. The new digital personal computers were not as susceptible to such issues and were small enough to sit on a desk. The use of personal computers revolutionized the way many things were done, a revolution that continues today.

Commercially available mobile telephones became available in the 1980s. Early mobile telephones, using primarily analog technology, were large machines requiring significant power. Many were mounted in automobiles, using available electrical power. Early handheld mobile telephones were called "bag phones" because the telephone required an enormous battery and the entire unit was usually mounted in a carrying bag the size of a lunch box. One of the first all-in-one mobile telephones was known as a "brick" because it was about the size and weight of one.

A new disease showed up in our world during the 1980s. This disease, acquired immunodeficiency syndrome (AIDS), confused doctors until they realized that it was a symptom of infection by the human immunodeficiency virus (HIV). HIV progressively compromises the body's ability to fight off infection, becoming AIDS and allowing other opportunistic diseases to thrive when they normally would not survive. The method of propagation was finally determined to be exchange of body fluids. At this time, the disease has no cure. It is often fatal, and once a person is infected, that individual remains infected for life. Today, more than thirty-five million people in our world are infected with HIV, and more than twenty-five million of those are in sub-Saharan Africa. Some countries in Africa report as much as 25 percent of their population is infected with the disease. The World Health Organization has classified HIV/AIDS as a pandemic.

Energy issues continued to affect our world during the 1980s; however, new sources of petroleum were identified and accessed, helping to lessen the grip of the OPEC nations on the world's petroleum supply. As a result, after thirteen years of a national fifty-five-miles-per-hour speed limit, the law was amended in 1987 to allow for speeds up to sixty-five miles per hour on interstate highways.

Figure 7.06

Early, all-in-one "brick" mobile phone. Air time was expensive, call clarity was poor, and battery consumption was measured in minutes, but the cool-factor made it all worthwhile.

© 2013 by mikeledray. Used under license of Shutterstock, Inc.

1990s Society

In the first months of the new decade, the Communist government of the Soviet Union collapsed. Elections over the next year resulted in a representational government. The collapse of the Soviet Union left the United States as the world's only superpower. Both America and Russia struggled to find their new roles in the world.

Figure 7.07

Prior to internet availability, every computer was a stand-alone machine. Information could only be shared by saving it to a disk and carrying it to another computer.

© 2013 by Pan Xunbin. Used under license of Shutterstock, Inc.

Apartheid, meaning separateness, was a legally mandated and enforced system of racial segregation in South Africa. During the first half of the twentieth century, people of different races were forced to move to racially segregated districts. People of color were stripped of national citizenship and assigned tribal citizenship based upon their district. Separateness included segregation not only of living areas but also of education, access to health care, and other basic services. Apartheid was dismantled in 1994, and Nelson Mandela, an activist who had been jailed for protesting apartheid, was elected president of South Africa.

In the early 1990s, access to the Internet, previously limited to universities and governmental agencies, became available to everyone. It was not until the development of easy-to-use software that Internet use became popular. Initially limited to connection over telephone lines, Internet access was slow and download of files routinely took hours. Modern broadband access accomplishes these same tasks in seconds.

Evolving throughout the 1990s, small, handheld mobile telephones, based upon digital technology, replaced the large analog units of the 1980s. Digital telephones offered clearer reception, and networks continued to expand, providing service to more areas. The development of pocket-sized devices, ease of portability, and continually increasing numbers of users created a new issue for society to address: mobile telephone etiquette.

In 1995, the national speed limit laws were repealed and states took control of these regulations. Analysis indicates that more than two decades of reduced speed limits had only yielded a total energy savings of one percent or less.

2000s Society

The new millennium brought with it new challenges and expansions of old ones, including addressing terrorism and suicide terrorist activities. On September 11, 2001, religious fundamentalist terrorists hijacked four commercial passenger jets, flying two of them into the World Trade Center in New York and one into the Pentagon in Arlington, Virginia. The fourth, redirected to Washington, D.C., was retaken by the passengers but crashed during the process. All passengers onboard the four airliners were killed. All of the hijackers died. The World Trade Center was destroyed, and the Pentagon damaged. More than three thousand people from ninety countries died; almost all were civilians.

In 2003, the United States and a coalition of other nations invaded Afghanistan and Iraq, deposing their leaders in answer to the attack. While direct links to the September 11 terrorists were evident in Afghanistan, the link to Iraq proved to be more tenuous.

The city of New Orleans, Louisiana, and the Gulf Coast of the United States from Florida to Texas were devastated by Hurricane Katrina in 2005. Levees protecting New Orleans, a city built below sea level, failed as a result of the storm and the city flooded. Storm surge, especially to the east of the city, simply wiped away existing structures. New Orleans,

a major American city and international port, had to be evacuated. This was the largest natural disaster in the history of the United States.

Growing energy shortages manifested themselves in 2008 when gasoline rose to its highest price ever. More efficient automobiles and alternative sources of energy continue to be developed. Also arriving in 2008 was a worldwide economic recession that has proved to be the worst since the Great Depression of the 1930s.

Lifestyle technologies continued to advance in the new millennium. Computers, once considered small when they could fit on a desktop, continued to shrink. Cathode ray tube monitor screen technology was replaced with flat-screen, liquid crystal display technology resulting in larger viewing screens that required less desktop space, as well as enormous television screens in living rooms. Desktop computers continued to also shrink in market share, as portable laptop computers became ever more popular and less expensive. Wireless access to the Internet became the norm. Almost every portable device was equipped with wireless technology and many businesses found themselves expected to offer wireless Internet access to their customers. As the line between digital computers and digital telephones continued to blur, new "smart phones" that could take on tasks of both of these devices emerged, allowing people to talk, text message, check email, surf the web, and connect in other ways from anywhere during their daily lives.

Various forms of a global positioning system (GPS) had been in development since the end of World War II but were often hampered by Einsteinian relativity physics that saw time in the gravity of earth passing at a different rate than in the weightlessness of space. Working out a solution, modern satellite-based GPS began in the 1970s as a U.S. Department of Defense project, became available commercially in a lesser, purposely-degraded form in the 1980s, was used extensively by the military in the 1990s, and became available in its non-degraded form to all users in 2000, resulting in new gadgets for automobile use—GPS units. In 2004, the first use of GPS in mobile phones was released and in the late 2000s, with the rise of smartphone use, GPS devices were so common that many people no longer felt the need to learn map reading skills.

In 2009, just over fifty years after the U.S. Supreme Court ruled against segregated schools and Rosa Parks refused to give up her seat on a bus, one success of the civil rights movement was presented when Barack Obama, son of an American woman from Kansas and a black man from Africa, was sworn in as the forty-fourth president of the United States.

Figure 7.08

The attack of 9/11/2001 destroyed two buildings, killed thousands of people, made national heroes of the NYPD and FDNY, and led to the US being embroiled in war that shaped the country's thought for over a decade.

Figure 7.09

The One World Trade Center replaced the World Trade Center twin towers that were destroyed on September 11, 2001.

2010s Society

This decade is the first when more of our world's people live in cities than in rural areas. Improvements in medicine and greater access to it, along with declining birth rates in developed nations, resulted in the oldest average age (30) of our world's population ever. In the U.S., because of the Baby Boom generation, the average age is 38. Life expectancy in 1900 was to the mid-40s and today average U.S. life expectancy is into one's 80s—almost doubled due to medical advances.

In the 2010s, China became our world's second largest global economy and was recognized in 2011 as a superpower. Revolution against governments in the Middle East resulted in civil war and the ouster and/or execution of several rulers. This movement, called Arab Spring due to the timing of its initial events, affects many governments throughout the region.

In the United States, the Great Recession continued to show evidence of economic recovery, though unemployment and underemployment did not keep pace with the recovery. Many young professionals in the new millennium still find economic independence to be challenging. One challenge is their accumulation of significant debt in the form of college student loans. Withdrawal from the war in Afghanistan proved to be even more difficult than withdrawal from the war in Iraq. In spite of both of these negatives, President Barack Obama was reelected in 2012. One of the signature actions of his administration was sweeping changes to the US health care system, reforms that make themselves felt throughout the decade.

Extreme violence perpetrated by individuals against multiple random victims, often in settings that one would consider to be safe such as restaurants, shopping centers, and airports, continued to grow in number throughout our world. Extremism, evidenced by suicide-type attacks against soft, civilian targets, angered and frustrated much of our world. In the U.S., terror attacks, both by religiously motivated individuals and by those suffering from mental health disorders, prompted increased numbers of individuals securing concealed-carry gun permits as well as changes in gun laws. Many states began to allow their citizens with gun permits to carry weapons into areas where they were previously prohibited, including malls, theaters, and even schools and universities.

Failures of complex machines resulted in at least two instances of pollution damage on a large scale. An explosion on a drilling rig caused it to sink, leaving the well it had drilled to gush almost five million barrels (over 200 million gallons) of crude oil into the Gulf of Mexico, the worst marine oil spill in history. It closed down the region's fishing and tourist industries and required billions of dollars in cleanup activities. Fishing, shrimping, and other food-gathering activities continue to be banned in some areas where large amounts of oil and tar are still found. Another large pollution event took place half a world away, when a tsunami damaged two nuclear power plants in Japan. Radioactive water leaked into farm and fishing areas and these places are still not safe for producing or gathering food.

Computing, an important part of modern life, saw several major changes. One was the shift away from housing data and software within on-desk or laptop machines, instead placing them in "cloud" storage within the internet to be shared between multiple users. This

shift reduced resource requirements, enabling smaller, simple devices to have access to powerful programs and extensive data banks. Another computing change was the introduction and amazingly fast acceptance of tablet-based computers that abandoned traditional concepts such as large data storage, built-in keyboards, and mouse-like pointing devices. These tablet computers were small, lightweight, and combined the keyboard, mouse, and display screen into a single unit that was driven by touch and finger movements. Inexpensive tablet devices quickly caused sales of traditional laptop computers to decline significantly. As part of the new tablet computing approach, traditional software found itself out of favor, replaced by inexpensive applications (called "apps") that required far less resources.

The film and television industries that dominated pop culture since the 20th Century found themselves struggling due to consumers' movement to online, on-demand entertainment —often viewing these on new tablet computing devices or smart phones. The number of cable television subscribers declined as users shifted their viewing, and their dollars, to online streaming services. Television manufacturers quickly responded by building onboard internet capabilities into their TVs in order to try to maintain the large, living room TV as a component of modern lifestyle.

Computer gaming reflected many of the things noted above. One example is that computer games are no longer associated only with children and teenagers; the average age of a person who plays video games is now 30 years old. Computer games moved away from in-box software applications to cloud-based offerings that allow greater interaction between online players. Gaming also shifted its focus from dedicated game boxes to tablet and smart phone-based approaches. As social media concepts from the previous decade combined with new ideas about gaming, the result was games associated specifically with social networking sites.

Several movements continue throughout the decade, including focus upon "green" technologies that are more energy saving in use and more recyclable when their functionality has been superseded by something new. Interest in green automobiles, green design architecture, and green energy sources continues to reflect the changing priorities of citizens of the third millennium world. Global awareness of the plight of others can be seen in choices by many people to shun products that are produced through taking advantage of the people of poor countries, especially their children. Greater acceptance of others' lifestyles drove movements to support same-sex marriage, resulting in a U.S. Supreme Court ruling that made same-sex marriage legal. Interestingly, in spite of all of the forward motion, fashion and music find themselves experiencing several retro approaches, influenced by the 1980s.

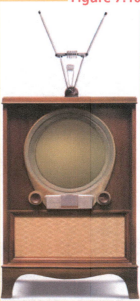

Figure 7.10

Early televisions projected a small black and white image on the inside of a large bulb-shaped tube, but they still took their viewers to new, exciting places.

© 2013 by James Steidl. Used under license of Shutterstock, Inc.

TECHNOLOGY AND MUSIC

Many lifestyle technologies emerged after 1950. They provide for ease of communication, entertainment, and transmission of information. Music, a part of the human experience, often found inclusion in these technologies.

Advances in Communications Technologies

Radio was the dominant communications technology of the first half of the twentieth century, bringing news, entertainment, and music into the home. In the 1950s, a new technology became commercially available to consumers: television. Its impact upon society was profound. Radio had brought the concert hall to the living room. Television

transported the viewer to the concert hall. Not only did the sound of the music reach remote audiences, but those audiences participated in the concert experience.

Radio of the first half of the twentieth century used a technology called *amplitude modulation,* also known as *AM radio. Frequency modulation,* known as *FM radio,* resulted in less static interference and became extremely popular in the 1970s. This technology permitted two independent data streams to exist side by side. FM receivers decoded these two streams into instructions for independent left and right speakers, resulting in stereo sound, an improvement over AM radio's monaural (one sound) technology.

Another communications technology, the Internet, not only offers the radio experience through computer speakers and the television experience via the computer screen but also adds an interactive experience, allowing the viewer to interact with sound and image in ways that previously were never possible.

Advances in Recording Technologies

Many recording and playback technologies have been used since 1950. Almost every advance not only provided the consumer with a more stable platform but also enhanced audio reproduction.

Phonograph

Phonograph records use an analog technology that records data as bumps and dips; silence is a smooth surface. Record disks have a single line, or *groove,* that spirals from the outside edge toward the center, leading the tone arm along a data-gathering path. In the 1960s, a pleasing record was called *groovy* because it had good sounds stored in the groove; the term came to be used to indicate pleasure with something or someone. Phonograph records are susceptible to scratches. A slight scratch is interpreted as a data bump or dip and results in a "pop" sound every time the record spins and the tone arm comes into contact with the scratch. Deep scratches either cause the tone arm to skip over one or more grooves toward the disk's center, omitting data, or to skip back toward the disk's edge, repeating data endlessly. This phenomenon prompted the phrase "sounding like a broken record," meaning to say something repeatedly.

The phonograph record format of the early twentieth century first required that the disk spin at a rate of seventy-eight revolutions per minute (rpm), providing playback lengths of about four minutes per record side—usually sufficient for a single song. Longer pieces of music were spread across several disks and required the listener to frequently turn over or change disks. In the late 1940s, a new format called the *long-playing,* or *LP,* record was released. These new records relied upon enhanced phonograph technology that allowed the disk to spin more slowly, at 33 1/3 rpm. The slower speed, coupled with tighter placement of the record grooves, allowed playback lengths

Figure 7.11

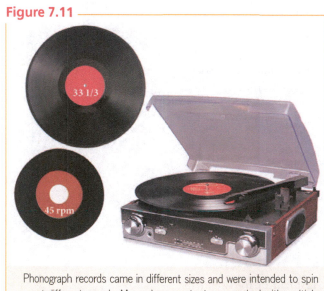

Phonograph records came in different sizes and were intended to spin at different speeds. Many phonograph players worked with multiple record formats.

of up to twenty-six minutes per side. Larger-sized disks produced even longer playback times and were sometimes labeled as *extended play*, or *EP*. The new medium allowed artists to put several songs on a single disk, giving rise to the concept of the album project. In the late 1950s, advances in recording technologies allowed different information to be stored on each side of a record groove, resulting in stereo playback.

About the same time that the LP record was first introduced, a smaller, similar format appeared. This record was designed to hold one song per side with a maximum playback length of about four minutes per side. Using the tightly packed grooves of the LP record, it was only seven inches in diameter. These disks spun at a rate of 45 rpm and were commonly known as *45s* or *singles*. They had a much larger center hole because they were designed for mechanical use in jukeboxes; the larger hole would automatically center the disk when slipped over a tapered shaft.

Analog Tape

The magnetic audiotape recording format was originally developed in Germany during the 1930s. Since it had potential military applications, the Nazis did not release the technology to the rest of the world and the format was not commercially available until the late 1940s.

An analog technology, magnetic tape is made up of a layer of iron oxide particles glued to a plastic backing ribbon and covered with a smooth, flexible shellac. When placed in the presence of a magnetic field, the iron oxide particles align and store the magnetic charge. Microphones convert into electricity the fluctuations in the vibrations that make up sound. Electromagnets convert electricity into magnetism. Connecting these devices and moving a ribbon of tape past the charged electromagnet at a constant speed results in fluctuations in the magnetic field being stored on the tape in the order and time sequence in which they occurred. The tape can then be rewound and the magnetic representation of the sound can be moved past the uncharged electromagnet. The magnetism stored on the tape creates a fluctuating electrical current in the electromagnet. Sending the electrical current to an audio speaker results in the original sound being heard. The audiotape recording may also be stored for extended periods yet retain the magnetic charges that represent the sounds.

A few simple guidelines help in understanding variations in analog magnetic audiotape formats. One is that the faster that tape moves past the electromagnet (called the *tape head*), the better the storage and reproduction of high frequencies. Another guideline is that the wider the strip of magnetic data, the better the storage and reproduction of low-frequency (bass) sounds. Most formats use multiple tape heads (usually two) to simultaneously read or write to parallel *data strips* (also called *tracks*). Two strips result in stereo recording and playback. Four strips were used for a time in the 1970s to create *quadraphonic playback*, an early form of surround sound. Recording studios often used machines with extremely wide tape that provided multiple tracks and special tape recorders that could play some tracks while recording on others.

Figure 7.12

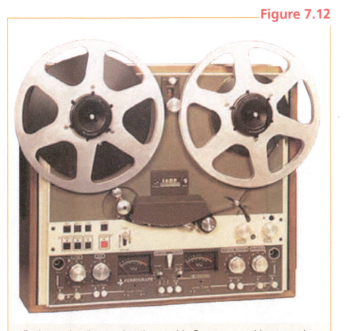

Reel to reel audio recorders, invented in Germany, used large spools of audio tape.

Figure 7.13

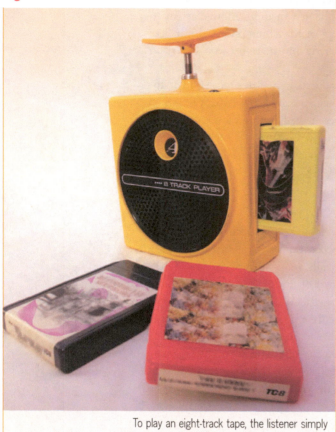

To play an eight-track tape, the listener simply plugged it into the tape player.

Figure 7.14

The cassette audio player/recorder was much easier to use than reel to reel machines because cassette audiotape was self-contained. Unlike the eight-track player, the cassette player could rewind tape and allow the listener to immediately re-hear a selection.

Reel-to-reel tape recorders had the fastest-moving, widest tracks in consumer use. The sound from these machines was the best available; however, the tape reels had to be large to hold enough tape for even a few songs. It was also a delicate operation to attach the tape reels and thread the tape through the machine.

In the mid-1960s, a simpler format arose. The eight-track cartridge was a closed box a little smaller than a paperback novel. The tape was exposed at one end but was recessed into the package to protect it. To listen to music, the consumer simply plugged the cartridge into a compatible machine. No threading was necessary. The tape was stored inside the cartridge as a continuous loop, pulling from the center of the spool while it wound tape around the outside of the spool. Once inserted into a player, an eight-track cartridge would continue to play and the double (stereo) tape head would physically move from one pair of tracks to the next, allowing four different programs from the eight magnetic tracks on the tape. Unfortunately, this format tended to destroy its tapes by continually stretching them as it pulled from the center of the spool. By the end of the 1970s, the format had been replaced.

The cassette audiotape used two spools, with tape winding from one to the other much like the reel-to-reel tape format. The spools, however, were much smaller and were enclosed within a protective box. Like with the eight-track cartridge, the consumer simply plugged the cassette into the tape player; no threading was necessary. Cassette tape format used the slowest speed and narrowest tape path of all formats; its sound quality was the worst of all analog tape formats.

Digital Technologies

As with most other approaches to electronic devices, audio recording underwent a major shift in the 1980s when it moved from analog to digital technology. Analog recording stores louder sounds as stronger magnetic fields and softer sounds as weaker magnetic fields. Since the movement of the tape past the tape head creates a constant amount of static electricity, significant limitations existed on how soft a sound could be and still be heard over the background hiss of the tape. Also, as analog recordings sit on a shelf and age, they tend to lose magnetism, giving up the sounds that were stored on the tape. Placing magnetic

recording tape anywhere near a magnetic field, such as those present in and around speaker cabinets, greatly accelerated the tape's loss of magnetism. Digital technologies convert the analog electrical signal into numbers (a digital representation) and simply store the numbers. At playback, the numbers are converted back into an analog electrical signal and sent to the speakers. Our ears are analog devices and must receive analog input. Speakers are also analog devices. Contrary to some manufacturers' advertisements, there can be no such thing as digital speakers.

Digital Audiotape—In the mid-1980s, audiotape gave its last gasp in its final incarnation as digital audiotape (DAT) and digital compact cassette (DCC). DAT was enclosed in a box about half the size of a cassette tape and was intended as a professional format for use in recording studios. DCC was the same size as a cassette tape and was designed as a consumer format, since both DCC and analog cassette tapes could be played in a single, dual-use machine. Digital audiotape formats stored the digital (numerical) representation of the sound on magnetic recording tape through an analog process. Because of the limitations of other technologies, digital audiotape formats were the only read/write digital audio formats that were commercially and economically available. The formats were short lived, thanks to advances in audio recording technologies.

Compact Disc—In 1982, the compact disc (CD) was introduced. Its physical size was determined by the capacity initially desired. One story indicates that the determination of how much material a CD should be able to hold was based on the length of a performance of Beethoven's Ninth Symphony: seventy-four minutes. A disc 120 mm in diameter was required to hold that much data, and that size became the standard. Later advances in technology pushed the amount of data capable of being stored beyond the initial determination; however, no change in standard physical size has occurred.

The CD is a digital device, storing numbers that digitally represent sounds. Unlike audiotape, magnetism plays no part in CD technology. The CD stores data in an optical format. A laser is directed on one side of the disc as it spins. The laser reads data as either dark or reflective areas representing ones and zeros. Data is stored on paths leading from the center of the disc to the edge, unlike the phonograph record's edge-to-center path.

Initially conceived and designed as an audio format that would replace the LP record, CD technology was quickly adopted as a data storage medium for any type of digital data. The advent of read/write devices and discs cemented the CD's place as a storage device for use with computer files.

Digital Video Disc—The digital video disc (DVD) became available to consumers in the United States in the late 1990s. As with most consumer electronic

Figure 7.15

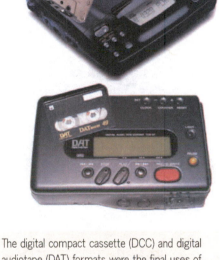
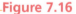

The digital compact cassette (DCC) and digital audiotape (DAT) formats were the final uses of magnetic audiotape. New read/write data storage mediums quickly replaced them before they even found solid footing in industry or consumer use.

Figure 7.16

The compact disc, or CD, was the first commercially successful digital medium for distributing music.

devices, it was initially expensive yet over time the cost gradually dropped and its popularity steadily increased. While it uses an optical format and was designed to have the same physical dimensions as the CD to allow a single device to play back both types of discs, the DVD uses an advanced technology that permits storage of about six times as much data as a CD. DVDs did not make a significant mark as an audio distribution medium, however, until the increased storage capacity made distribution of a concurrent technological advance possible: surround sound.

Surround Sound—Initially, sound recording was monaural, capable of recording only one stream of data and playing only one stream. Early phonograph records and early reel-to-reel audiotape used this technology. We have two ears that usually receive different data while listening, allowing us, among other things, to close our eyes and still determine where a sound source is located. Recording sound with two distinct simultaneous streams of data and then playing these back through two strategically placed speakers results in a more realistic, stereophonic sound. (The best way to place stereo speakers is to determine where you want to sit when you listen and then put the speakers at angles level with your head, creating an equilateral triangle with your head at one point and the speakers at the other two.)

Figure 7.17

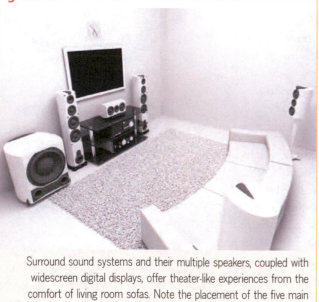

Surround sound systems and their multiple speakers, coupled with widescreen digital displays, offer theater-like experiences from the comfort of living room sofas. Note the placement of the five main speakers that combine with the large low frequency speaker to make up a 5.1 surround sound system.

Surround sound technology puts the listener in a room or place and offers the ears data that fills in the space all around the listener. This is done through the use of multiple audio speakers, each connected to its own data stream. Walt Disney used an early type of surround sound in the 1930s to enhance the movie *Fantasia*. Another early type of surround sound, discussed earlier in this text, was quadraphonic sound, used in the 1970s. Modern surround sound uses six distinct data streams that drive five full-range audio speakers and one speaker that is optimized for the production of low frequencies. This format is called *5.1 surround sound* and was developed for use in movie theaters. The popularity of home entertainment systems has brought the use of surround sound systems into living rooms, and DVD discs and players are capable of storing and delivering these widescreen digital video and surround sound audio presentations.

Digital Music Player—Technological advances, especially in digital storages devices, have continued to provide increasing storage capability for ever-smaller devices. Combining relatively large storage devices, simple onboard file management, and a plug for headphones resulted in digital music players. The first commercially available devices appeared in the late 1990s, followed by the most common device, the Apple iPod, in 2001. These devices, successors to the personal mobile CD player, store audio files and allow the listener to

manipulate the order in which they are played. Storage capacities continue to grow, allowing listeners to store vast libraries of music on a single handheld device, and these handheld devices often integrate telephones, computers, digital music players, and other capabilities into a single unit.

Internet Distribution

When phonograph records were first marketed, it was common to include on the label the name of the store from which they were purchased. Throughout the twentieth century, publishers and distributors of recorded music were able to maintain control of access to their product because it was provided to consumers in a physical format. Piracy of recorded music was either not possible or, later, resulted in inferior analog copies. Digital technology made piracy easier because each copy or copy of a copy was just as perfect as the original. Distribution still required physical media, so record companies, composers, and recording artists could count on a successful album or song generating income. Internet distribution requires a new system. Several approaches have been tried, including rights management systems that lock data so that it cannot be copied. Every technological advance for securing copyright ownership of music seems to be met with another advance that finds a way around the security technology. At present, no definitive solution exists to the issue of protecting music copyrights in our digital age.

One approach that has become standard is to stream data that makes up a song playback instead of sending and storing the entire audio file at once. The receiving device processes a streamed data packet, plays the sound created by that data, and then discards the data and moves on to the next packet. This approach reduces storage requirements in playback devices and also helps to safeguard the copyright owner's property, since a complete copy of the song is not stored on the listening device. Consumers benefit through being able to listen to a variety of music without being forced to purchase each song individually. Music service providers, such as the one used to supply the music that accompanies this textbook, allow consumers to pay a monthly fee and listen to unlimited music. You are able to do this through the music service account that is included in the cost of this book. Many music service providers allow the user to create personalized radio stations that automatically select and play music, based upon personal preferences and history of listening by the user. An additional benefit of streaming music

Figure 7.18

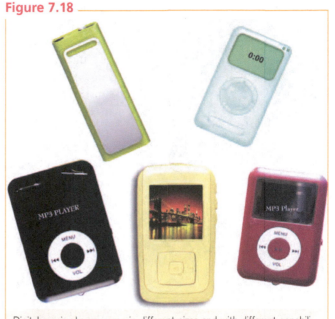

Digital music players come in different sizes and with different capabilities. Some can serve as both audio and video playback devices. These stand-alone devices are increasingly being replaced by multipurpose units that can also act as telephones.

Figure 7.19

Smartphones can function as telephones, web browsers, contact list databases, word processors, e-book readers, music players, and many other devices. Listening to streaming music with a smartphone is an everyday experience in the 2010s.

Figure 7.20

Electronic instruments come in many styles and can utilize a variety of techniques, such as this wind controller, for triggering synthesized sounds.

technology is that it enables multipurpose devices like smartphones to make more effective use of storage capacities, helping to reduce the hardware requirements and cost of these devices.

Internet distribution of music, the most common method of obtaining music for listening today, usually uses MP3 format files that are read by digital music players. A data compression scheme is applied to these files, making them eleven times smaller than CD files, enabling quicker transmission over the Internet, and requiring less storage space in digital audio players. Interestingly, this data compression also results in a recording that is inferior to CD-quality sound and marks the first time in the brief history of recorded music that we seemed to move backward in embracing a lesser quality of sound reproduction.

Instruments

Most advances in instruments since 1950 involved the use of electronics. Leo Fender and Les Paul both worked on electric guitar designs. Fender's company also created a smaller, guitarlike electric version of the double bass called the electric bass guitar. Robert Moog designed a commercially available portable synthesizer that brought an entirely new palate of sounds to the stage. Products of the 1950s and 1960s, all of these devices used analog technology.

In the 1980s, digital synthesizers were developed. These devices stored programs (sounds) as numbers (digital data), allowing sounds and timbres to be instantly recalled. Initially limited to musical control through a piano-type keyboard, other controllers followed. Musicians more comfortable with wind, percussion, or stringed instruments could find devices that would allow them to perform in familiar ways and have those performance instructions sent to a synthesizer programmed to produce any sound imaginable.

MUSIC SINCE 1950

Although art music has continued to evolve, it has moved ever further from the mainstream of society's preferences in music. The rise of pop culture and the music that reflects it are discussed in Chapter 8 of this text. Many musical approaches have affected both art music and pop music.

Increased Interest in Traditional Music of Other Cultures

As communications technologies advanced, people throughout our world found more opportunities to experience and explore music of other cultures. These different types of music have influenced Western music, and Western music has influenced them. Some governments, in an effort to preserve their cultural heritage, support or subsidize practitioners of their traditional music.

India

Traditional music of India may be divided into two types, Carnatic and Hindustani, different in both makeup and geographical location.

Carnatic—Shaped by ancient Hindu traditions and now based in southern India, *Carnatic* music is primarily a vocal style. When instruments are used, the approach to performance is to mimic vocal styles. Carnatic music is an excellent example of how outside influences can alter traditional music of a culture; one of the primary instruments used in this style of music is the violin, an instrument design traceable to northern Italy in the late 1600s. The study of Carnatic music also underscores one of the challenges of researching music that lacks a historical, written notation; it is difficult, if not impossible, to experience the music in its pure, unpolluted form.

Four components make up Carnatic music: *swara*, the note or syllable; *śruti*, the relative pitch of the scale tone; *tala*, the repeating rhythmic pattern; and *rāga*, the notes of the melodic pattern. The tala and rāga may be different lengths, creating tension in the music as the two move out of sync and resolution as they cycle back into synchronization. A drone instrument, traditionally the *tambura*, provides the pitch underpinning and stability to the music, while rhythmic regularity is supplied by one or more rhythmic instruments, such as *tabla* drums.

Polyphony is not a component of this type of music; however, improvisation is key. The study of Indian music includes years of instruction in the rules and structure of traditional improvisation within different forms of tala and rāga.

Hindustani—Indigenous to northern India and nearby Bangladesh, Pakistan, Nepal, and Afghanistan, *Hindustani* is considered a classical style of Indian music. Hindustani grew from Carnatic, but its primary difference is the inclusion of influences by Persian music brought on by the Muslim conquest of northern India and the surrounding areas. Because of the dual makeup of the population of this area, Hindus and Muslims, it is common for two words to be used to name a single thing. For example, Muslim musicians are called *ustad* while Hindus are called *pandit*. Both types of musicians traditionally perform music associated with both cultural groups.

As an outgrowth of Carnatic music, Hindustani is also based upon vocal styles and uses the same tala and rāga structural elements of Carnatic music. Differences lie in the swara; Hindustani music uses a musical scale with seven notes, a scale similar to that used in Western music. The Roman Empire encompassed several areas that later became part of Muslim-dominated lands, and many Western concepts entered Muslim culture. To Western ears, Hindustani music can sound both familiar and exotic at the same time.

GUIDED LISTENING 7.01

Music of India

Based primarily upon structural components of *raga* and *tala*, traditional music of India can be divided into two main types: Carnatic and Hindustani. Though similar in some ways, they each contain distinctive elements. Listen for scales, meter, a drone instrument or tone, and types of percussion.

Music listening may be accessed from www.ourworldourmusic.com

Figure 7.21

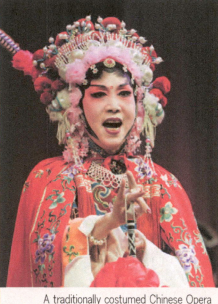

A traditionally costumed Chinese Opera performer.

China

Traditional music of China has a documented history since before 1000 B.C. The Chinese also have a central legendary character, Ling Lun, who is said to have made instruments from bamboo (probably flutes) that could imitate birds. As with many things in China, state control was applied to music more than two thousand years ago, when ceremonial, military, and even folk music was specified and enforced. The traditional music of China was influenced by Western music when a Jesuit missionary-priest presented the emperor with a harpsichord in 1601. At the beginning of the twentieth century, Western influences in China reached a peak. Orchestras were created, instruments such as saxophones and xylophones were used in traditional Chinese music, and even jazz found a place within the music of China. When the Communist Party came to power in China near the middle of the twentieth century, it labeled all of these Western influences as "pornographic" and began to control ceremonial, military, popular, folk, and all other types of music in the country, much as had been practiced two thousand years before. Unfortunately, a return to "traditional" music was almost impossible due to centuries of Western influences.

GUIDED LISTENING 7.02

Music of China

With a 3,000+ year history, music of China is in some ways older than any other known music in our world. Unfortunately, as China's society has evolved during that time, much has been either lost or combined with other influences. Today, a truly individual Chinese music is difficult to determine. Listen for scales, meter, percussion, and many Western elements to be combined with a traditional singing style for the voice.

Music listening may be accessed from www.ourworldourmusic.com

Figure 7.22

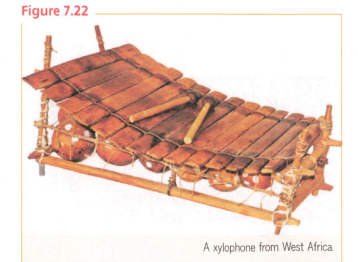

A xylophone from West Africa.

Africa

No single type of African music exists; however, some elements are common to the music of many areas within this vast continent. One unifying element is the common use of percussion-based rhythmic approaches. Instruments vary from area

to area and are often based upon availability of materials for their construction. Melodies are usually based upon capabilities of the human voice. Call and response, somewhat similar to imitation in Western music, is integral to performance practice. Polyphony is not common; however, music of Africa often uses heterophony. Western musical scales tend to be dominant, but they are relaxed in their intonation.

Idiophones and membranophones dominate, although a common stringed instrument in western Africa is the *kora*. Traditional African music is a participatory experience in which all present join in, unlike Western music's performer-and-audience approach. Vocal music approaches often use pops, clicks, shrieks, and other sounds not common in Western music. These instruments and performance practices have been exported to other parts of our world and are often adopted into other types of music.

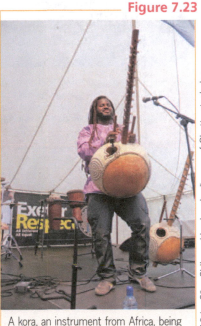

Figure 7.23

A kora, an instrument from Africa, being played at an outdoor event.

© 2013 by Clive Chilvers. Used under license of Shutterstock, Inc.

GUIDED LISTENING 7.03

Music of Africa

There is no single type of African music, however there are many elements that seem to be common or similar in the music from many areas across this vast continent. Percussion instruments tend to dominate, however stringed and other instruments are also present. Dance, singing, and playing are all frequently parts of a single experience and there is no rigid distinction between performers and audience. Listen for relaxed tuning, hand percussion, and multiple simultaneous meters.

Music listening may be accessed from www.ourworldourmusic.com

Indonesia

With more than seventeen thousand islands separated by water, Indonesia cannot be said to have a single culture or a single type of music. The most famous and most popular form is *gamelan*, performed by groups of musicians playing bamboo flutes, stringed instruments, and many types of percussion instruments. Prominent in Java, Lombok, and Bali, gamelan uses relaxed tuning and scale systems. The center of the gamelan is the metallophone, a type of xylophone with metal bars. Also important are gongs in various sizes. Claude Debussy's music in the early twentieth century was influenced by Javanese gamelan music.

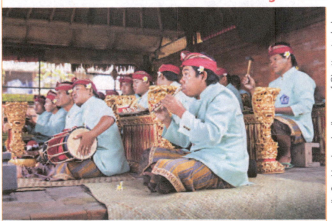

Figure 7.24

A Gamelan orchestra plays traditional Balinese music to accompany dancers at a festival.

© 2013 by saiko3p. Used under license of Shutterstock, Inc.

Tone Row Music

Introduced during the first half of the twentieth century, the tone row technique of composing music had two resurgences during the second half of the twentieth century. The first resurgence was in the years following World War II, when composers from countries where music had been controlled encountered tone row technique and viewed it as new. The enthusiasm of these composers encouraged others to revisit the technique, and Arnold Schoenberg's concepts enjoyed a second life. A similar thing happened in the 1990s following the collapse of the Soviet Union. Composers who had lived in controlled Communist Soviet society experienced tone row technique as something new and music of this type enjoyed another revival.

Minimalism

In response to elaborate and complicated musical styles, some composers in the 1960s began to compose using not only minimal performance resources but also limited harmony, melody, and other musical devices. Characteristics of minimalist music include repetition, slowly changing harmonies, and lack of directional movement. Minimalism creates moods or washes of sound that encourage the listener to float along with the music.

Aleatoric Music

The word *alea* is Latin for "dice." *Aleatoric music,* sometimes called *chance music,* includes one or more elements that are determined by chance. Sometimes the composer leaves options for the performer, such as tempo, rhythms, or even the order in which parts of the music should be played. Sometimes electronic devices are used with variable components, such as including a radio; in this example, whatever is, or is not, on a specific frequency becomes part of the music. Random audience noises can also become part of an aleatoric work.

Each of the examples noted previously have been used in pieces of aleatoric music. Perhaps the most famous piece of aleatoric music is a work by John Cage titled *4' 33"* (the title refers to the length of the piece). At the beginning of the piece, the performer sits at the piano and raises the cover over the piano keys. The next four minutes and thirty-three seconds are filled with only the random human noises from the audience and other sounds that creep in from the outside and from the building itself. At the conclusion of the time period, the performer closes the cover over the keys, signaling the end of the piece. No musical note is ever played.

GUIDED LISTENING 7.06

Aleatoric Music

Abandoning the fully scripted instructions approach used by Romantic period composers, aleatoric music contains one or more element of chance. While the composer may have control over some or most of the piece, the part left to chance could be determined by the performer or it could be determined by something under nobody's control. Listen for the scripted portions and then try to determine what are the chance elements.

Music listening may be accessed from www.ourworldourmusic.com

Tonality Continues

Throughout the twentieth century and today, composers have been exploring new ideas and approaches concerning making music. While some famous experiments may seem rather extreme, most people composing music since 1900 have worked within a more traditional framework. Tonality in modern music follows many of the structural guidelines that have shaped music since the Baroque period. Harmonies may have been extended, new instruments may have appeared, or sounds from other types of music in our world may have influenced the composer. These things only help to make the familiar fresh and new. Since the first monophonic chant was written and preserved for our later study, Western music has been built around the concept of a central pitch to which a melody returns.

Figure 7.25

Musicians today perform music and manipulate sounds directly using technologies and techniques of the 2010s.

© 2013 by Pitroviz. Used under license of Shutterstock, Inc.

Electronic Music

Just as electricity helped to shape the world of the twentieth century, it also exerted substantial influence upon the music of that time. New instruments, tools, and approaches to composing music resulted from the application of electricity to the making of music.

Pure Electronic Music

Advancing twentieth century technologies were regularly adopted and adapted by musicians. The reel-to-reel tape recorder literally placed sounds in the hands of the composer. By cutting, splicing, and rearranging the order of pieces of recording tape, composers could manipulate sounds directly instead of writing notes to represent sounds and then having a performer interpret the writing into sound.

Synthesizers, created during the first half of the twentieth century and developed throughout the second half of the century and into today, have become a part of almost every type of music. Never before have composers and musicians had such variety of sounds and timbres available to them. The ability of digital synthesizers to communicate directly with computers allows composers to play music on the synthesizer and then store and manipulate the sounds within the computer. Software applications can allow the computer to work for the composer in the same way that word processors work for authors. Composers can play music on a digital keyboard, and computer software can immediately translate the performance into musical notation, greatly speeding up the compositional process.

Mixed Media

Composers often combine electronic and acoustic elements within a single piece of music. This has sometimes resulted in new approaches to counting time and noting rhythm, as composers write for things in minutes and seconds rather than in traditional music notation. Sometimes, the combining of visual media with electric and acoustic musical elements results in new approaches to identifying structure and form as the music adapts to interact with the visual component. Mixed media presentations often engage audiences more fully through their impact upon multiple sensory inputs.

Figure 7.26

Combining music with visual elements can increase the emotional impact of a performance.

© 2013 by Faraways. Used under license of Shutterstock, Inc.

GUIDED LISTENING 7.09

Mixed Media

Combining the sound of music with some other medium can enhance the presentation. Throughout this book, musical examples have been combined with video. Composers often plan their music with a video element in mind. When multiple media are addressed, the impact of the presentation can be greatly enhanced. Listen for accents in the music that correspond with events on the video screen.

Music listening may be accessed from www.ourworldourmusic.com

For learning activities, practice quizzes, and other materials,
visit: www.ourworldourmusic.com

Name: _____

1. After the two world wars, which countries emerged as superpowers?

2. What effect did the use of automation and robotics have on manufacturing?

3. What was the Cold War?

4. What does MAD stand for, and what does it mean?

5. Describe what happened to China and the Soviet Union during the second half of the twentieth century.

6. Discuss these three events that influenced society since the 1950s:

baby boomers

civil rights movement

space race

7. Which country launched the first satellite into orbit? What was its name?

8. Name some technological advances of the 1970s.

9. What is OPEC?

7.2 Worksheet

Name: _____

1. In the 1980s, the world shifted from _____ to _____ technology.

2. When was the personal computer introduced?

3. In the 1980s, how was information shared from computer to computer?

4. When did the mobile telephone become available?

5. What do AIDS and HIV stand for?

6. The fifty-five-mile-per-hour speed limit law was amended in _____ , and the new limit was _____ .

7. How did the United States become our world's only superpower?

8. What event triggered the election of Nelson Mandela in South Africa?

9. What is the date of the largest terrorist act on the American homeland?

10. What places were directly involved?

11. The largest natural disaster in America, occurring in 2005, was _____ .

12. Who is Barrack Obama?

13. After the television, the _____, another technological advancement, allowed people
 to experience sounds and images in a new way.

14. Explain how a phonograph produces sounds.

15. From where does the term "groovy" come? What does it mean?

Name: _____

1. What is the difference between an EP and a LP?

2. Who developed the analog tape recorder? How does it work?

3. Discuss these types of analog magnetic audiotapes:

 Reel-to-reel

 Eight-track tape

Cassette tape

4. When did sound recording switch from analog to digital?

5. How does a digital audiotape differ from an analog tape?

6. What is a compact disc (CD)?

7. What does Beethoven's Ninth Symphony supposedly have to do with CDs?

Name: _____

1. What is a DVD, and how does it work?

2. Explain surround sound.

3. How is a digital music player used?

4. How is music recorded and distributed from the internet?

5. What is the difference between an on-air radio station and a "music service provider"?

6. What is different about where people live in the 2010s?

7. Which country has risen to be a second superpower in the 2010s?

8. Discuss two instances of large scale pollution in the 2010s.

9. In regard to computers, what is "cloud" storage?

10. To what does the term "apps" refer?

11. What decade seems to be influencing music and fashion now?

12. Tell what these individuals added to electronic music:

Leo Fender

Les Paul

Robert Moog

13. What technology aided people of the world to experience music of other cultures?

7.5 Worksheet

Name: _____

1. Discuss these types of music from India:

 Carnatic

 Hindustani

2. Traditional music from China has been documented since _____ .

3. Who is the legendary character in China who made instruments from bamboo?

4. When did Western musical influences peak in China?

5. How many types of music are there in Africa?

6. Which kinds of instruments dominate African music?

7. How does African music differ from Western music?

8. The most famous and popular form of Indonesian music is _____ .

9. Which twentieth-century composer was influenced by hearing gamelan music from Java?

Name: _____

1. When did the tone row technique reappear in the second half of the twentieth century? Why?

2. Describe minimalism.

3. What does the Latin word *alea* mean?

4. Aleatoric music is often called _____ .

5. Describe John Cage's work *4' 33"*.

6. Discuss some influences of electricity upon music.

7. Why do mixed media presentations engage audiences so well?

8. How can combining music with visual elements affect the impact of performances?

9. How would you describe the music you enjoy? Discuss its characteristics.

7.7 Worksheet

Name: _____

Define the following terms:

1. AM radio

2. FM radio

3. groovy

4. EP

5. LP

6. Analog tape

7. Reel-to-reel tape

8. Eight-track tape

9. Cassette tape

10. Digital audio tape (DAT)

11. Compact disc (CD)

12. Digital video disc (DVD)

13. Surround sound

14. Digital music player

15. mp3 format

7.8 Worksheet

Name: _____

Define the following terms:

1. Carnatic music

2. Hindustani music

3. Ling Lun

4. kora

5. gamelan

6. metallophone

7. minimalism

8. aleatoric music

9. tonality

10. electronic music

11. synthesizer

12. mixed media

RISE OF POP MUSIC AND ITS PLACE IN SOCIETY

While art music continued its evolution, a parallel path of musical development was evident in the evolution of pop music. In nineteenth century Europe, popular music was opera and the shorter operetta. Much of this was exported to the rest of the Western world. In America, the run-up to the American Civil War, its fighting, and the devastation of its aftermath found American patriotic music as a form of popular music. Some of this popular music supported one side of the conflict, and some supported the other. Popular, patriotic songs of the period include *The Star Spangled Banner, The Yellow Rose of Texas, The Battle Hymn of the Republic (Glory Hallelujah), When Johnny Comes Marching Home,* and *America the Beautiful.*

Figure 8.01

A parade in New York in the mid-1800s. Military-style marching bands are still a part of outdoor parades.

Minstrelsy, the nineteenth century stage shows in America, included singing, dancing, and comedy but little plot. They were more revues than musical theater. Minstrel shows were initially performed by white performers in blackface, depicting stereotypical, often disparaging, characterizations of blacks. The songs in these shows supported this approach to entertainment. Following the Civil War, many blacks, wearing blackface, became minstrel performers. Often, the popular songs of Stephen Foster were borrowed and used in these shows. It is interesting to note that minstrel shows enjoyed significantly more popularity in the North than in the South.

Another popular type of music during the second half of the nineteenth century was wind band music, popularized by bandleaders such as Patrick Gilmore (who wrote the lyrics to *When Johnny Comes Marching Home*) and John Philip Sousa. The makeup of the wind band allowed for a greater variety of concert venues, as opposed to orchestras that needed a large indoor concert hall for their performances. March music was a staple of the wind band during this time. Many of Sousa's marches were derived from his attempts at opera.

Figure 8.02

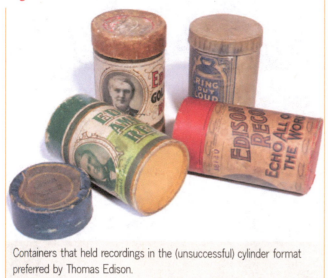

Containers that held recordings in the (unsuccessful) cylinder format preferred by Thomas Edison.

© 2013 by Terence Mendoza. Used under license of Shutterstock, Inc.

TECHNOLOGY'S INFLUENCES

Recording technology, invented during the latter part of the nineteenth century, did not result in significant distribution of recorded music until the war between two competing formats was resolved. Thomas Edison, the technology's inventor, preferred to record sound on a cylinder, similar to a soup can with both ends removed. Emile Berliner, his main competitor and a founder of the Victor Talking Machine Company (later to become RCA Victor and use an iconic dog listening to a recording of his master's voice in its advertisements), preferred a flat disk. Ease of use and convenience of storage eventually led Edison to realize that consumers had made their choice evident through their purchases. His company, too, began to manufacture phonographs that used flat disks rather than cylinders. The resolution of the format war prompted wider distribution of recorded music.

Phonograph Records

Phonograph records, the disks that won the format war, were capable of holding only about four minutes of material on each side of the disk. Complex, involved musical works were too long to fit on a single side of a disk. Listening to long musical works required the listener to repeatedly turn over or replace disks. Shorter, individual songs, however, fit well onto this format. Society's shift in interest from large concert works to shorter songs was influenced by the limitations of recording technology.

Recorded music led to the phenomenon of widespread popularity of a single singer. For the first time, performers became widely popular with audiences that had often never seen them. Audiences began to identify more with the sound and names of singers than with titles of works and names of composers. The most successful singer, selling the most records during the first half of the twentieth century, was Bing Crosby. He used a rapidly improving technology on stage: the microphone. This device allowed him to approach performance in a more intimate manner. Crosby created a style of singing based upon operatic approaches, emphasizing nuances in the voice rather than the almost shouting approach required to fill a theater when not using a microphone. He recorded an English translation of *Stille Nacht Heilige Nacht*, an Austrian song that was a hundred years old, and *Silent Night* joined the list of

Figure 8.03

Bing Crosby's star on the Hollywood Walk of Fame in California. Note the old fashioned microphone included in his memorial.

© 2013 by Jorg Hackerman. Used under license of Shutterstock, Inc.

traditional Christmas songs, along with *White Christmas,* another of his recordings. Bing Crosby's recording of *White Christmas* is the largest selling single recording of all time. It is followed by Sir Elton John's remake of his own *Candle in the Wind* as a tribute to Princess Diana upon her death. Cosby's 1942 *White Christmas* (50 million), John's *Candle in the Wind,* 1997 (33 million), and Crosby's 1935 Silent Night (30 million) are the world's #1, #2, and #3 largest selling singles. The new dynamic of digitally downloading singles rather than albums may push Crosby into the #1 and #2 slots by the end of the 2010s, though John will likely not fall below #3.

Radio

The European and American approaches to radio broadcast were different. In Europe, owners of radios were charged an annual fee (tax). Governments controlled and limited the number of broadcasters, and broadcasters were underwritten through the radio tax. In America, tax was only charged at the time of sale. The federal government licensed and allowed a large number of broadcasters. Broadcasters competed with one another as a part of the capitalist system, generating their income through advertising.

The result was diversity of types of radio stations in America, supporting widely varying types of music. Radio promoted the "product" of the music industry: songs. Record labels gave records to radio stations and were in constant competition with one another to have the most popular product. This competition drove constant musical innovation and revolution. The capitalist, commercially driven system helped to create a culture in which new was desirable and older music, even a few years old, was out of fashion and no longer desirable. This *pop culture* approach to constantly seeking innovation continues today.

Europe's popular music growth was stunted during the first half of the twentieth century because marginal and new music was not played. Extreme control of radio stations and the types of music they broadcast was exerted by the Nazis in Germany, the Communists in the Soviet Union, and other totalitarian regimes. In Europe during the first half of the twentieth century, musical styles were slow to change and musical innovation was severely limited.

TIN PAN ALLEY AND POP MUSIC

In the second half of the nineteenth century, the primary means of distributing music was in the form of written sheet music. During that period, the best-selling sheet music in America was for opera songs, followed by sheet music for minstrel songs. The first million-selling song (in sheet music) in the 1890s brought interest to that industry and prompted the rise of the popular music business.

To more easily recruit songwriters, many music publishers opened branch offices in New York near the vaudeville theaters. This area became known as Tin Pan Alley, and the business of popular music grew from this place. Tin Pan Alley was a music factory dedicated to producing popular songs. Composers would often write a few lines of a song and shop it to various Tin Pan Alley publishers, completing the song only after it had been purchased by a publisher. Tin Pan Alley catered to a diverse audience, resulting in the recording and distribution of many types of music. Tin Pan Alley–type music factories grew up in many cities in America. One was Memphis, Tennessee, home of W. C. Handy. Handy hired songwriters, including William Grant Still and Scott Joplin, to spend their days writing popular songs in the hope of creating hits.

GUIDED LISTENING 8.01

Tin Pan Alley and Pop Music

Songs of Tin Pan Alley drove the emerging popular music industry for the first few decades of the 20th Century. Usually these songs were written in AABA format, lookinga bit like that of sonata form, though much shorter since each section was usually only eight measures. Sometimes these songs had a prelude section that resembled recitative from opera. They always used theme and variations form as the song repeated for different verses or solos. Listen for form and catchy phrases that are called "hooks."

Music listening may be accessed from www.ourworldourmusic.com

STAGE AND SCREEN

In a parallel with opera, individual songs that appeared on stage, and later on screen, often became pieces of popular music. The use of technology in promoting this music on radio and in distributing it through phonograph records was enhanced when the technology of the motion picture advanced sufficiently in the early twentieth century to support the inclusion of music.

Broadway Musical

The minstrel shows of the mid-nineteenth century evolved into *burlesque*, a risqué form of revues that included singers, dancers, comedians, scantily clad young women, and even strippers. Burlesque was an entertainment form that "burlesqued" or ridiculed people and events of that period's society. Burlesque cleaned itself up a bit and evolved into *vaudeville*, still a type of revue without much of a plot but now more appropriate to audiences of both men and women. Vaudeville, in conjunction with opera, operetta, and theater, contributed to the evolution of the Broadway musical.

The *Broadway musical*, or often just *musical*, was a play with spoken dialog. At frequent intervals during the play, characters would suddenly break into song with elaborate instrumental accompaniment, often also including dancing. Suspension of reality on the part of the audience allowed this performance device to work. That same suspension of reality also allowed composers and playwrights to address issues that might otherwise be considered taboo in early twentieth-century society. One of the earliest musicals,

Figure 8.04

There are over 40 prominent theater houses in New York and Broadway shows and musicals are considered to be among the world's highest levels of commercial theatre.

Show Boat, used music and comedy to seriously address the issue of interracial love—in 1927. Despite its topic, the show became a huge hit. Another musical, *Fiddler on the Roof* in 1964, used a setting in pre-revolution Russia to tackle issues of conflicting cultures, prejudice, and persecution. By using the experience of Jews in tsarist Russia, the writers were able to cleverly address the same issues and experiences of African Americans, and doing so at the height of the civil rights movement.

Film

Motion pictures brought theatrical performances to areas that could not support lavish stage productions. Initially, films were silent and live musicians were employed to enhance the content of the film, as well as to cover up the noise made by the projection equipment. That changed in 1927 with the release of *The Jazz Singer,* the first feature-length "talking" film. The film starred singer Al Jolson, initially famous as a blackface performer, who already had several hit songs and was known to audiences. Songs included in the film included *Blue Skies, Toot, Toot, Tootsie (Good Bye),* and *My Mammy.* Motion pictures were never again the same.

Figure 8.05

Film projector. Movies were often called "films" because they were distributed as a series of pictures printed on a strip of plastic film. The strip moved past a light that flickered, blending the images together to simulate movement and resulting in another name for this medium: motion pictures.

© 2013 by Everett Collection. Used under license of Shutterstock, Inc.

GUIDED LISTENING 8.02

Film and Music

When technology advanced to the point of the 1927 release of the first "talking" picture, music was an integral component. Characters in films could not only talk, they could sing. The silent film industry quickly went out of business. Listen for catchy melodies and phrases in songs that would spill over into seperate music sales, increasing the revenue of a film. These songs were often products of Tin Pan Alley.

Music listening may be accessed from www.ourworldourmusic.com

RISE OF POP CULTURE

Beginning around the turn of the twentieth century, dance halls became popular. First the *fox-trot* and then the *Charleston* became popular dances, finally followed by the *jitterbug* just in time for World War II. These dances were much faster than the sedate waltz and minuet of previous periods. The popularity of dancing resulted in consumers shifting their spending habits from sheet music to phonograph records. Sheet music required active participation in making music; recordings allowed passive participation with music, making dancing an option. The cultural shift from playing the music to dancing to the music emphasized the

Figure 8.06

Pop art often draws upon things from everyday life for subjects. Repeated patterns, bold colors, and comic book-type feel are hallmarks of this genre.

cultural shift from art music to popular music. During the twentieth century, a gap was widening between the two forms. This gap also evidenced itself in many other arts forms. Painters began to paint objects that were common in everyday life, such as artist Andy Warhol's paintings of Campbell's soup cans in 1962. In examining pop culture and its impact upon music, it is important to remember that novelty and innovation were of paramount importance. Often, pop culture emphasizes the new, not necessarily the well done.

TYPES AND DEVELOPMENTS OF POP MUSIC

Many forms and styles of pop music grew up during the late nineteenth and twentieth centuries. Interestingly, almost every form of pop music that developed had some element of African heritage as a fundamental component.

Figure 8.07

Illustration of a Ragtime pianist. Note the pop art style of this drawing.

Ragtime

Developed around the turn of the twentieth century, *ragtime* was derived from a combination of marches and banjo playing. Some advertisements for ragtime sheet music spoke of it as banjo imitations. Primarily a piano-based style, ragtime music contrasted a regular "oompah, oompah" left-hand part with a syncopated right-hand part, resulting in what some perceived as "ragged time" and giving rise to the name of this style. The most famous of the ragtime musicians and composers was Scott Joplin. Although famous for "rags," as ragtime songs were often called, Joplin was a classically trained musician who included two operas in his list of compositions.

GUIDED LISTENING 8.03

Ragtime Music

Initially distributed as printed music before recorded music became commercially popular, Ragtime was a piano-based music common in bars and saloons. Listen for a straight 1-&-2-&- feel in the low notes (left hand) and a syncopated melody in the high notes (right hand). Considerable coordination is required for the player to execute these parts simultaneously.

Music listening may be accessed from www.ourworldourmusic.com

Blues

Around 1900, a musical style called *blues* began as an oral tradition music in the Deep South. The first published blues music was in early the 1910s. Blues is a combination of European harmony and African melodic and performance practice. Blues draws upon the African device of *call and response*, a practice in which one voice or instrument makes a statement and other voices or instruments answer it. Call and response does not have to be in imitative form. Other characteristics of blues music include the use of *blue notes*, scale tones that are lowered to the next adjacent note, and a traditional vocal, melodic, and harmonic structure. Vocal lines are presented in A A B format, in which a statement is made and repeated before a counterstatement is made. Melodies are created around the structure of Blues lyrics. Harmonic structure, while varying initially, has followed the same tradition since early in the twentieth century: a twelve-measure, or "12-bar," structure is standard, and while some variation may occur, most blues is based upon the harmonic structure that is indicated in Figure 8.08.

Figure 8.08

12-Bar Blues Structure												
Measure number:	1	2	3	4	5	6	7	8	9	10	11	12
Melody: (often voice)	Part A Statement (Call or Question)				Repeat of Part A Statement				Part B Statement			
Reply to Melody: (often instrumental)			Reply to Melody (Response or Answer)				Repeat Reply to Melody				Reply to Part B Statement	
Chord built on scale degree:	I	I	I	I	IV	IV	I	I	V	V	I	I

Basic structure for Blues music.
Courtesy of Robert Elliott.

Jazz

Jazz is difficult to define due to its many ty`pes. Born around the beginning of the twentieth century, different influences in different decades of the twentieth century drove the development of different types of jazz. Jazz often combines with other musical styles, creating new types of jazz.

Jazz grew from many of the same sources as blues. Ragtime may be considered a form of jazz. Blues, too, may be considered a form of jazz. Similarities include the use of call and response and the use of blue notes. *Improvisation,* the art of creating and performing music at the same time, is a fundamental component of jazz. Driven by the extensive inclusion of improvisation, theme and variations form dominates the style. Two common structural forms are most often used: the 12-bar blues format and a 32-bar format that is often associated with the music of Tin Pan Alley. The 32-bar form has four eight-measure sections and may be notated as A A B A. These components are often used as the basis for several types of jazz.

Dixieland Jazz

Dixieland jazz is a style that began in New Orleans in the red light district bars and brothels on the downriver side of the French Quarter called Storyville. The style also found application in the New Orleans funeral tradition. Small brass bands played hymns and dirges while the family, friends, and mourners accompanied the casket to the cemetery. After the body had been placed in the crypt (bodies cannot be buried in New Orleans because the city is built below sea level), the band would play lively music as it left the cemetery. This lively music took on elements of jazz and developed into Dixieland. These funerals came to be known as *jazz funerals.*

Characteristics of Dixieland include the use of small instrumental groups, usually about six players if the group is stationary, such as on a stage at one of the Storyville bars or brothels. If the group is moving, as at a funeral, slightly more players will be required. The six players are arranged in two rows: in the front line are the horns: trumpet, trombone, clarinet, or saxophone.

Figure 8.09

Young street musicians playing Dixieland music for the lunch time crowd in a park.

The back row is made up of the rhythm section: drum set, string bass or tuba, and piano or banjo. Theme and variations form dominates, and the songs are usually drawn from marches, spirituals, and especially Tin Pan Alley songs. Dixieland is one of the only forms of jazz that uses simultaneous improvisation. The typical song form starts with the melody being played all the way through by the front line. This is followed by individual players taking turns improvising solos that follow the harmonic structure of the song. Following the individual solos, the entire group enters the *shout chorus*, where simultaneous improvisation helps the song to build to a climax before ending. Since Dixieland bands often played for long hours in the bars and brothels, wind instrument players would often find that the muscles in their lips became tired, making it difficult to play. To help compensate for the need to play for hours, some players began to sing their improvised solos on nonsense syllables. This style of singing, called *scat singing*, became a hallmark of Dixieland music and was made famous by the trumpeter Louis Armstrong.

GUIDED LISTENING 8.05

Dixieland Jazz

Performed using a mixture of woodwind, brass, percussion, and sometimes stringed instruments, Dixieland music was an improvisational playground for musicians. Listen for call and response, improvised solos, a "shout chorus" climax, and scat singing.

Music listening may be accessed from www.ourworldourmusic.com

Big Band Jazz

While Dixieland jazz was improvised, *big band jazz* relied upon written arrangements. Big band jazz was the music of the late 1930s and of World War II. The standard instrumentation of five saxophones, four trombones, four trumpets, piano, string bass, drums, guitar, and vocalist yielded an ensemble of close to twenty members. Melodies were traded among the choirs of saxophones, trumpets, and trombones. Solos, while still improvised, were scripted into the music in terms of length and background accompaniment. Often, while one group of instruments was playing the melody, another group would play short background figures, called *riffs*, in support. Many famous big bands created the pop music of the time, including those led by Count Basie, Glenn Miller, Bennie Goodman, and Duke Ellington.

Figure 8.10

Saxophones were to Big Band music what violins are to orchestra music: the primary melody instrument. Ever since the Big Band era, the saxophone has been linked to jazz in the minds of many.

© Shutterstock, Inc.

GUIDED LISTENING 8.06

Big Band Jazz

While Dixieland music made use of small groups of instruments and frequent improvisation, Big Band jazz groups were made up of twenty or more performers and relied upon written music with scripted in places for improvisation. Interestingly, if a singer was present, he or she did not sing until later in the music, and then usually for only one chorus. Listen for call and response between groups of instruments and for improvised solos.

Music listening may be accessed from www.ourworldourmusic.com

Figure 8.11

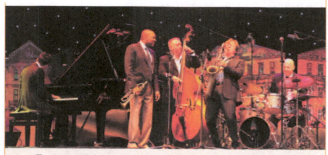

Traditional Bebop jazz combo with three piece rhythm section and two horns.

Bebop Jazz

Following World War II, society looked for new things. Some musicians, bored within the structure of the big bands' written arrangements, sought smaller group opportunities. These small groups, called *combos*, provided more freedom for extended improvisation. The controversial new style, called *bebop* or *bop*, was embraced by many, such as Dizzy Gillespie, Thelonious Monk, and Charles Mingus. It was also rejected by many of the big band musicians. The greatest of the bebop players was Charlie Parker, a saxophonist also known as "Bird." Parker led the way in extending melodies to notes within the harmony that were seldom played. His genius was tempered, however, by his heroin addiction and alcoholism.

Characteristics of bebop include extended solos, very fast tempos, blindingly fast notes, harmonies and chords extended well beyond anything used previously, and stripped down, small combos of usually no more than five players: piano, string bass, drum set, and two horns. Bebop music did for jazz what tone row technique had done for classical music: it took music beyond a point where audiences were willing to follow. As a result, when jazz ceased to resonate within society in the same way, it fell from favor and other types of music rose to replace it.

GUIDED LISTENING 8.07

Bebop Jazz

Large groups required large audiences to support them. Bebop's reliance upon small groups, usually about five instrumentalists, allowed for smaller performance venues and audiences. The style did not easily lend itself to dancing, being better suited for listening, and drove away those patrons who had enjoyed dancing to Big Band jazz. Listen for fast notes, extended periods of improvisation, and small ensembles called "combos."

Music listening may be accessed from www.ourworldourmusic.com

Cool Jazz, Free Jazz, and Fusion Jazz

In reaction to bebop's frantic pace and notes played so quickly that they were almost indistinguishable, some musicians moved to a more relaxed form of jazz called *cool jazz*. Miles Davis and Dizzy Gillespie were leaders in this style that flourished in the 1950s. It was

followed in the 1960s by experimental music that matched the experimental nature of 1960s society, called *free jazz*. This type of jazz resembled aleatoric music because free jazz left much of its harmonic, structural, and melodic components to chance. The music also resembles the psychedelic styles that were appearing in other art forms, styles often associated with the 1960s drug culture. *Fusion jazz* brought together, or *fused*, traditional acoustic instruments of earlier jazz styles with the new electric instruments of other pop styles. Often this meant the use of electric guitar, electric bass guitar, and electric keyboards, coupled with drum set and horns.

Figure 8.12

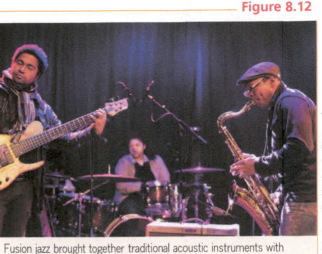

Fusion jazz brought together traditional acoustic instruments with modern electric instruments.

© 2013 by lev radin. Used under license of Shutterstock, Inc.

GUIDED LISTENING 8.08

Cool Jazz, Free Jazz, and Fusion Jazz

Cooling out the excessive fire in Bebop, Cool Jazz is the forerunner of modern Smooth Jazz. Tapping into the mood of the 1960s, Free Jazz reflected the turned on/tuned out mindset of that era. Bringing together acoustic and electric elements, Fusion Jazz brought fire to jazz, but in a controlled and controlable form. Listen for elements of these types of jazz.

Music listening may be accessed from www.ourworldourmusic.com

Figure 8.13

Country

Country music derives from separate, similar roots that came together in two places at the beginning of the twentieth century. In the Southeast United States in the Appalachian Mountains, people from Germany, Ireland, Spain, Italy, and Africa interacted to create a type of music that was initially labeled *Hillbilly music*. Characteristics included the use of stringed instruments from each of these cultures, blended together in a simplistic but interactive way. The first recording of this type was released in the 1920s. The name of the genre was changed in the 1940s to *Country music* because *hillbilly* was considered to be degrading. Using stringed instruments, purists rejected the use of drums though they had no problem with scratching on washboards or slapping spoons

1930s movie version of a stereotyped "Hillbilly" band. Notice the false beards on most of the players and the differently dressed stage crew member who wandered into the shot in the back-left.

© 2013 by Everett Collection. Used under license of Shutterstock, Inc.

together in rhythm. Pure Country music of this type is now called *Bluegrass music*, while the generic term *country* refers to more modern, evolving styles that incorporate influences from other types of popular music.

GUIDED LISTENING 8.09

Country - Bluegrass Music

Primarily using stringed instruments, Bluegrass music represents the style of music derived primarily of influences from peoples in the Appalachian Mountains of the Eastern U.S. Listen for instruments trading the lead melody back and forth. Also watch for the carefully orchestrated stage movement of the instrumentalists as they move around to always keep the melody instrument closest to the microphone.

Music listening may be accessed from www.ourworldourmusic.com

Figure 8.14

For a while, singing cowboys were the hit of movies, radio, and records. Songs often referenced cowboy topics, places, or contained made-up cowboy phrases, and dress was based upon a stylized concept of the American West. Every little boy wanted to be a cowboy.

In the Southwest, especially Texas, immigrants from most of the cultures responsible for the development of Country (Bluegrass) music—Germany, Ireland, Spain, and Italy—interacted with people already present, such as new-world Spanish, Mexican, and Native American people. The combination of this mix of musical heritage resulted in a regional type of music originally called *western music*. This term can be confusing. *Western Music*, as in originating in the western United States, does not refer to the more generic Western music that references music influenced by Western culture as defined by those societies directly or indirectly influenced by the Roman Empire. To add to the confusion, "western (U.S.) music" was, indeed, a type of "Western (culture) music." Perhaps use of its other name, *Cowboy music*, will help to straighten out the semantics. Cowboy music was popularized in films, giving rise to the singing cowboy.

Western, or Cowboy music, absorbed influences from jazz and came to be known as *Western Swing*. The style primarily used strings instead of horns, although some mariachi influences brought in trumpets and instrumental breaks between singing frequently had a distinctly jazz-like sound. Western Swing also included a drummer playing a drum set, a concept borrowed from jazz. This idea was ported over to Country music, and almost all forms Country music since the 1960s, except Bluegrass, have included drums in their instrumentations.

GUIDED LISTENING 8.10
Country - Western Swing Music

Using stringed instruments and adding brass and percussion, Western Swing was a cousin of Bluegrass. Both remain separate as individual styles, yet they also blend together to contribute to a greater whole of Country music. Note Western Swing's use of drums, voice pairing from the Renaissance, and improvised solos that contain elements of jazz.

Music listening may be accessed from www.ourworldourmusic.com

Country music was made popular through radio broadcast. The Great Depression severely affected sales of recorded music. Most people heard music through radio. In 1925, the *Grand Ole Opry* began being broadcast by WSM radio in Nashville. That station, licensed for high-powered transmission, could be heard throughout the Southeast and often across the country. The program is still broadcast by WSM radio. One result of the broadcasts was that Nashville came to be viewed as the center for Country music. Today, Nashville, New York, and Los Angeles are the three recording and popular music centers of the United States, producing music in all genres.

Country music blended with Rhythm and Blues and Rock and Roll in the 1950s to create *Rockabilly*, a style made famous by Elvis Presley, Johnny Cash, and Carl Perkins.

GUIDED LISTENING 8.11
Country - Rockabilly

Blending Country, Rock and Roll, and Rhythm and Blues near the middle of the 20th Century created a style called Rockabilly. Listen for accents on beats 2 & 4, featured guitar sound, and vocals with a country accent.

Music listening may be accessed from www.ourworldourmusic.com

Nashville sound met Gospel when Ray Charles, a blind piano player who began his career playing in Country bands, brought his heritage of Gospel music that he learned in his mother's black southern church and joined the two genres. Some objected to the fusion of these sacred and secular styles, while others embraced this new sound.

GUIDED LISTENING 8.12
Country - Ray Charles

Another blending, this time of Nashville's Country music sound with a full choir, an orchestra, and gospel piano playing, yielded a new sound. No one thought that these elements could be brought together--except Ray Charles. Listen for all of the elements noted above.

Music listening may be accessed from www.ourworldourmusic.com

Beginning in the 1960s and continuing well into the remainder of the twentieth century, Country and Rock came together in a genre called *Country Rock* or *Southern Rock*. This style rejected slick, studio-produced Country with violins and orchestras for more raucous, barroom-appropriate musical approaches.

GUIDED LISTENING 8.13

Country - Southern Rock

Country frequently reinvents itself by blending with other styles. In the 1960s, some musicians rebelled against the overly produced Country style that used orchestras, choirs, and large groups. Stripping down to the strings-based roots of Country and blending it with Rock yielded a new Country Rock (a.k.a. Southern Rock). Listen for small groups, solo singing, and stringed instrument accompaniment and solos.

Music listening may be accessed from www.ourworldourmusic.com

Country is primarily based upon a structure of alternating verse and chorus, much like traditional hymns and probably derived from rondo form from the Classical period. This common pop music song form typically uses a structure of A B A B C A B tag-out. Country music often includes yodeling and other influences from people of the different cultural groups that came together to create the genre. Modern Country music, sometimes called New Country, often finds influences in other styles, resulting in an almost pop-country feel.

GUIDED LISTENING 8.14

Country - New Country

Modern Country music, sometimes called New Country, draws upon any and all of the previous forms of Country, making use of historic elements such as twangy singing, single note guitar solos, banjo, fiddle, and drums. It combines this historic approach with modern Pop music, resulting in something that can frequently cross into multiple genres of popular music. Listen for electronically augmented acoustic sounds combined with historic elements of Country music.

Music listening may be accessed from www.ourworldourmusic.com

Rhythm and Blues

Originally developed following World War II, the term *Rhythm and Blues* has come to be an umbrella term that includes many types of music originally made by, and marketed to, African Americans. The term *Rhythm and Blues* was originally used to replace an older identifier, *Race Music*, which was considered offensive by the newly awakened civil rights movement. For a period in the 1950s, Rhythm and Blues was also called *Rock and Roll*, and many of the same artists were topping the best-selling record charts for both categories. Elvis Presley had songs that simultaneously charted at or near the top of the Rock and Roll, Country, and Rhythm and Blues charts. Nat King Cole did the same on Rock and Roll and Rhythm and Blues charts. Some bands intentionally avoided putting pictures on their albums to sell to both white and black listeners. At times, the term Rhythm and Blues has included some styles of Gospel, Soul, Funk, and Disco. Motown sound, from Detroit, has also been included under the term Rhythm and Blues. Modern R&B, identified by using the initials rather than the full phrase, was influenced by Funk and Soul.

R&B continued its evolution in different directions than Rock and reached a high level of prominence in the 1990s and early 2000s when "slow jams" dominated the output of many artists. Since then, R&B has moved in directions that blend it with more driving dance styles, Electro-pop sounds, and with pop ballads that have a different feel than R&B of years past. R&B in the 2010s became a genre that spoke more to musical style than to race, as several new performers from a variety of racial backgrounds embraced R&B, bringing their own cultural experiences to fuse with and influence the style. As a result, R&B continues to change and adapt in ways that help it to resonate with its listeners, assuring that it will be a part of popular music for the foreseeable future.

GUIDED LISTENING 8.15

Rhythm and Blues - a.k.a. R&B Music

In the 1950s, Rhythm and Blues was also called Rock and Roll. Many hit songs fit both monikers.,but the two styles grew apart. Rock and Roll became Rock, a guitar-driven approach with rebellious lyrics with which many young and adolescent men identified. Rhythm and Blues became R&B, a story-telling style that embraced technology and became more keyboard driven. R&B evolved throughout the second half of the 20th Century and beyond. Listen for inclusion of technologies, story telling, and prominent keyboards. Music listening may be accessed from www.ourworldourmusic.com

Rock and Roll

The roots of Rock and Roll are firmly planted in 1950s Rhythm and Blues, with influences from Country, Folk music, jazz, and classical music. The first song to top the Rock and Roll charts was *Rock Around the Clock* by Bill Haley and His Comets. Rock Around the Clock is the fourth top selling single recording of all time (25 million), behind the Bing Crosby and Sir Elton John recordings noted earlier in this chapter. Bill Haley is known as "The Father of Rock and Roll" for his signature song, though Richard Penniman, a.k.a. Little Richard, is sometimes referenced as sharing that title due to his contributions to performance practices that came to define both Rock and Roll and Rhythm and Blues.

GUIDED LISTENING 8.16

Rock and Roll

Rock and Roll was based upon components of 1950s Rhythm and Blues, Country, Folk music, jazz, and classical music. True to its formative period, the style had no real racially identifiable characteristics. Two people are regularly recognized with the title "Father of Rock and Roll." Listen for slightly accelerated tempo, aggressive performance practices, and strong accent on beats 2-&-4.

Music listening may be accessed from www.ourworldourmusic.com

Characteristics of Rock and Roll

Rock and Roll, later shortened to Rock, is electric guitar-based music with a heavy accent on beats two and four, called *backbeats*. Guitars are supported by drums, electric bass guitar, and keyboard instruments such as piano, electric organ, and later synthesizers. Rock often uses Blues harmonic progressions, seldom using more than three or four chords per song. Often, the featured singer also plays an instrument while singing. Rock has often merged with other forms of music to create variant forms of Rock.

The Beatles

The Beatles were a 1960s phenomenon, affecting music, culture, and social awareness more than any musicians ever. The Beatles were John Lennon, Paul McCartney, George Harrison, and Ringo Starr. An English group, they made their first visit to America in 1964, triggering the "British invasion." Other English groups followed. The Beatles sold more than one billion records worldwide, and their records are still selling. They have sold more albums in the United States than any other band. Following the group's breakup in 1970, all four members went on to have productive solo careers and hit records. Unfortunately, John Lennon was shot and killed in 1980 just after his 40th birthday by a fan who's album copy Lennon had autographed earlier in the day. In 1999, George Harrison suffered over 40 knife wounds when a man broke into his home and attacked him, only being subdued when Harrison's wife beat him with a poker. Harrison survived the attack, then died two years later of cancer.

GUIDED LISTENING 8.17

The Beatles

"Invading" America in 1964, the Beatles led British groups that soon followed. American Blues and Rock and Roll went through the British filter and returned in an altered form that was widely embraced. Listen for chord structures borrowed from these previous forms of popular music, however not always presented in strict 12-bar blues format. Small, guitar-driven groups such as the Beatles were based upon the Rock and Roll groups of the previous decade. A different look from American groups, including haircuts, clothes, and shoes, set the tone for American fashion. Lyrics, while quite innocent initally, soon evolved into topics that reflected the times and the Beatles, in music content and their many interviews, became both leaders in, and reflectors of, 1960s society.

Types of Rock

The electric guitar defined Rock from its beginning. As Rock matured, it was influenced by many types of music and by changes within society. Constants continue to be the guitar-based sound and heavy backbeat accents.

GUIDED LISTENING 8.18

Types of Rock

Like R&B, Rock matured and evolved during the second half of the 20th Century and beyond. It continued to emphasize the electric guitar and strong beats on 2-&-4. Lyrics, though still frequently oriented toward rebellious adolescence, also matured to become more introspective and thoughtful. Listen for evolution of lyrical content over time, electric guitar emphasis, and inclusion of technologies as the state of the art advanced.
Music listening may be accessed from www.ourworldourmusic.com

After the slick, polished Rock productions of the 1970s and the big-hair, over-the-top excesses of glamour rock in the 1980s, musicians in the 1990s turned to a stripped down approach that harkened back to the 1960s. A style of rock called *Grunge* developed in the Pacific Northwest, personified by Kurt Cobain and Nirvana. As the millennium changed, rock adopted elements from other styles, including borrowing the vocal styling of Rap and incorporating it into the electronic, guitar-driven sound of Rock.

Rock in the Third Millennium

Rock music continued to have a dedicated following and remain popular. Rock's overall place on the popular music charts declined, driven mostly by changes brought about by consumers' shifts from purchasing physical (CD) albums to buying individual songs through digital download. The traditional "concept album" approach of Rock does not fit well with modern cafeteria-style selection and purchasing of music. Most of the new hard rock and heavy metal music came from bands that originated in the previous century. Breaking from 1990s Rock's extremely compressed instrumental sounds and its studio mixes that frequently treated lead vocals and electric guitar sounds as equals in volume, Alternative and Indie Rock often modeled itself upon, or attempted to sound much like the 1980s. Instruments were arranged in more "transparent" studio mixes that left more room for each individual sound to be heard, and the balance between instruments and vocals in released recordings shifted back to lead vocals that were louder than, and in front of, the backing instrumental and vocal parts. The electric guitar continued to be an important component of Rock, however for many artists as they embraced new technologies, other sounds often played lead roles. Continuing with approaches pioneered by the Beatles, Paul Simon, and others, Rock in the third millennium embraced sounds, instruments, and influences from other parts of our world.

GUIDED LISTENING 8.19

Rock in the Third Millennium

In the 21st Century, Alternative Rock, Indie Rock, and other forms of Rock style continue to alternately leap forward to new ideas and to flash back to previous stylistic influences. Even when looking backward, new technologies and societal evolution impact the art that is created, moving the style forward. Listen for electric guitar, strong emphasis on beats 2-&-4, and angst-influenced lyrics.

Music listening may be accessed from www.ourworldourmusic.com

Rap and Hip-Hop

Hip-hop is a musical style based upon *Rap*, a performance practice that uses rhythmic, rhymed speech with backing beats and simple, repeating instrumental accompaniment. The earliest roots of Rap can be found in the music of African *griots*, storytellers who traveled and told their stories while accompanying themselves with repetitious, rhythmic music. Hip-hop emphasizes rhythm over melody or harmony. The instrumental components are intentionally simple to allow words to remain dominant. The stylistic concept is similar to the Baroque period recitative in its emphasis of words over musical accompaniment. Hip-hop often draws excerpts from existing recordings and builds upon them as a foundation. This approach is called *sampling*. Hip-hop began in the late 1970s in New York City.

1980s Hip-Hop

Technology again had a significant impact upon music when new digital technology of the 1980s, especially new sampling synthesizers, fueled the use of layers of sampled music in new pieces of Hip-hop music. This practice is still integral to the style today. During the 1980s, Hip-hop was exported to the world and adopted in many areas, prompting the emergence of many variants of Hip-hop. *New-school style* became stripped down and relied

upon aggressive, assertive lyrics and delivery, often taunting other rappers. Hip-hop became the new form of socially aware music, mirroring Rock's role in the 1960s.

1990s Hip-Hop

The 1990s saw a new, inner-city style of Hip-hop develop in Los Angeles. This new style was more violent and derogatory than the New York style. Soon, competition between the two camps for audiences turned into slights and taunts aimed at each other and then into an East Coast versus West Coast war. Guns were drawn, and people were shot during Hip-hop awards programs. Major Rap stars accused one another of making attempts on their lives, and some stars died. West Coast rapper 2Pac Shakur and East Coast rapper Biggie Smalls were casualties.

GUIDED LISTENING 8.20

Rap and Hip-Hop

Hip-hop relies upon performance of rhymed speaking set against simple, repeated instrumental accompaniment. This accompaniment, initially performed live by multiple musicians, was later produced electronically, often by manipulating snippets of previously recorded music. Listen for rhymed speaking and simple accompaniment.

Music listening may be accessed from www.ourworldourmusic.com

Hip-Hop in the Third Millennium

The third millennium began with Hip-hop's popularity still increasing and with it becoming a significant influence on other musical styles. Sales of Hip-hop peaked in 2002 and by the end of the decade, though Hip-hop continued to be an influence, its sales were in steep decline. By the 2010s, sales of Hip-hop trailed sales of both Rock and Country. Hip-hop styles and its artists frequently joined with mainstream Pop, Rock, Country, and other performers to create songs that fused Hip-hop with other types of music. Audiences turned away from 1990s Hip-hop that advocated violent, self-destructive behaviors, misogynistic references to women, and celebration of gangs and prison time. Though some Hip-hop artists continue to create music in this genre in the 2010s, it is evident that audiences that once flocked to Hip-hop performances and bought recordings of this genre's artists, are moving on to new things. As stated many times in this book, a musical style flourishes when it resonates within a society, such as when the frustrations of urban youth in the 1980s and 1990s was manifested in a type of music that became extremely popular. When a type of music ceases to resonate within a society, something else takes its place. While Hip-hop will continue in the foreseeable future, it is unlikely that it will reclaim its previous level of prominence—no type of music has ever resurrected itself in its previous form. Hip-hop's influences, along with influences from many other styles, will be a part of whatever new type of music emerges. It will be interesting to see and hear the next new thing.

Pop Music

Some types of popular music defy categorization into one of the standard formats. These types can often only be referred to generically as *pop music.* One of the foremost artists in this area was Michael Jackson (1958–2009), who was referred to as the "King of Pop." Jackson

still holds the record for the best-selling album of all time; his *Thriller* album sold more than 109 million copies. Four of his other albums, *Off the Wall*, *Bad*, *Dangerous*, and *HIStory*, are also among the top-selling albums in the world. He received thirteen Grammy awards, had thirteen number one singles, and by the time of his death, had sold more than 750 million records.

Originally a Rhythm and Blues Motown artist, Jackson started his career in the company of his brothers as a member of the Jackson 5. He later began working as a solo artist, creating music that can only be defined as pop music. Like early pop music, dance was an important part of this music's performance and of his audience's participation. Capitalizing upon an emerging art form at the time, Jackson transformed the music video, using it not only as a promotion tool for sales of his albums but also as a mini-motion picture with a plot line told through the music. His signature dance steps became staples that were copied on dance floors throughout the world.

GUIDED LISTENING 8.21

Pop Music

Pop music, a dance-oriented style that usually makes use of significant amounts of electronic music technology, tends to draw its audiences from young people in each generation. Borrowing elements from a variety of styles, Pop music's stars often begin their careers in one popular music style and then cross over to Pop. Listen for technology influences and elements, along with solo vocal performance that is the heart of the song and style. Music videos often help to drive acceptance and popularity of a song. Music listening may be accessed from www.ourworldourmusic.com

OUR WORLD, OUR MUSIC, AND THE FUTURE

Time moves on, or as one song says, "keeps on slippin' into the future." (See if you can find the song and artist!) As many of the pioneers of modern popular music continue to age, notices of their deaths are becoming more and more common. Just as the music of the giants of previous musical periods continues to be heard, so will the music of these more modern greats. Thanks to the invention of recorded music, they and their work live on to impact new audiences while we continue to see them in videos. Interestingly, new audiences often do not even know when a song was recorded or if the artist is alive and touring or is long gone. The music of these artists continues to be influential in shaping music within genres and in facilitating cross-pollination between multiple musical genres, styles, times, and places.

In our age of global communication, a new "world music" style is starting to emerge. This style freely mixes elements from multiple cultures and does not depend upon the heritage of its creator. While merit is found in preserving traditional, culturally identifiable styles of music, much can be gained by merging the unique musical ideas of one culture with those of others. As our world becomes more connected and people build relationships across and between continents, the blending of cultural identifiers is one more way of helping to bind us together as humans. As we more intimately share our world, our music benefits from that sharing and its influences.

For learning activities, practice quizzes, and other materials,
visit: www.ourworldourmusic.com

8.1 Worksheet

Name: _____

1. Name some popular patriotic songs of the Civil War era.

2. What were minstrel shows?

3. What did Patrick Gilmore and John Philip Sousa help to popularize in the second half of the nineteenth century?

4. Phonograph records could only hold about _____ of material on each side of the disk.

5. What led to the popularity of a single singer?

6. What are the top three largest selling single recordings of all time and who were the artists responsible for them?

7. What is the top selling album (not single song recording) of all time and who is the artist(s) responsible for it?

8. Compare the approaches to radio broadcasts in Europe and in the United States.

9. What was Tin Pan Alley?

10. Describe each of the following types of shows:

burlesque

vaudeville

Broadway musical

8.2 Worksheet

Name: _____

1. Name some dances that were popular in the first half of the twentieth century.

2. Who was Scott Joplin?

3. What is "ragtime" music?

4. The first blues music was published in _____ .

5. Blues is a combination of _____

 _____ .

6. Explain the basis of jazz.

7. Describe these types of jazz:

Dixieland jazz

big band jazz

bebop jazz

cool jazz

free jazz

fusion jazz

Name: _____

1. From what two geographic areas does Country music derive?

2. Hillbilly music is now called _____ .

3. Cowboy music can also be called _____ .

4. Country music was made popular primarily through _____ .

5. What is Rockabilly music? Who made it famous?

6. Ray Charles combined what two genres of music? Why was that controversial?

7. Describe Rhythm and Blues.

8. In the 1950s, Rhythm and Blues was called _____.

9. Who is known as "the Father of Rock and Roll"?

10. One other artist may share this title. Who is he?

11. What are the characteristics of Rock and Roll?

12. Who were the Beatles?

13. Describe "Grunge" rock.

8.4 Worksheet

Name: _____

1. What does Rap music use as a basis of its performance practice?

2. Hip-hop became the new form of _____.

3. What are some contributing factors to Hip-hop music not being as popular in the 2010s as before?

4. What is sampling?

5. Michael Jackson was referred to as the _____.

6. Name Michael Jackson's best-selling album, which also launched a music video that revolutionized that film genre.

7. Explain how Rock's place on the popular music charts was affected by the evolution of digital download.

8. Alternative Rock is heavily influenced by music of the _____.

9. How does the world benefit from sharing its music?

10. What do you predict for the future of music in our world?

List of Composers for Reports

1. Dina Appeldoorn
2. Johann Sebastian Bach
3. Bela Bartok
4. Ludwig van Beethoven
5. Hector Berlioz
6. Leonard Bernstein
7. Hildegard von Bingen
8. Joseph Boulogne, Chevalier de Saint-George
9. Margaret Bonds
10. Johannes Brahms
11. Harry Burleigh
12. Frederic Chopin
13. Aaron Copland
14. William Dawson
15. Claude Debussy
16. Nathaniel Dett
17. Antonin Dvorak
18. E.K. "Duke" Ellington
19. George Gershwin
20. Louis Moreau Gottschalk
21. George Frederick Handel
22. Franz Joseph Haydn
23. Nora Douglas Holt
24. Charles Ives
25. Scott Joplin
26. Ulysses Simpson Kay
27. Franz Liszt
28. Adolfo Mejia Navarro
29. Felix Mendelssohn
30. Claudio Monteverdi
31. Wolfgang Amadeus Mozart
32. Maria Theresia von Paradis
33. Julia Amanda Perry
34. Florence Price
35. Giacomo Puccini
36. Maurice Ravel
37. Amadeo Roldán y Gardes
38. Clara Wieck Schumann
39. Robert Schumann
40. Franz Schubert
41. Irene Britton Smith
42. John Phillip Sousa
43. Olufela Obafunmilayo Sowande
44. William Grant Still
45. Igor Stravinsky
46. Barbara Strozzi
47. Samuel Coleridge Taylor
48. Pyotr Tchaikovsky
49. Guiseppe Verdi
50. Richard Wagner
51. Clarence Cameron White

Concert Report

Please attach a signed concert program, ticket stub, or both to show proof of attendance.

Name: _____ Class Meeting, Day, and Time: _____

1. Date of Concert: _____

2. Starting and Ending Times of the Concert: _____ to _____

3. Name of the Location (theater and city): _____

4. Name(s) of Performer(s): _____

5. Classification of Music Ensemble (soloist, quartet, symphony, bluegrass band, etc.): _____

6. What style of music was performed (classical, rock, Celtic, country, world music, etc.)?

7. What instruments, if any, were used in the performance?

8. How did the performers visually present themselves (wearing costumes, sitting, standing, moving across the stage, etc.)?

9. Did the performers look professional? Why or why not?

10. Did you like or dislike the concert? Explain.

11. Identify three musical things that you observed during the performance.

12. Which piece or song in the concert most interested you?

13. Who wrote the piece or song that most interested you?

14. Provide a short biography of this composer.

15. Why or for what purpose was this piece written?

16. What performing media (voices, instruments, etc.) were used to present this piece?

17. Using musical terms, discuss the style, texture, and form of this piece.

18. What was the mood of this piece, and what did the composer do to convey that mood?

19. How did the audience react to the performance of this piece?

20. Would you attend a performance of this type again? Why or why not?

Concert Report

Please attach a signed concert program, ticket stub, or both to show proof of attendance.

Name: _____ Class Meeting, Day, and Time: _____

1. Date of Concert: _____

2. Starting and Ending Times of the Concert: _____ to _____

3. Name of the Location (theater and city): _____

4. Name(s) of Performer(s): _____

5. Classification of Music Ensemble (soloist, quartet, symphony, bluegrass band, etc.): _____

6. What style of music was performed (classical, rock, Celtic, country, world music, etc.)?

7. What instruments, if any, were used in the performance?

8. How did the performers visually present themselves (wearing costumes, sitting, standing, moving across the stage, etc.)?

9. Did the performers look professional? Why or why not?

10. Did you like or dislike the concert? Explain.

11. Identify three musical things that you observed during the performance.

12. Which piece or song in the concert most interested you?

13. Who wrote the piece or song that most interested you?

14. Provide a short biography of this composer.

15. Why or for what purpose was this piece written?

16. What performing media (voices, instruments, etc.) were used to present this piece?

17. Using musical terms, discuss the style, texture, and form of this piece.

18. What was the mood of this piece, and what did the composer do to convey that mood?

19. How did the audience react to the performance of this piece?

20. Would you attend a performance of this type again? Why or why not?

Concert Report

Please attach a signed concert program, ticket stub, or both to show proof of attendance.

Name: _____ Class Meeting, Day, and Time: _____

1. Date of Concert: _____

2. Starting and Ending Times of the Concert: _____ to _____

3. Name of the Location (theater and city): _____

4. Name(s) of Performer(s): _____

5. Classification of Music Ensemble (soloist, quartet, symphony, bluegrass band, etc.): _____

6. What style of music was performed (classical, rock, Celtic, country, world music, etc.)?

7. What instruments, if any, were used in the performance?

8. How did the performers visually present themselves (wearing costumes, sitting, standing, moving across the stage, etc.)?

9. Did the performers look professional? Why or why not?

10. Did you like or dislike the concert? Explain.

11. Identify three musical things that you observed during the performance.

12. Which piece or song in the concert most interested you?

13. Who wrote the piece or song that most interested you?

14. Provide a short biography of this composer.

15. Why or for what purpose was this piece written?

16. What performing media (voices, instruments, etc.) were used to present this piece?

17. Using musical terms, discuss the style, texture, and form of this piece.

18. What was the mood of this piece, and what did the composer do to convey that mood?

19. How did the audience react to the performance of this piece?

20. Would you attend a performance of this type again? Why or why not?

Concert Report

Please attach a signed concert program, ticket stub, or both to show proof of attendance.

Name: _____ Class Meeting, Day, and Time: _____

1. Date of Concert: _____

2. Starting and Ending Times of the Concert: _____ to _____

3. Name of the Location (theater and city): _____

4. Name(s) of Performer(s): _____

5. Classification of Music Ensemble (soloist, quartet, symphony, bluegrass band, etc.): _____

6. What style of music was performed (classical, rock, Celtic, country, world music, etc.)?

7. What instruments, if any, were used in the performance?

8. How did the performers visually present themselves (wearing costumes, sitting, standing, moving across the stage, etc.)?

9. Did the performers look professional? Why or why not?

10. Did you like or dislike the concert? Explain.

11. Identify three musical things that you observed during the performance.

12. Which piece or song in the concert most interested you?

13. Who wrote the piece or song that most interested you?

14. Provide a short biography of this composer.

15. Why or for what purpose was this piece written?

16. What performing media (voices, instruments, etc.) were used to present this piece?

17. Using musical terms, discuss the style, texture, and form of this piece.

18. What was the mood of this piece, and what did the composer do to convey that mood?

19. How did the audience react to the performance of this piece?

20. Would you attend a performance of this type again? Why or why not?

Concert Report

Please attach a signed concert program, ticket stub, or both to show proof of attendance.

Name: _____ Class Meeting, Day, and Time: _____

1. Date of Concert: _____

2. Starting and Ending Times of the Concert: _____ to _____

3. Name of the Location (theater and city): _____

4. Name(s) of Performer(s): _____

5. Classification of Music Ensemble (soloist, quartet, symphony, bluegrass band, etc.): _____

6. What style of music was performed (classical, rock, Celtic, country, world music, etc.)?

7. What instruments, if any, were used in the performance?

8. How did the performers visually present themselves (wearing costumes, sitting, standing, moving across the stage, etc.)?

9. Did the performers look professional? Why or why not?

10. Did you like or dislike the concert? Explain.

11. Identify three musical things that you observed during the performance.

12. Which piece or song in the concert most interested you?

13. Who wrote the piece or song that most interested you?

14. Provide a short biography of this composer.

15. Why or for what purpose was this piece written?

16. What performing media (voices, instruments, etc.) were used to present this piece?

17. Using musical terms, discuss the style, texture, and form of this piece.

18. What was the mood of this piece, and what did the composer do to convey that mood?

19. How did the audience react to the performance of this piece?

20. Would you attend a performance of this type again? Why or why not?

Concert Report

Please attach a signed concert program, ticket stub, or both to show proof of attendance.

Name: _____ Class Meeting, Day, and Time: _____

1. Date of Concert: _____

2. Starting and Ending Times of the Concert: _____ to _____

3. Name of the Location (theater and city): _____

4. Name(s) of Performer(s): _____

5. Classification of Music Ensemble (soloist, quartet, symphony, bluegrass band, etc.): _____

6. What style of music was performed (classical, rock, Celtic, country, world music, etc.)?

7. What instruments, if any, were used in the performance?

8. How did the performers visually present themselves (wearing costumes, sitting, standing, moving across the stage, etc.)?

9. Did the performers look professional? Why or why not?

10. Did you like or dislike the concert? Explain.

11. Identify three musical things that you observed during the performance.

12. Which piece or song in the concert most interested you?

13. Who wrote the piece or song that most interested you?

14. Provide a short biography of this composer.

15. Why or for what purpose was this piece written?

16. What performing media (voices, instruments, etc.) were used to present this piece?

17. Using musical terms, discuss the style, texture, and form of this piece.

18. What was the mood of this piece, and what did the composer do to convey that mood?

19. How did the audience react to the performance of this piece?

20. Would you attend a performance of this type again? Why or why not?

Concert Report

Please attach a signed concert program, ticket stub, or both to show proof of attendance.

Name: _____ Class Meeting, Day, and Time: _____

1. Date of Concert: _____

2. Starting and Ending Times of the Concert: _____ to _____

3. Name of the Location (theater and city): _____

4. Name(s) of Performer(s): _____

5. Classification of Music Ensemble (soloist, quartet, symphony, bluegrass band, etc.): _____

6. What style of music was performed (classical, rock, Celtic, country, world music, etc.)?

7. What instruments, if any, were used in the performance?

8. How did the performers visually present themselves (wearing costumes, sitting, standing, moving across the stage, etc.)?

9. Did the performers look professional? Why or why not?

10. Did you like or dislike the concert? Explain.

11. Identify three musical things that you observed during the performance.

12. Which piece or song in the concert most interested you?

13. Who wrote the piece or song that most interested you?

14. Provide a short biography of this composer.

15. Why or for what purpose was this piece written?

16. What performing media (voices, instruments, etc.) were used to present this piece?

17. Using musical terms, discuss the style, texture, and form of this piece.

18. What was the mood of this piece, and what did the composer do to convey that mood?

19. How did the audience react to the performance of this piece?

20. Would you attend a performance of this type again? Why or why not?
